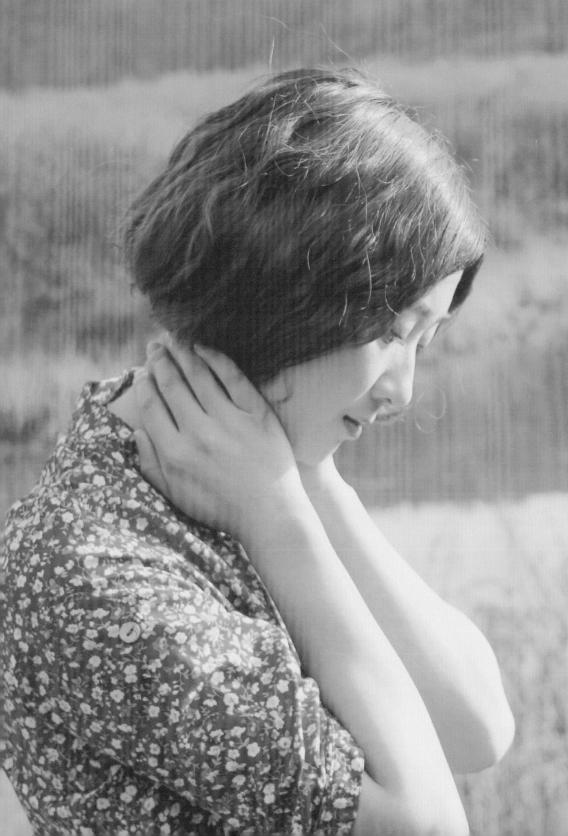

馬

丹

Ma Dan

藝術家

目　錄
CONTENTS

序

何政廣

藝術家出版社發行人

馬丹的畫作，流露出純淨原真的童心。我們看著她筆下的小女孩，與她曾經擁有的不倒翁玩具經歷了又一次的微笑偶遇，帶著小黃鴨屢屢深入田園林間探險尋奇，與大白鵝一起在草地上看著湖景，有時或許孤單，但她總能以奇異豐富的想像力挖掘樂趣，生命真相，就在虛幻與真實之間豁然開朗。

馬丹成長於鄉林，她對於大自然的觀察已形成一種能力。自然花草動物的形象，豐富了她在生活中的體驗，也積累為藝術創作的資源。我們在她的畫裡看到花朵的美妙形態、大白鵝的逗趣行徑、被風吹著變換隊形的白雲以及小女孩獨自立於林間、行走於泥土路的背影，想像著這個以馬丹幼時模樣進入畫境的孩子，在生活與夢想之間遊歷。

最初可能是因為回憶，馬丹透過繪畫與小女孩相遇，並且為她布置新奇的環境，以撫慰她一度陷入孤寂的心情。逐漸地，在形式與構圖中找到了可以進一步抒發自身情感與理想的途徑。馬丹畫裡的世界，成了她行動的舞台。穿著披風的小女孩登場，那是一個更勇於冒險並有能力改變自己生活的她。她也開始嘗試遠行，帶著她家鄉的白雲深入那個異鄉詭異的夜間咖啡廳，感受梵谷瘋狂又帶著激情的紅綠。當然，也該去會會她的偶像，高更先生。在時空交錯中，通過抽象的想像描繪理想而奇妙的現實景物，構成超凡的風景畫。

馬丹的油彩繪畫作品，讓我們感受到真純的美與愛，面對自然、現實、考驗與夢想，她的繪畫總是能將一縷陽光帶入我們的心裡。藝術可以對應哲理，也可以純真愉悅。她手繪的風景比數位時代的「虛擬實境」更逼真自然，而富有情感。在現實和想像世界裡混同交錯，並置於明麗高彩度色調中呈現人與自然的和諧，引領我們看見引人入勝的視覺新世界。

2019年6月於藝術家雜誌社

Introduction

Ho, Cheng-kuuang
Publisher of Artist Publishing Co.

Ma Dan's paintings reveal a childlike innocence. We observe the little girl in her works, who has yet another smiling encounter with the roly-poly doll she once owned. With the little yellow duck, she ventures deep into the field and forest in search of new and wonderful things, and enjoys the lake view with the big white geese. It could be lonely at times, but she can always rely on her vivid and lively imagination to find joy and the truth of life, and be enlightened in a flash in the interstices between illusion and reality.

Ma Dan grew up in the wooded countryside, and she developed the ability to observe nature. The shapes of flora and fauna have enriched her experiences in life and also provided resources for her artistic creation. In her paintings, we see the wonderful forms of flowers, the amusing behaviour of the big white geese, the white clouds billowing in the wind, and the shadow of a little girl alone in the forest and walking on the dirt road. We can imagine that this little girl is Ma Dan entering into the painting in her deam, and wandering between life and dream.

Initially perhaps to recall the past, Ma Dan met with the little girl through painting, and arranged novel settings for the little girl so as to soothe her lonely heart. Gradually, however, Ma Dan found ways to further express her emotions and ideals through form and composition. The world in Ma Dan's paintings became the stage for her action. When the little girl appeared with her cloak, it signaled that she had become a girl who was more adventurous and capable of changing her life. She also began to travel afar, bringing her hometown clouds to go deep into the strange night cafe, and to experience Van Gogh's intense and passionate reds and greens. Of course, it was also time to go meet her idol, Mr. Gauguin. At the intersection between time and space, and through using an abstract imagination to depict the ideal and wondrous aspects of actual scenes, Ma Dan's works constitute extraordinary landscape painting.

Ma Dan's oil paintings allow us to experience true beauty and love. Facing nature, reality, trials and dreams, her paintings always bring a ray of sunshine into our hearts. Art can be philosophical, and it can also be pure joy. Her hand-painted landscape is more realistic and more emotional than the "virtual reality" of the digital era. In the meeting of reality and imagination and with bright and colourful tones, the harmony between man and nature is presented, leading us to see a fascinating new visual world.

June 2019, in Artist Magazine

2019

作品 Artworks

窺見方寸─被安定好的偶然 Glimpse of a Small World - Settled Coincidence　布面油畫 Oil on Canvas　100×100cm　2019

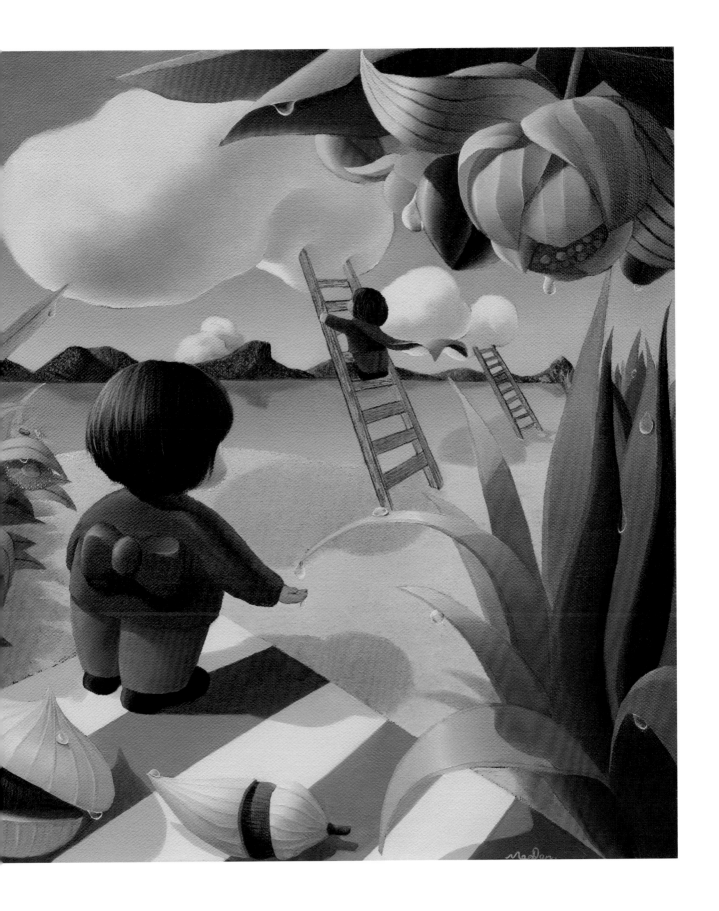

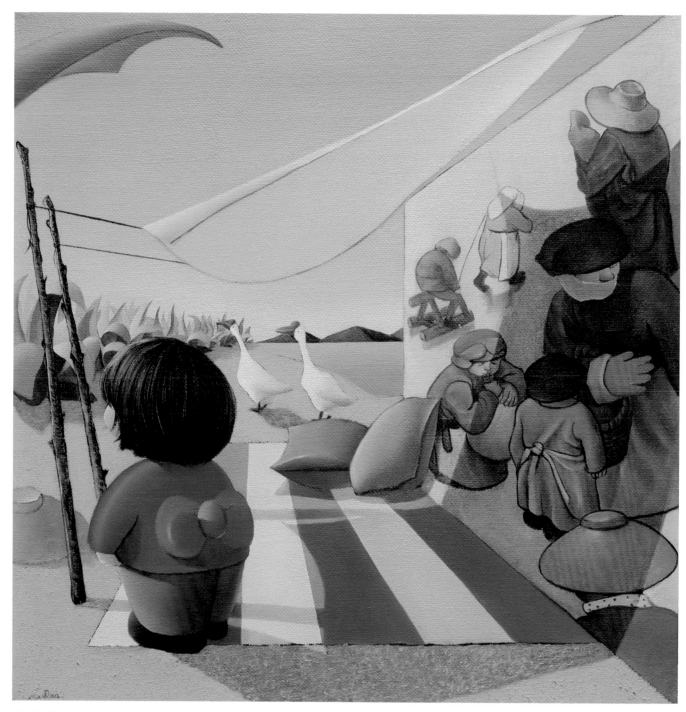

明媚中飄來一縷勃魯蓋爾 Bruegel under Sunshine　布面油畫 Oil on Canvas　150×200cm　2019

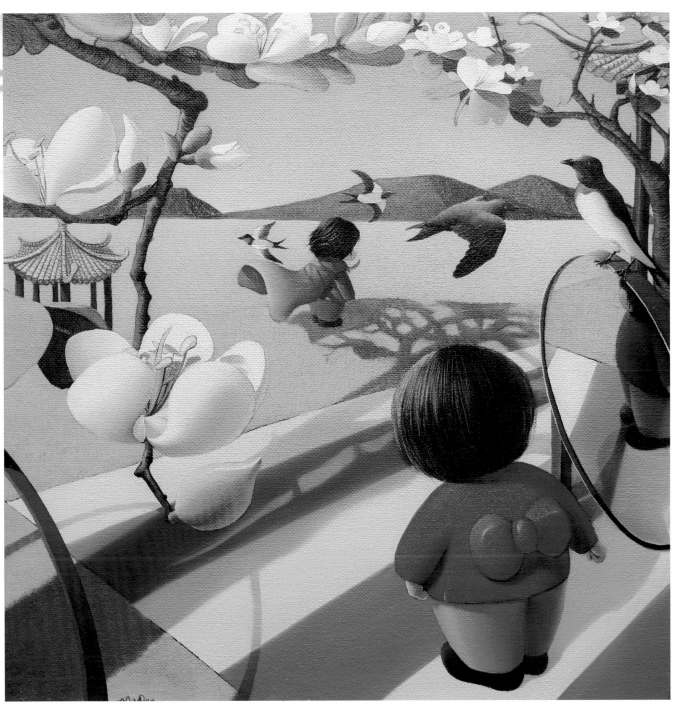

窺見方寸—影子 Glimpse of a Small World - Shadow　布面油畫 Oil on Canvas　100×100cm　2019

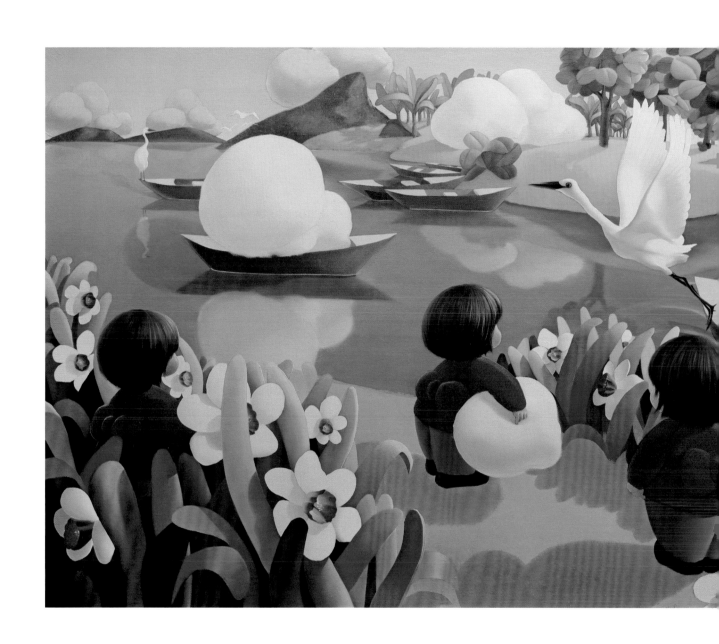

窺見方寸一試圖抱起飄來的輕 Glimpse of a Small World - Try to Hold a Floating Cloud　布面油畫 Oil on Canvas　150×200cm　2019

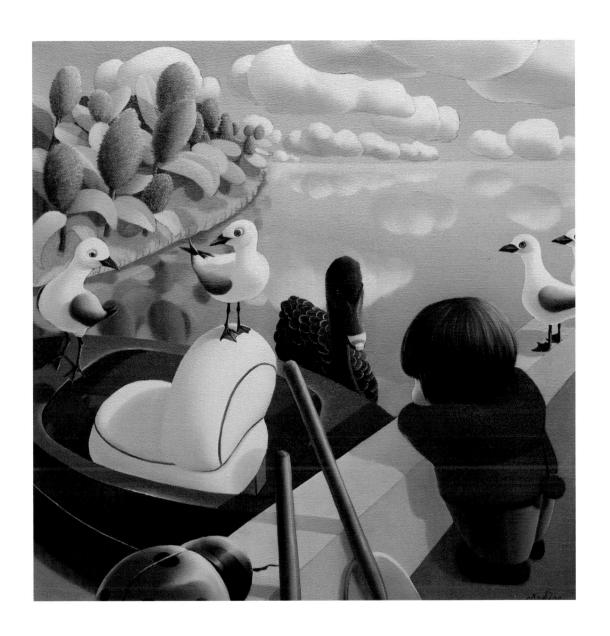

窺見方寸─被閒置的合理隨湖面一起陷入沉思 Glimpse of a Small World - The Reason and Lake Are Lost in Thought
布面油畫 Oil on Canvas　100×100cm　2019

窺見方寸—相互守候在一望無際中
Glimpse of a Small World-Waiting for
each other in a Endless World
布面油畫 Oil on Canvas
130×130cm　2019

（窺見，往往發生於一種無意識的狀態裏，〈窺見方寸〉這一系列的作品都是我無意識的狀態裏瞥見的諸多內心活動，是那些日記般的喃喃自語，也是某種意義上的自我精神審查，通過這樣的記錄，算是逃避，歇息，自審，成長。）

〈相互守望在一望無際中〉這幅畫，我自製了一個世外桃源，一個充滿「欲」的無盡幻境中。當欲望被看作一個中性詞時，也許更能正視自己的行為軌跡。或是借用鏡子來反觀自己，或是借用記錄來提示自己，最終都會發現，那些來自心靈深處既細膩又恢宏的發問或掙扎，僅僅證明此時此刻的存在，它毫無意義，卻也慰藉著來自外界的不安。

(Glimpse often involves the subconsciousness. The inspiration for the series Glimpse of a Small World is derived from an unconscious self-reflection; it is as if I am mumbling in my diary, or as if I am examining my psychological world. Through this process, I escape, rest, self-criticize, and grow.)

In Watching Each Other in an Endless World, one of the works in this series, I create an idyllic fairyland, an unreal paradise full of desire. When the word desire becomes neutral, perhaps it will be easier for us to recognize the intention of our behavior. We see ourselves either through a mirror or through a self-record. Eventually, the delicate yet extensive emotions of self-questioning and struggles of the heart are merely the proof of self-existence. While it is meaningless, it comforts us from the disturbances of the external world.

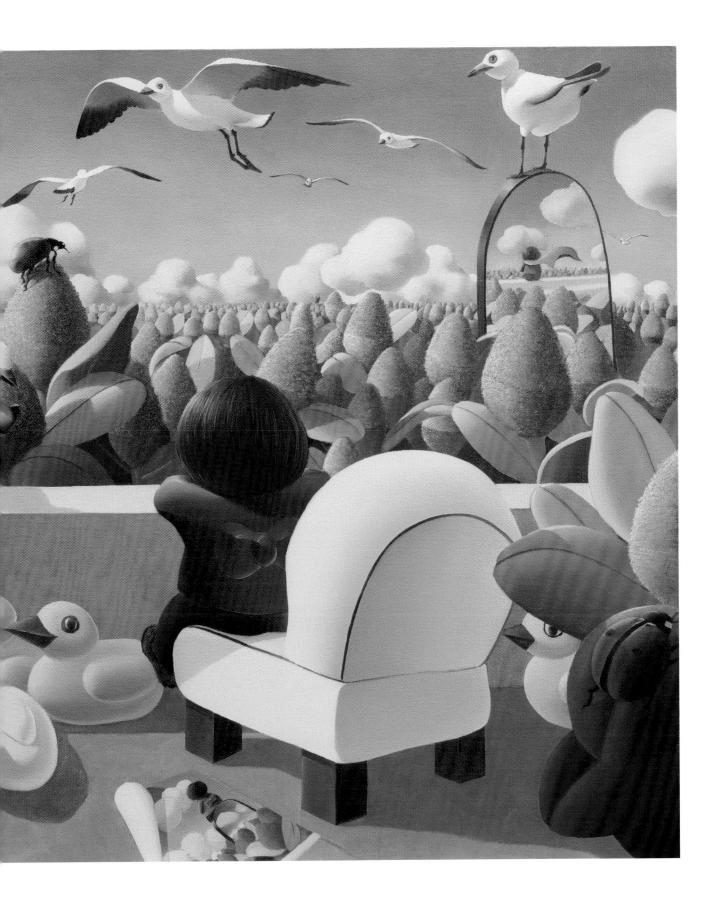

須耕耘自己的花園：馬丹的藝術

帕斯卡爾・勒托萊爾

法國藝術評論家、策展人、巴黎美術院出版社負責人

杜斯妥也夫斯基（Dostoïevski）曾寫道「美將拯救世界」，蘇格拉底（Socrate）說應「認識你自己」，伏爾泰（Voltaire）則曾告誡「須耕耘自己的花園」。在我看來，這就是馬丹為自己制定的藝術創作規畫。

北京艾米李畫廊已為馬丹舉辦過數次展覽。部分展覽畫冊中的評論文章，亦曾提及馬丹與亨利・盧梭（Henri Rousseau）在作品上的某種聯繫。然而，雖然他們作品中確實都有茂盛的植物，可以讓我們想到其中的某種關聯，但是馬丹作品中帶有自傳和幻夢性質的敘事形式，卻不是真正意義上的幻想，她更未借助荒誕，而是以之做為一種哲學探索。盧梭僅是在房屋的周圍和巴黎的植物園遊覽、騎在老虎背上彈吉他，畫出他想像中的叢林世界；馬丹展示的則是故鄉雲南土地上自在生活的動物，以及兒時記憶中曲靖鄉下的家禽：鴨子、公雞、天鵝、羊、牛、瓢蟲和蝴蝶……。同樣地，她筆下的大自然並不具備異域風情，而是展現了雲南的植被——那是由鮮花、植物和水果構成的天堂。在昆明，也就是馬丹生活與創作的城市，有著世界上最大的鮮花市場。她的作品充滿水仙花、槐樹、三葉草、向日葵、仙人掌、柏樹、蕨菜、香蕉樹、獼猴桃，有時還會出現麥田和白菜，這些都是生長於斯的植物。

也有一些批評家認為，馬丹這位新時代年輕藝術家開創了自己的神話世界，不再像上一代中國藝術家那樣關注毛澤東時代留下的公共記憶。我在1990年代曾經為前代中國藝術家舉辦過展覽或寫過藝術評論，譬如居住在法國的嚴培明、茹小凡與王度，或者生活在中國的隋建國、陳文波、郭偉、黃岩和王廣義等，他們都以自己的方式形成一種政治的、批判的或忠實記錄全球化消費社會的藝術。確實，馬丹與他們完全不同。

馬丹在2004至2008年間師從毛旭輝，在雲南大學藝術學院學習，也是毛旭輝任教於該藝術學院以來指導的第一批藝術家。毛旭輝帶著他的學生們遠離城市，到圭山地區寫生，就像多年前他也曾經和張曉剛在那裡寫生一樣。馬丹在那裡找回兒時的記憶，以及在曲靖與外公一起生活的場景。馬丹在作品「圭山」系列運用毛旭輝所鍾愛的塞尚式畫法，其中留有這段學習階段的可貴回憶：在大自然中研習，而與之合而為一。她四歲時的一張照片，成為自2008年以來其作的主要人物形象。這一形象總是以背影出現，講述她的生活、疑慮、幸福與冥思。畫中的背影在大自然中遺世獨立，一如在中國古代繪畫中的人物，人們通過此一人物而得以觀看風景；她是畫面的軸心，是「風景的覺醒之眼，躍動之心」。（法蘭西學院院士、詩人程抱一 Francois Cheng 語）

馬丹的首批作品「我的書本」系列創作於2008年的畢業前夕。畫幅中的小女孩正思考著她的未來，孤獨地處於大學的圖書館中，迷失在那一排排由圖書組成的灰色世界。隨後，馬丹以一系列充滿象徵符號的作品，開啟了蘇格拉底式的自我認知追尋和關於智慧的探索：「我用模仿自己的方式來嘗試了解自己，在一些未知的領域尋找那些平時被忽略的可貴之處。」穿著紅色裙子的小女孩從不露出自己的面孔，把日常或夢想中的物件一件件地展示出來：紅色或藍色鈴鐺的不倒翁、俄羅斯方塊遊戲、相機……，畫中的箭頭，以及向天空延伸的梯子，彷彿標誌出今後的方向。噴壺和經常出現的水（露珠、水池與湖），則象徵著她的成長與生活。

透過看展覽、參觀博物館或參加藝術活動、閱讀、旅行等，馬丹逐漸吸收了藝術史中的參照對象。她與西方現代藝術大師展開對話，關於自然（如高更 Gauguin 和梵谷 Van Gogh）也關於形上學（如喬治・德・基里訶 Giorgio de Chirico 和雷內・馬格利特 René Magritte）。她或是借用參照，或是自導自演，直接進入大師們的作品之中。在「暖丘」或「紅土」系列中的柏樹和向日葵是梵谷的最愛，「窺見方寸」系列中的〈六月天的甜蜜陽光灑入房間〉讓我們想到高更的〈白馬〉；前文提及作品中的黑白格子，則直指基里訶的〈午後的抵達之謎〉；在「窺見方寸」系列的〈夢遊者〉、〈試圖抱起飄來的輕〉及「夏陽」系列的〈綠色

舞台〉這幾件作品裡，她將雲南的白雲擁入懷中，則是超現實主義畫家馬格利特的標誌。維拉斯蓋茲（Vélazquez）在〈宮娥〉的畫中畫、約翰內斯·坎普（Johannes Gumpp）的〈鏡中自畫像〉，或馬格利特那些腦袋出現在雲層裡的自畫像，都被馬丹轉用，在作品中通過鏡子暗示她自身的探問，如2010與2011年分別創作的兩件同名之作〈自拍〉、2019年「窺見方寸」中〈被安定好的偶然〉皆是如此。在2015至2017年的「內外」系列中，這種探索逐漸深入。面對這些藝術史中的傑作，迷失於風景中的馬丹自問：「我是誰？」

馬丹也隸屬於與電視、媒體、網路與虛擬實境共同成長的一代。她的人物形象並非寫實或模仿，而是透過回憶或簡化來表現。如同普普藝術中的肖像、宮崎駿（Hayao Miyazaki）的動畫（馬丹和宮崎駿都癡迷於純潔的自然和天空）或大眾影像中的超級英雄，從〈柔軟的窗子內外〉開始，可以在她的作品裡找到穿著超級英雄披風的人物。從這個階段開始，畫面中的小女孩開始與電影裡的超級英雄愈見相似，可以說是出現了許多分身，也可說類似波赫士小說裡的人物。「另一個」系列一如波赫士（Borgesiens）在短篇小說〈另一個人〉寫到的，敘述者在河邊遇到了另一個過去的自己，兩個人同時想著：自己是夢見了對方。

然而，馬丹作品的力量和獨創性更在於她對存在哲學的探索，以及對美學、純粹性和詩意的追尋，透過繪畫的結構與表現將其融為一體；正是這一點，讓她在今日的藝術舞台上脫穎而出。馬丹既引用尼采（Nietzsche）、沙特（Sartre），同時引用泰戈爾（Tagore）或波赫士，並添入馬克·羅斯柯（Mark Rothko）或竇加（Degas）的元素，甚至可以引用康德（Kant）。康德在《判斷力批判》中提及創造力時，認為那是一種能夠「呈現美的理念」的能力；他接著說：「我所說的『美的理念』，指的是想像力的再現，可以激起無數思考，同時避免某種固定思維，也就是說，不具有任何固定的概念。」

馬丹作品的名字，以及她素描本裡的一段段文字，就像日記一般，講述她的冥想和凝視對象。譬如她曾如此描述「暖丘」系列中的〈聞〉：「我想不起來到底是兒時的記憶還是夢，我在一些不知道名字的植物中間向前行走，陽光灑在大地上，空氣中充滿喜悅，一切都那麼和諧。」或是同系列的〈跟縱〉：「我們是可以和自然界的動物和植物對話的，即使有些對話顯得沒什麼意義。我嘗試著用自己的方法與它們融為一體，如此一來，我的存在就不再顯得那麼突兀。」她坐在湖邊或是陽台上，或行走在路上，一直都在凝視和探問自然，尋找一個「屬於她的冥想之所」。

馬丹時常提到孤獨，尤其是她兒時體驗過的孤獨。如2012年的〈等〉中，她一個人在鄉下，等待著久候不至的朋友；就像總是專注而沉默的竇加，這種孤獨對於藝術家保持個性和單純是必要的。如同菲特列 C. D. Friedrich 或庫爾貝，她獨自面對湖光山色，感受世界的真實，約莫可以像杜甫寫出這樣的詩句：「江上被花惱不徹，無處告訴只癲狂。」她在〈午後的抵達之謎〉重拾基里訶作品裡黑白相間的石板，同時也參照尼采在《查拉圖斯特拉如是說》提到的那種孤獨：「我講述我看到的謎，最孤獨者之所見。」

同時，馬丹也像伏爾泰在《憨第德》中說到的一般「耕耘自己的花園」。在〈守護〉中，我們可以看到她確實在澆灌那些植物和向日葵，也意味著對生命和創作展開沉思。馬丹以雲南千變萬化的細膩光影來培育她的花園。那即是她的聖維克多山。花園中遍布紅橙和奇異果，有向日葵之黃色、仙人掌和松柏之綠色，以及滇池之藍色。她並沒有使用中國傳統繪畫中的梅、蘭、竹、菊，而是創造了自己的象徵符號體系。如同在2014年的〈遠遊〉所顯示的，她對自然的理解具有普世性，對她來說，繪畫首先是超越表象的，是對美的探求，亦是天地之間的精神之旅：「在莊嚴的寂靜中，一切生命變成永恆，平庸被放逐天際……當我處於這種寂靜狀態時，我喜歡尋找這種美。」

馬丹作品的魔力在於她打開了通向內外之美的窗口。大自然顯現於人，它的無形之美在畫面上昭然若揭，一如波特萊爾（Baudelaire）所述：「能俯瞰人間，輕鬆懂得花兒的低唱和無聲言語者，乃有福之人。」

2019年4月於巴黎

Ma Dan—« Il faut cultiver son jardin »

Pascale le Thorel

Critique d'Art et Commissaire d'Exposition Indépendant

« La beauté sauvera le monde », écrivait Dostoïevski, « Connais-toi toi-même », disait Socrate, « Il faut cultiver son jardin », affirmait Voltaire. Tel semble être le projet artistique, le programme que s'est fixé Ma Dan.

Lors de ses précédentes expositions organisées par Amy Li, les auteurs des catalogues avançaient une filiation entre son travail et celui du Douanier Rousseau. S'il est vrai que l'on peut établir une correspondance entre ses natures exubérantes et celles de l'artiste française, sa peinture – qui prend la forme d'un récit à la fois autobiographique et rêvé – est devenue avec le temps avant tout une quête philosophique, et n'est pas de réelle fantaisie, ni ne fait appel au grotesque. Le Douanier Rousseau, qui n'a jamais voyagé qu'autour de sa chambre et du Jardin des Plantes à Paris, se promène sur le dos d'un tigre en jouant de la guitare, peint des jungles d'invention. Ma Dan représente, quant à elle, les animaux qui vivent naturellement dans sa région du Yunnan. Tout un bestiaire domestique, celui des villages de campagne de son enfance, près de Qu Jing : canards, coqs et oies, chèvres, bœufs et vaches, coccinelles et papillons… De même, sa nature n'est pas exotique mais représente la végétation du Yunnan, ce paradis des fleurs, des plantes et des fruits, devenu, avec le marché aux fleurs de Kunming, où elle vit et travaille, le premier site mondial de vente de fleurs naturelles. On voit dans ses tableaux des jonquilles et des sophoras, des trèfles et des tournesols, des cactus et des cyprès, des fougères et des bananiers, des kakis et des cyprès, quelquefois des choux et des champs de blé, toutes plantes indigènes.

D'autres auteurs, situent son travail dans le cadre des nouvelles générations qui ne se préoccupent plus de la mémoire collective des années Mao mais créent leur propre mythologie. J'ai présenté ou écrit en France sur ces artistes chinois des années 1990, travaillant en Europe – Yan Pei-Ming, Ru Xiao-Fan ou Wang Du – ou vivant en Chine– Sui Jianguo, Chen Wenbo, Guo Wei, Huang Yan et Wang Guanyi, qui pratiquent, chacun à leur manière, un art politique, critique ou de chronique de la société de consommation mondialisée. Il est vrai que Ma Dan s'inscrit tout autrement.

Ma Dan a fait des études d'art auprès de Mao Xuhui à la Yunnan Art Academy de Kunming (2004-2008) et appartient à la première génération d'artistes formés à l'Université du Yunnan où n'existait, avant sa création par Mao Xuhui, aucun enseignement artistique. Mao Xuhui avait pour pratique d'emmener ses étudiants « en retraite », peindre d'après nature dans la campagne, dans la région de Gui Shan, comme il le faisait lui-même avec Zhang Xiaogang. Ma Dan a retrouvé là l'univers de son enfance, quand elle vivait auprès de son grand-père à Qu Jing et reprend le modèle cézanien, cher à Mao Xuhui, dans des tableaux qui gardent la trace de ces moments privilégiés d'étude et de communion avec la nature (série *Paint on Gui Mountain*, 2009). C'est aussi de cette enfance qu'elle fait renaître, d'après une photographie d'elle prise à l'âge de quatre ans, le petit personnage qui habite ses tableaux depuis 2008. Un archétype qui apparaît toujours de dos, qui raconte sa vie, ses doutes, ses bonheurs, ses méditations, et qui, isolé dans la nature comme l'étaient les personnages des anciennes peintures chinoises, est l'axe à travers lequel on voit ce paysage, est « l'œil éveillé et le cœur battant du paysage » (François Cheng).

Dans les premiers tableaux, peints à la fin de ses études, cette petite fille interroge son devenir, apparaissant seule, isolée dans la grande bibliothèque de l'Université, un univers tout gris, où elle semble perdue, parmi les allées de la connaissance (série *My books,* 2008). Par la suite, elle met en place toute une symbolique qui tourne autour de la question socratique de la connaissance de soi et de la recherche de la sagesse : « J'utilise des imitations de moi-même pour essayer de me comprendre, cherchant des territoires inconnus pour trouver ces choses précieuses mais négligées » (*Stage*, 2013). La petite fille est vêtue d'une robe rouge, ne montre jamais son visage et dévoile peu à peu les objets de son quotidien ou de ses rêves : les poupées culbuto à clochettes rouges ou bleues que toutes les petites chinoises de sa génération ont possédées, la console de jeu Tetris, un appareil photo numérique… Des flèches de signalétique, des échelles qui montent à l'assaut du ciel semblent indiquer un chemin à suivre. Des arrosoirs, la présence récurrente de l'eau (la rosée, les bassins, les lacs), évoquent de manière métaphorique la croissance et la vie.

Ses visites d'expositions et de musées, ses rencontres, ses lectures, ses voyages enrichissent son vocabulaire de références à l'histoire de l'art. Elle dialogue avec les maîtres de la modernité de la peinture occidentale qui, comme elle, se sont rapprochés de la nature (Gauguin ou Van Gogh), ont créé leur peinture métaphysique (Chirico ou Magritte). Elle reprend des citations de leurs œuvres ou se met en scène, entrant littéralement dans leurs tableaux. Dans *Cypres*, *Warm Mound* ou *Red soil* apparaissent les cyprès et les tournesols chers à Van Gogh ; dans *Glimpse of a Small World – Sweet sunshine of June pouring into the room*, *Le Cheval Blanc* de Paul Gauguin. On retrouve les damiers de *L'énigme de l'arrivée de l'après-midi* de Giorgio de Chirico dans *Glimpse of a small world - Sweet sunshine of June pouring into the room*, et les nuages du Yunnan, qu'elle tient parfois dans les bras (*Glimpse of small world – Sleepwalker* ; *Glimpse of small world - Try to hold a flosting cloud*; *Summer Sunshine-Green Stage*), conversent avec les peintures surréalistes de Magritte. Le miroir, la mise en abyme des

Ménines de Vélazquez, la représentation du peintre par le peintre, tel *L'autoportrait au miroir* de Johannes Gumpp, ou les autoportraits de Magritte la tête dans les nuages sont détournés pour suggérer les questionnements de Ma Dan (*Autoportrait*, 2010 ; *Autoportrait*, 2011 ; *Glimpse of a small world-Settled Coincidence*). Ses interrogations s'intensifient dans les tableaux de 2015 à 2017 (*In or Out*), face à toute cette histoire de l'art, à ces chefs d'œuvre, perdue dans le paysage : « Qui est-elle ? ».

Ma Dan appartient aussi à la génération de la télévision, des médias, d'internet, du virtuel. Sa figuration n'est pas réaliste ou d'imitation, mais de remémoration et simplifiée et comme les figures du Pop, comme celle des héroïnes des dessins animés de Hayao Miyazaki (avec qui elle partage cet attrait pour la pure nature et les cieux), ou celle des super-héros, dont un de ses personnages hétéronyme porte à la cape à partir de *In and out of the curtain*. Dès cette période, la petite fille se démultiplie dans les tableaux comme les super-héros des films, mais aussi comme les héros borgesiens, semblant faire écho à *L'Autre* où le narrateur rencontre son double au bord du fleuve, qui n'est autre que lui-même dans le passé, chacun pensant qu'il est en train de rêver l'autre.

Mais ce qui fait la force et la singularité de son travail – et son côté unique dans le paysage de l'art d'aujourd'hui -, c'est la synthèse que Ma Dan effectue entre ces éléments et l'expression d'une quête existentielle et philosophique, sa recherche de la beauté, de la pureté et de la poésie. Ma Dan cite Nietzsche, Sartre mais aussi Tagore ou Borges, Rothko ou Degas.

Elle pourrait aussi citer Kant qui, dans la *Critique de la faculté de juger*, à propos de la création, traite de la faculté de « présenter des idées esthétiques, et par idée esthétique, j'entends cette représentation de l'imagination qui donne beaucoup à penser, sans pourtant qu'aucune pensée déterminée, c'est-à-dire, sans qu'aucun concept, ne puisse lui être approprié ».

Les titres des tableaux de Ma Dan et les petits textes de ses carnets d'esquisses et de dessins racontent comme un journal ses méditations et contemplations. Citons *Warm Mound - Smell* (2013) : « Je ne peux me rappeler si c'est le souvenir d'un rêve ou de l'enfance, j'avance parmi des plantes dont je ne connais pas le nom, le soleil disperse ses rayons sur le sol, il y a de la joie dans l'air, tout est en accord avec la nature » ou encore *Warm Mound - Following* (2014) : « Les animaux et les plantes sont des êtres vivants avec lesquels nous, et la Nature, pouvons dialoguer, même si certains de ces dialogues n'ont pas de sens. J'essaie d'utiliser ma propre méthode pour fusionner avec eux, ainsi mon existence ne me paraîtra pas si incongrue ». Qu'elle apparaisse assise au bord d'un lac, sur un balcon ou marchant sur un chemin, elle contemple et interroge la nature, recherche « un lieu pour méditer qui n'appartienne qu'à moi ».

Elle parle de la solitude, de celle qu'elle a connue enfant, lorsque, seule à la campagne, elle attendait en vain des amis qui n'arrivaient pas (*Waiting*, 2012), mais aussi, à l'égal de Degas, de la solitude nécessaire à l'artiste, à la préservation de sa personnalité et de son innocence. Elle contemple les rivages et les montagnes comme Caspar David Friedrich ou Courbet, seule face aux éléments de la nature authentique, et pourrait écrire, comme Du Fu, le poète de l'époque Tang : « Au bord du fleuve, miracle des fleurs sans fin. A qui se confier ? On en deviendrait fou ». Le tableau où elle reprend les dalles noires et blanches de Chirico, L'énigme de l'arrivée de l'après-midi, fait référence au Nietzsche d'*Ainsi parlait Zarathoustra* qui lui aussi parlait de cette solitude : « Je raconte l'énigme que j'ai vue, la vision du plus solitaire ».

Elle semble dire également, comme le Candide de Voltaire : « Il faut cultiver son jardin ». Dans *Guard* (2011) on la voit d'ailleurs littéralement arroser, cultiver plantes et tournesols, et donc méditer sur la vie, la création. Ce jardin, elle le nourrit des milles nuances et couleurs lumineuses du Yunnan, sa Sainte Victoire, de l'orange rouge des arbres à kaki, du jaune soleil des tournesols, du vert des cactus et des cyprès, de la terre rouge, du bleu du lac Dian de Kunming. Elle invente sa propre symbolique, sans se référer aux canons traditionnels de la peinture chinoise ancienne qui confère au bambou, à la fleur de prunier, au chrysanthème et au lotus des significations particulières. Son langage de la nature tend à l'universel et est avant tout une recherche de la beauté, un voyage spirituel entre ciel et terre, au-delà des apparences : « Dans le calme majestueux, toute vie devient éternelle, la médiocrité est reléguée à un horizon lointain (…) J'aime rechercher cette sorte de beauté quand je suis dans cet état de quiétude » (*Long trip*, 2014).

Le pouvoir de fascination de l'œuvre de Ma Dan est cette fenêtre qu'elle ouvre sur une idée de beauté intérieure et extérieure. La nature se manifeste et la beauté de son essence invisible est traduite par une atmosphère picturale qui appelle le regardeur à dire comme le poète Baudelaire : « Heureux celui qui plane sur la vie, et comprend sans effort le langage des fleurs et des choses muettes ».

Avril 2019, Paris

2018

作品 Artworks

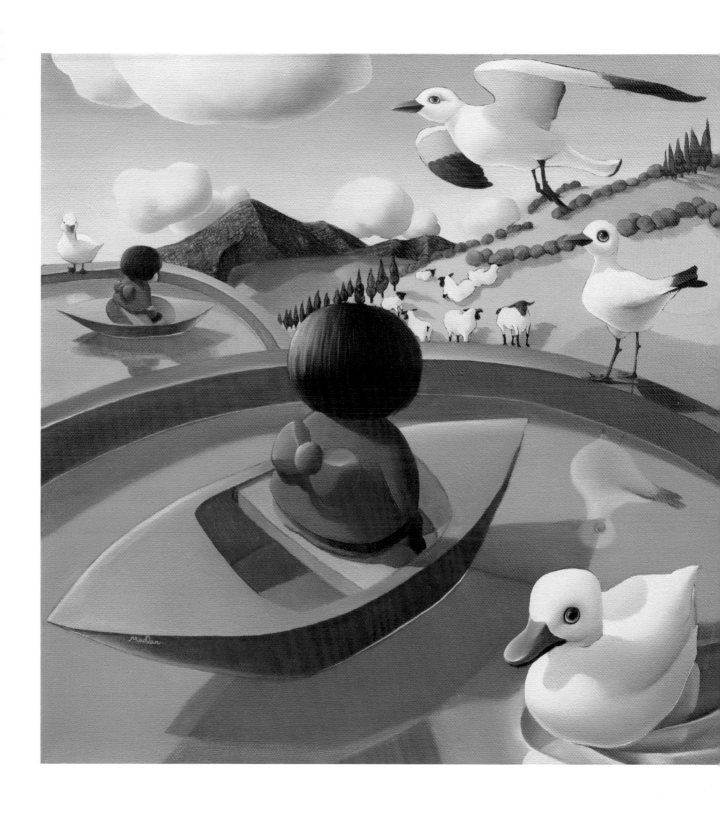

窺見方寸一白日夢中的無聊失眠 Glimpse of a Small World-The Bored Insomnia in Day Dreaming　布面油畫 Oil on Canvas　100×100cm　2018

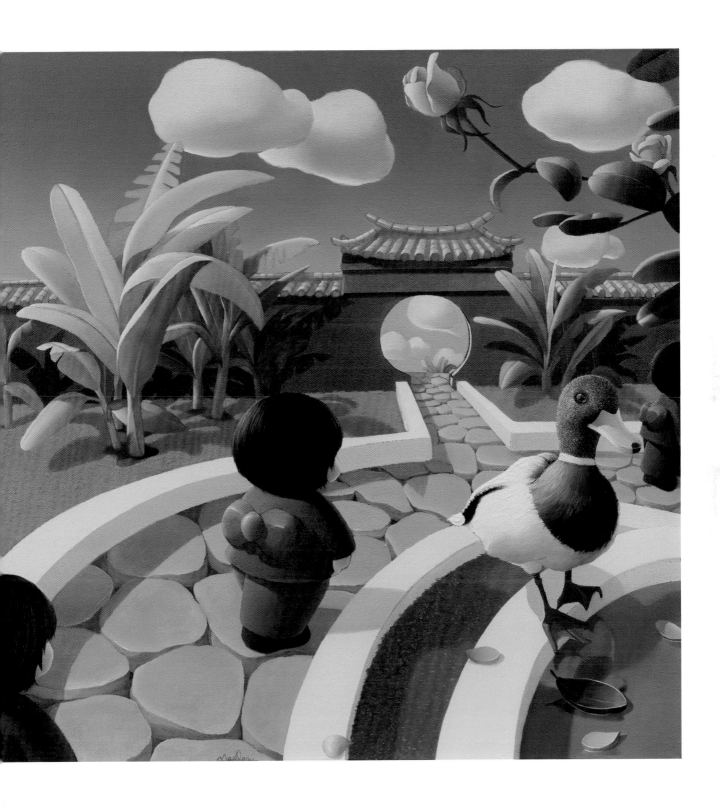

窺見方寸一循環 Glimpse of a Small World - Loop　布面油畫 Oil on Canvas　130×130 cm　2018

果園—放生 Orchard - Release
布面油畫 Oil on Canvas
160×130cm　2018

儀式，常常在特定的時候被我們需要著，有時需要藉以提示自己或別人這一刻與以往任何時刻的不同，當感知世界的觸角麻木時，儀式是那一點點內心深處的溫柔震顫。作為穿流於世界的一股細流，應該有點兒或隱蔽、或張揚的儀式來強大那顆被現實歷練著的內心，以保全通往美好的線索不至於滅跡。

Rituals are required in certain situations. Perhaps, they remind us or others that a specific moment is different from another. When we are too numb to sense the world, rituals are like the little gentle tremors stirring in the deep recesses of our heart. As we travel through this world like a slender stream, we need either hidden or public rituals to strengthen our troubled inner self, so that all the threads leading to goodness will not be destroyed.

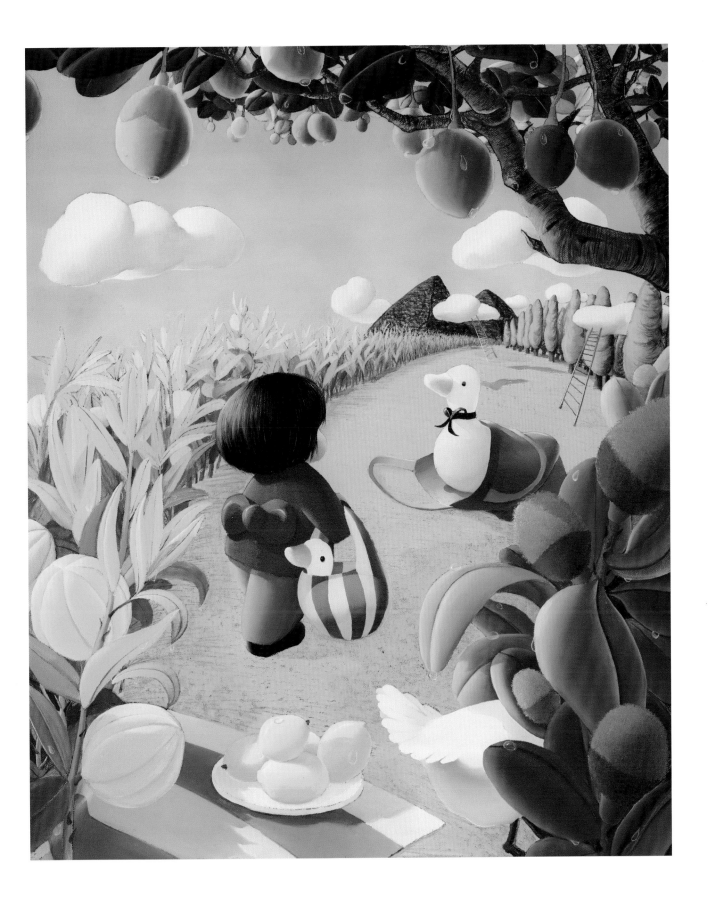

暖丘—循環 Warm Mound - Loop
布面油畫 Oil on Canvas　100×100cm　2018

有一天，當我飛到腦後、飛向天空，陡然發現：我生活在一個封閉但卻循環的形
式裏。心智，仍在固定的形態下發展著；臆想，仍在已有的框架裏蔓延著；日
常，同樣仍在日復一日裏循環著。

One day, as I free my mind with soaring thoughts, I suddenly realize that I have
been living in an isolated but cyclical system. My mind still expands steadily; my
imagination still stretches within the existing framework; and routines continue to
repeat themselves daily.

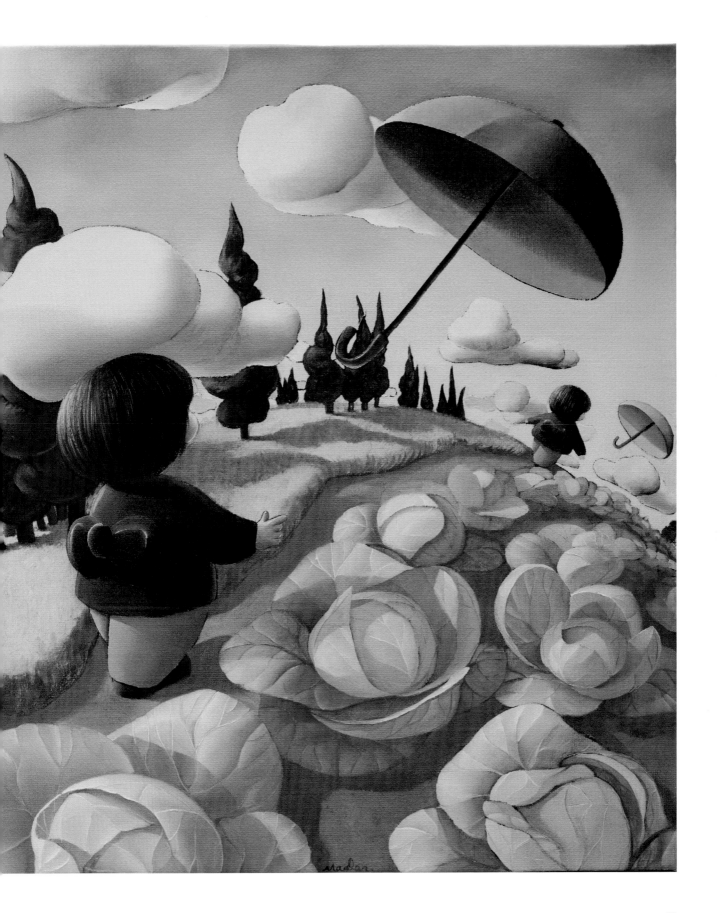

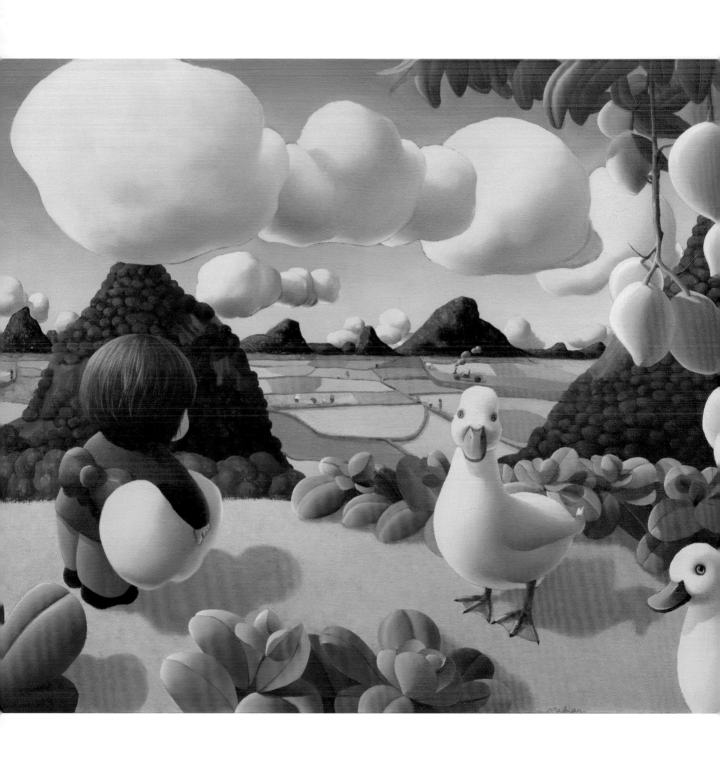

夏陽—綠色舞臺 Summer Sunshine - Green Stage　布面油畫 Oil on Canvas　130×160cm　2018

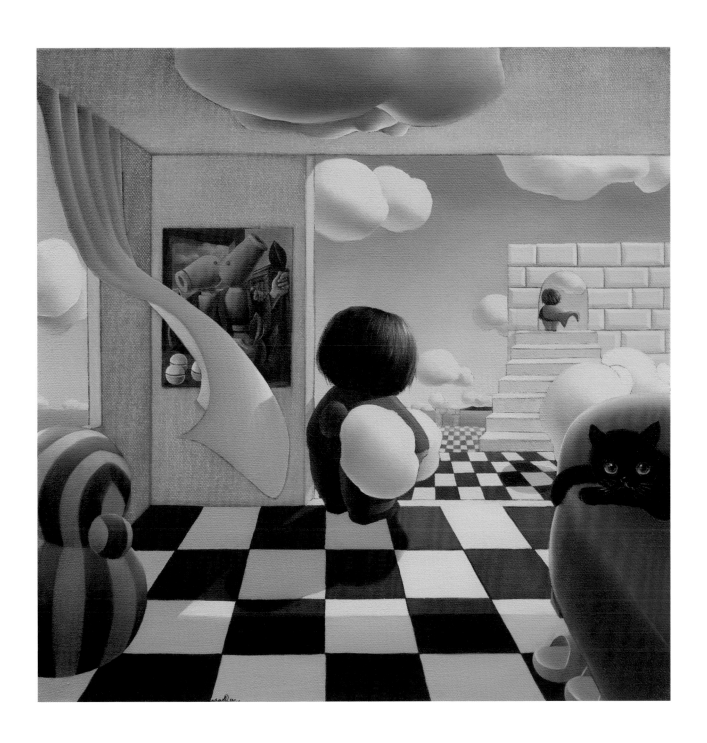

窺見方寸─夢遊者 Glimpse of a Small World-Sleepwalker　布面油畫 Oil on Canvas　100×100cm　2018

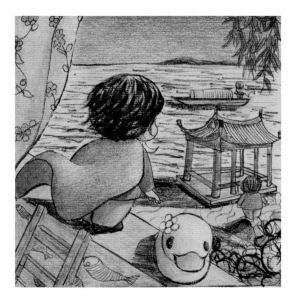

窺見方寸—撫仙湖的午後
Glimpse of a Small World -The Afternoon at Fuxian Lake
布面油畫 Oil on Canvas　100×100cm　2018

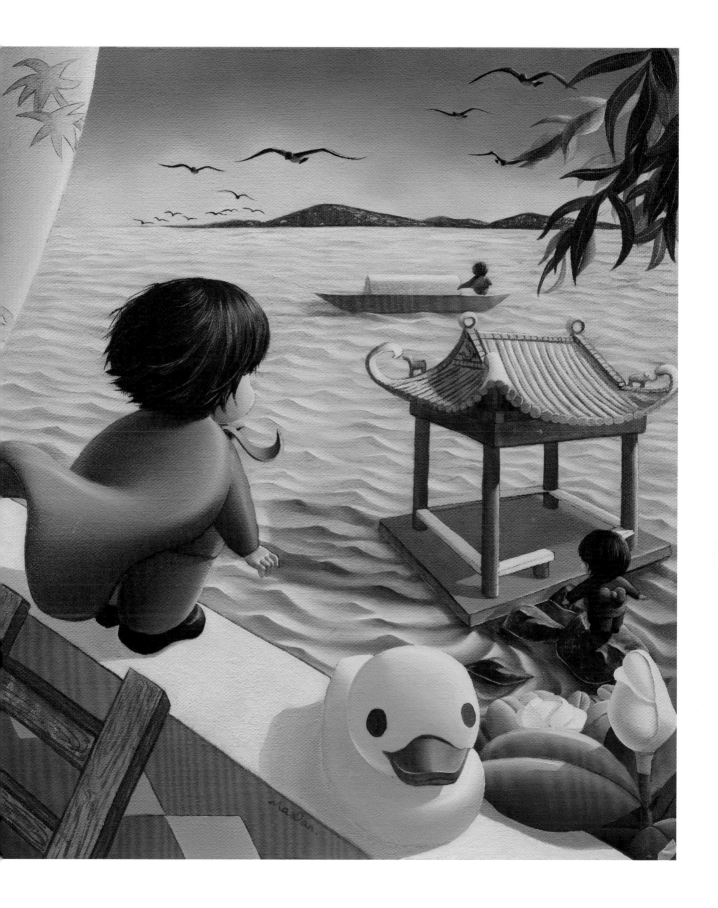

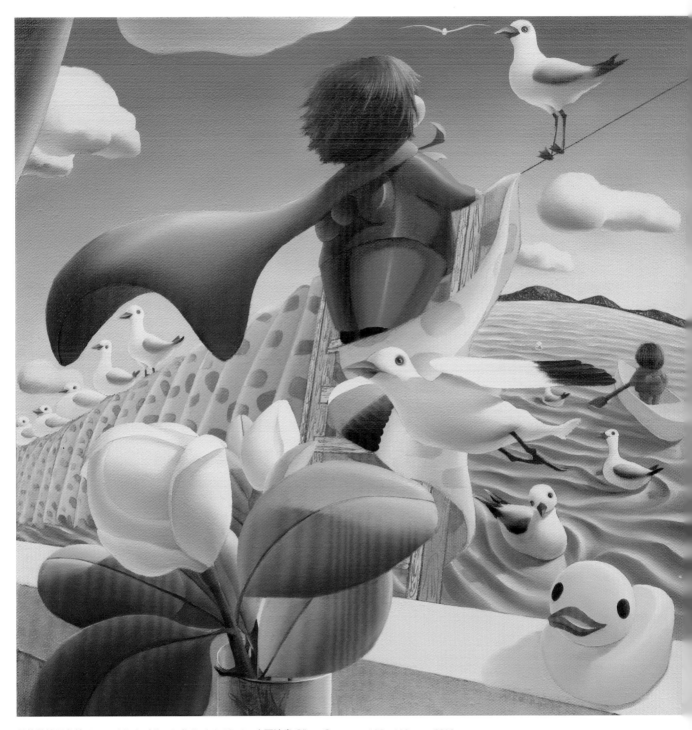

柔軟的簾子內外2 In and Out of the Soft Curtain No.2 　布面油畫 Oil on Canvas 　100×100cm 　2018

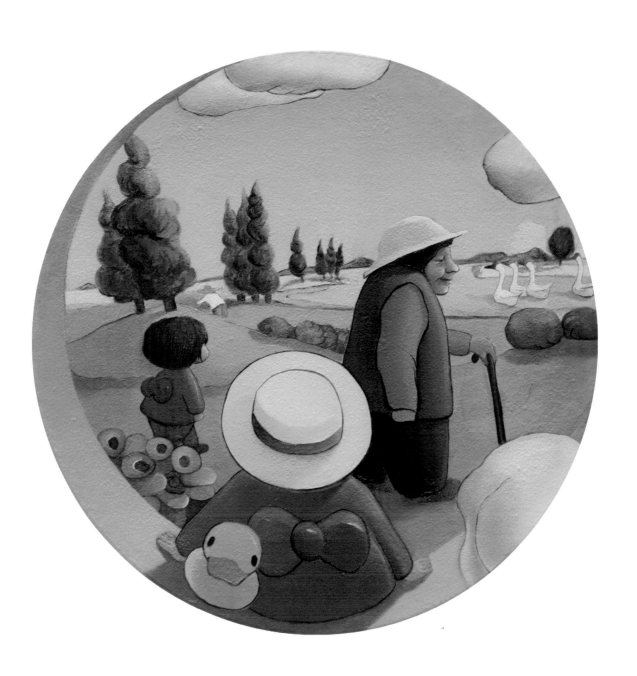

浮生—跟隨 Life Is Short As If a Dream - Following　布面油畫 Oil on Canvas　直徑D: 50cm　2018

窺見方寸—六月天的甜蜜陽光撒入房間
Glimpse of a Small World - Sweet Sunshine of June Pouring into the Room
布面油畫 Oil on Canvas　100×100cm　2018

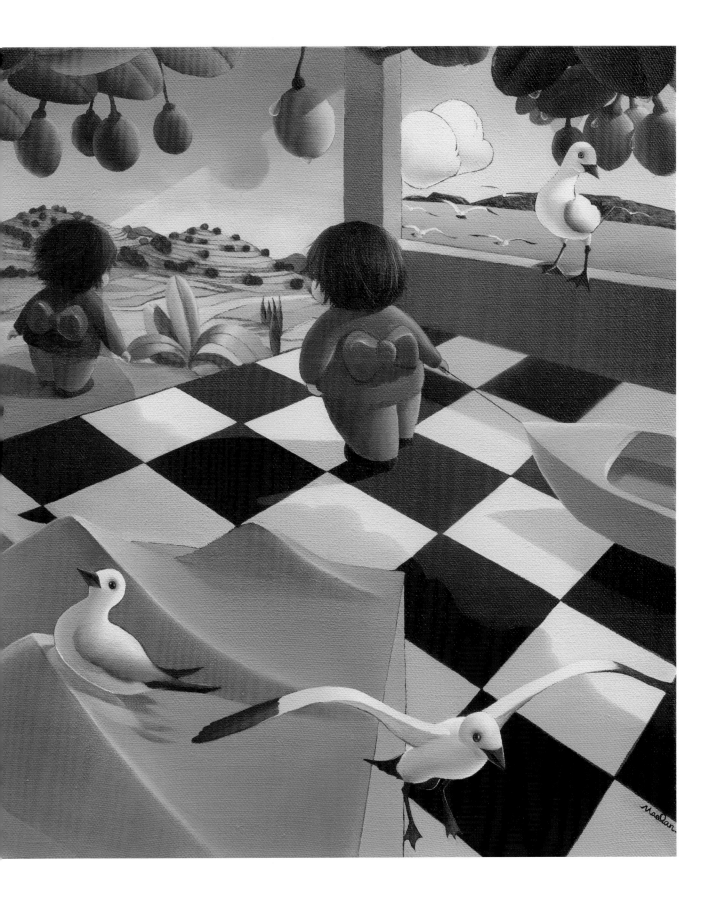

擦肩而過的自己 Passing by Myself
布面油畫 Oil on Canvas　60×120cm　2018

當我們觀察這個世界的時候，時常會用審視別人的眼光來審視自己，而後又不自覺地將真實的自己、重塑的自己，甚至是虛構的自己安插回這個世界。相同的瞬間，也許不同的自己會不期而遇，來不及交談，就又溜進下一個存在中。

When we observe this world, we often judge ourselves in the same way as how we judge others, and subconsciously place one self, a reconstructed self, and even an imagined self back into this world. Simultaneously, we might encounter a different self, however, without a chance to talk, it slips into another dimension.

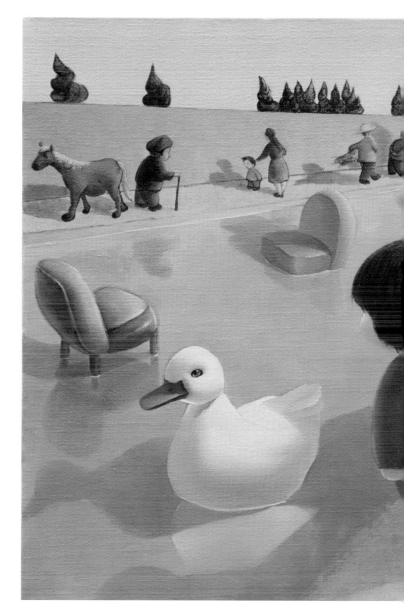

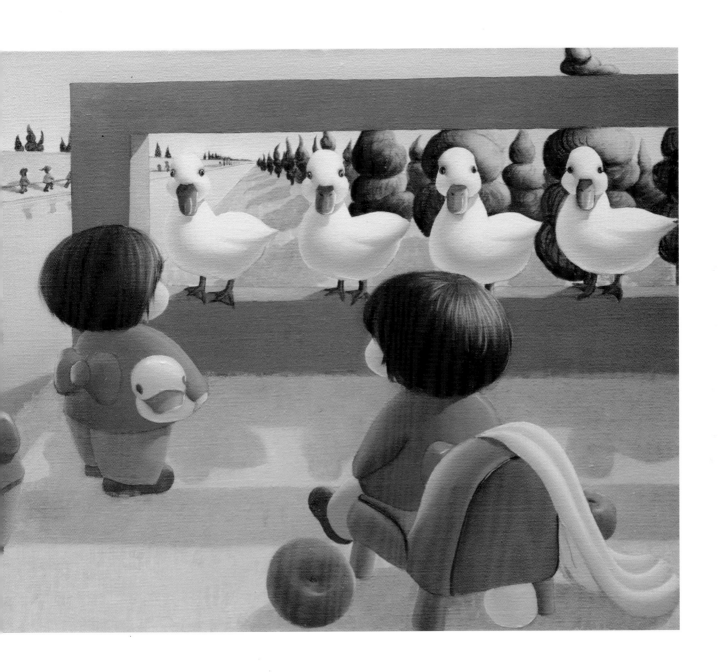

在生命中的無數個困惑的瞬間，充斥著各類形狀怪異的混沌。身處其境時，偶爾也能和另一個自己來段愉快的對話，斷斷續續的呢喃隨風而來，話語朦朧、易碎、近乎空白，幾輪問答後，言語雖能輕易打碎寧靜，但隨之被帶入的是另一種深邃的無知，正當我覺得我是存在的，對話也是認真的，問答也是有意義的，卻又被風吹進了另一個虛空，捲入另一個不可名狀的混沌中。

Life is filled with endless puzzles and odd moments. Occasionally, in life you can have a delightful conversation with another you; intermittent whispers rustle in the wind, and the words are vague, fragile, and nearly blank. After several rounds of questions and responses, even if the words could easily disrupt the serenity, it will eventually lead to a sense of profound ignorance. Because I can sense my existence, therefore the dialogue is sincere and meaningful; however, it is blown away into another void, and drawn into another, indescribable, chaos.

窗外—流逝或存在1 Outside of the Window - Passing or Staying No.1
布面油畫 Oil on Canvas 90×130cm 2018

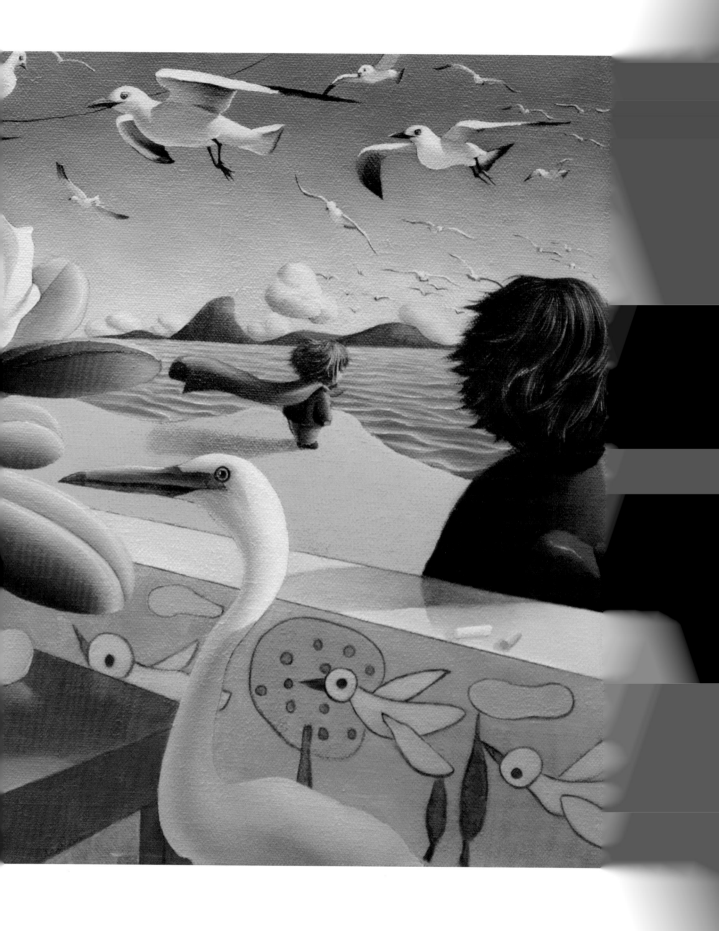

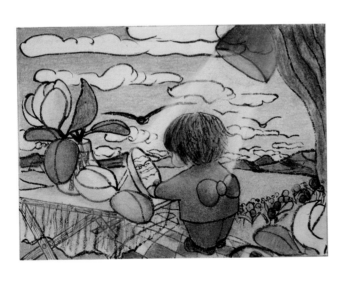

窗外—流逝或存在2 Outside of the Window - Passing or Staying No.2
布面油畫 Oil on Canvas　80×100cm　2018

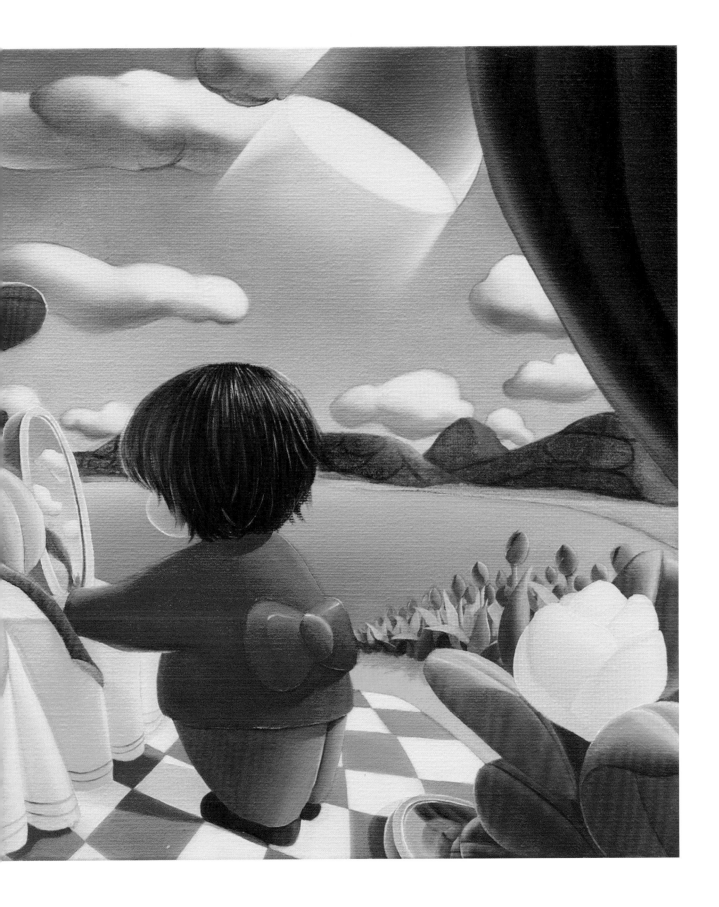

馬丹：誤入藕花深處

呂澎
美術史學家

讓我們脫開女性主義視角，脫開邏輯和術語，來看一看這位年輕女藝術家的作品。從技巧上來看，它非常謙遜，這使我們回想起素樸派藝術。你不會忘記盧梭、薩賀芬，你不會繞開高更，甚至有時候你的腦中會閃過大衛霍克尼。當我們試圖去界定這位藝術家帶一點隱喻氣質的作品時，我們會試圖在一長串譜系中尋找到她最適切的位置。迷人的地方在於，你總是找不到一個確切的比喻，或者說，我們很難找到一個恰當的位置，讓她安穩地停留在那些在腦中被喚起的風格類型。

她不是劉野，因為她畫中的女孩，從來不看蒙德利安，唯有一次，在〈孤獨〉中，她在看一些關於她自己的圖像，它們被陳列在美術館中。你也很難說她是亨利盧梭，因為除了風景中動用的材質略有相似之外，她表現的完全是另一種情懷。甚至連她自己表示非常迷戀的高更，也並不足以去界定她的作品。

在她的整個創作中女孩的正臉從未出現過，這是最令人迷惑的一點。她或者背對著觀眾，或者乾脆在遠景處幾乎消失，當我們僥倖看到她正面面對觀眾時，她卻用一朵葵花遮住自己的臉（例如在作品〈自拍〉中）。

馬丹似乎通過種種細節，傳遞給我們一些幽微的信息：這個畫中的女子能夠感知到觀眾的目光——這不由得使我們想起馬奈。在〈女神遊樂場酒吧〉以及他的許多作品中，一種新的繪畫方式被打開，正是由於他所繪製人物的目光，都是直視著我們的。因此，觀眾會留下一種截然不同的印象，畫中人必然發現了我們的存在。古典藝術的三一律，那個虛假的布幕被扯下來了。到這裏似乎一切都很順利，然而我們還是不能夠這樣去描述馬丹，因為她畫中的主角，實實在在的背對著我們，沒有任何目光的交流，為什麼我們會產生這樣一種驚動她的感覺？

答案或者在於那種一瞬間感到迷惘的自我意識。李清照曾經給我們留下這樣一首充滿隱喻感的詞：「常記溪亭日暮，沉醉不知歸路。興盡晚回舟，誤入藕花深處。爭渡，爭渡，驚起一灘鷗鷺。」（李清照《如夢令 常記溪亭日暮》）

這首迷人的詞中，我們感到最有趣的未必單純就是那種迷失體驗，而恰恰是在當一灘鷗鷺被驚起的時候，那一瞬間的自我覺知。在這一刻，想必我們會從一個更大的視野去看待我們自身和存在之間的關聯。有時候，我們還會記起那種神秘的體驗，想必許多人都曾經有這樣的記憶：在夕陽下行走著，忽然覺得有人在背後看你。或許那不是別的，恰恰是我們一瞬間湧起的自我覺知。

在馬丹的藝術中，這種自我覺知體現在許許多多的細節中，但有一點是毫無疑問的，那就是每一件作品或多或少的都涉及到這一母題。例如〈隨行〉，這件作品和李清照的詞一樣，都在池塘中發生。女孩正拉著一艘無人的小船，「泛若不繫之舟」，它似乎沒有打算停留，不知什麼時候會飄走。而女孩也並沒有打算上前，她只是忽然照見了自己的迷惘。船上沒有人，只是有一個稻草人與她照面。這個設定會在其它作品中反復出現。

關於迷失在湖中的作品還有許多。〈無憂〉也是一幅很典型的作品，女孩在一個平靜的湖中划船，留給我們一個背影，她望著雲。她的船槳沒有任何方向性，只是剛剛落入水中，留下一個正圓形的漣漪。船身也沒有任何移動的痕跡，水面異常的安靜。這暗示我們，她尚未做任何決斷，她或許不知道自己該向何處去，雖然她想像白雲深處的樣子。〈遠遊〉也是這樣一件作品，低矮的雲和近處島上金色的菠蘿蜜都讓我們想起憂鬱的熱帶，異國，原始主義的高更的大溪地，馬丹在表現一個關於島和遠方的意念，它並非是任何真實的島，它的背景是被懸置起來的，脫離任何具體的生活世界。

在〈遠遊2〉中，我們看到她在凝視一隻小黃鴨，以及一隻小綠鵝，水面依舊像鏡子一樣平靜，但在這幅作品中出現了一個值得注意的元素：不倒翁。那個笑吟吟的不倒翁大量地出現在馬丹的創作中，有趣的是，她很少和女孩對視，也從未顧忌觀眾的目光，而是看著別處。藝術家曾經這樣解釋這個特別的元素：

「我通過對一些我童年時出現過的玩具，來建立一種真實，並通過這種建立過程來重塑一種童年碎片，某種程度上說，這也是自我催眠。關於那個經常出現的不倒翁，她是我小時候一直想要但從未得到的玩具，可她好像一直在對我笑，小時候看到的笑是在說：我那麼美，你不想得到我嗎？後來淘到一個並經常畫她，她的笑卻都有不同，有時候在說：我不想笑，可是我已經被做成著的樣子。有時候也在說：我在模仿人們程式化的微笑，你看我笑的像嗎。偶爾也會天真地說：生活中有那麼多美好可以感受，當然微笑。於是不倒翁成了一個有著無限定義的面孔，帶著我的好奇心在她條紋包裹的身上不斷發現她的潛台詞。」（馬丹關於2016個展「浮生」的問答）

雖然在後面做了數層包裹，但我們仍然可以想像藝術家心靈的最初內核，關乎於一種略帶憂傷的體驗——想要而從未得到。對這件事的描述透露出藝術家心靈的一個秘密：那種與生俱來的憂愁。那種行動的無力感，那種面對一個華麗世界的驚顫體驗，那種忽然自我覺知的迷惘，那種不知道應當何去何從的疏離感。

關於馬丹想要訴說的東西，我們開始有所覺知，或許感同身受。〈雲上〉是一個非常動人的闡述，在我看來，這幅作品初看是非常安靜和穩定的，但我們注意到女孩的背影，一如既往地透露出迷惘。她的一隻腳已經朝前跨去，但身姿卻沒有朝前傾斜，可見她並沒有拿定主意跨過雲梯。雲在作品中無疑是幻像，就像在所有其他作品那樣，所有的一切都是非自然的幻像。或許對我們來說習以為常的事物，在敏感的心看來，卻是驚心動魄的。又或者，我們所履的平地，卻是萬丈深淵？

〈雲上探險〉更深入地闡述了這種覺知，女孩在她想要的不倒翁玩具的誘惑中在危險的雲上步行，她張開雙手勉力保持平衡，但她仍然在猶豫，到底是向前去滿足她的欲望，還是退後去消除她的恐懼，亦或是什麼都不做，以求取最大的安全呢？

藝術家給她的畫中人選擇了一個懸設，在每一個這樣或那樣的瞬間，有一種基本的結構支配著畫面舞台。一個女孩面對著陌生的世界，面對一個遙遠的、伸手不能及的奇觀，感到猶豫和徬徨。那奇觀的獲得並不能夠一蹴而就，常常埋藏著某種危險。這個世界或許存在著痛苦或危機，但它一定被藏匿的特別美好，因而維持著某種表象中的微妙的、脆弱的平衡。而不倒翁，正是這奇觀最大的象徵物。

對於表現正面的幾件作品會更加強烈的使我們與之照面。〈自拍〉中，女孩用葵花遮住自己的臉，這非常確切的表達了她對觀看者的知悉。即她能夠知道來自畫面以外的目光，以及照相機對她的捕捉。她遮住自己的臉，並猶豫著要不要與這個世界相照面。馬丹更強調自己對鄉土的聯繫，這種關於鄉土的情節，似乎和毛旭輝以及雲南本土藝術家一脈相承。她的許多作品系列都從奎山寫生脫胎而來：「我有時候覺得自己是一個帶有泥土味的畫家，小時候生活在農村，這種泥土味吸得夠夠的，這些味道裏有我喜歡的大公雞，有我害怕的會啄人的大白鵝，還有很多看不清樣子的飛鳥，農村也許還有很多別的小動物可以選，但是好像我自動篩選了對我印象深刻的。一開始他們在畫面裏出現只是構圖需要或是烘托氣氛，後來他們變成主角之一，他們把我帶到一個生命現場，有聲音和活力的場景。通過這些元素我並沒有特定想要表達的什麼，只是每幅作品的考量有所不同，也許很多鵝的出現，例如2013年畫的〈凝〉，是想再現我小時候被鵝圍攻，驚悚但可笑的畫面。」（馬丹關於2016個展「浮生」的問答）

這些帶有泥土味的場景和藝術家的心理結構相聯繫，從而改變了它的狀貌。它是一個披著原始主義或素樸派外表的後現代心理結構，馬丹坦承過自己的憂鬱，她力圖想要表達美好的、單純的事物時，一些莫名的孤獨、顧慮、好奇、甚至的恐懼也伴隨而來，這些莫可名狀的、莫名其妙的情緒一直在牽引著這位年輕的藝術家繼續向前。所以，我們或者可以推斷出，畫中的女孩終於跨出了她的第一步。

馬丹這個年齡的藝術家並不承接上一代藝術家的邏輯，她的藝術不過是視覺知識與自我本性的真實呈現。在這個觀念主義盛行的時候，這類藝術究竟處在什麼樣的位置？這是批評家面臨的問題。不過，馬丹沒有理會這些，她還是將自己真實的感受與體驗放在第一位，正如我們在前面暗示的：在繪畫要素上，她的藝術當然包含著不少風格與趣味的影子，這似乎就夠了，因為整個時代的形象已經面目全非，沒有什麼趨勢與風格可以為時代定位，馬丹堅守自己的基本立場：保持真實的態度與執著的精神，就有可能獲得人們的青睞！

2017年1月9日

Ma Dan: Straying into the Depths of the Lotus Flower

Lv Peng

Art Historian

Let us lay aside the feminist perspective, its logic and its language, and then take a look at the works of this young female artist. From the technical aspect, her works are humble, which reminds us of Naïve Art. You would not forget Henri Rousseau and Séraphine Louis; you would definitely think of Paul Gauguin. Furthermore, David Hockney might have even crossed your mind. When we try to define an artist's work with a bit of metaphor, we will try to fit her in a long list of names. The fascinating thing is that you can't always find the exact same one, in other words, since it is hard to find the one, let us keep the feeling that evoked by her works.

She is not Liu Ye as the girl in her paintings has never looked at a Mondrian work. Only once, in a painting entitled *Lonely*, has the girl in a Ma Dan painting looked at images that related to herself, and these images are depicted in a museum scene. Yet she does not quite resemble Henri Rousseau either, since only the applied textures are alike, but the feelings evoked by the works are different. Although she has expressed her obsession with Paul Gauguin, it is not sufficient enough to define her works.

In all of her works, the face of the girl who appears in each work has never been revealed, which is the most intriguing part. She either faces away from the viewer or appears indistinctly in the background. However, if we are lucky enough to see her facing the viewer, she covers up her face with a sunflower (e.g., in the work *Self Portrait*).

Through certain details, Ma Dan seemingly delivers to us a subtle message: that the girl in the painting is able to perceive the viewer's sight – this reminds us of Manet. In *A Bar at the Folies – Bergère* and many other works, Manet created a new way of painting, as the characters that he painted are looking directly at the viewer. Therefore, it has made a distinctive impression on us – the characters in the painting have sensed our presence. According to the trilogy of classical art, the false curtain was torn down. It seems that everything is going well here, but we still can't describe Ma Dan in this way, because the protagonist in her painting is really facing away from us, without any eye contact, why do we have such a kind of alarming her a feeling of?

Perhaps the answer can be discerned at the moment when a confused self-awareness arises. The famous poet Li Qingzhao has left us the following metaphoric verse:
Always remember the sunset at the pavilion by a creek, Drunken and not knowing the way back, Rowing towards home happy, Straying into the depths of the lotus flowers. Scrambling, rowing, startled gulls flew away.

The most fascinating part of this captivating verse might not be the experience of feeling lost, but rather the moment when the gulls were startled, which provokes in that instance our self-awareness. At that moment, we might think of the relationship between ourselves and our existence. Occasionally, we might even recall a strange feeling which many of us must have experienced: walking at sunset, and suddenly feeling that somebody is starring at us from behind. Perhaps it is nothing else, it is precisely the self-awareness that we have in a flash.

In Ma Dan's artistic practice, self-consciousness is implied through many details. Nevertheless, every work touches in some ways, some more than others, on this central enquiry. For example, the work entitled *Companion* is similar to Li Qingzhao's verse as they are both set in a lake scene. In the work, the girl is pulling a small canoe; there is no one in it. The canoe appears to float along without stopping and we do not know when it might drift away, whereas the girl does not appear to want to board the canoe. It is as if the girl has just become aware of her perplexity. Save for a scarecrow facing her, the canoe is otherwise empty. Such a motif will appear repeatedly in other works.

The idea of being lost in a lake appears in many of her paintings. *Carefree* is a representative work. A girl paddles a boat on a calm lake. We can only see the back of the girl, while she is gazing at the clouds. Having been dipped into the water, the paddle is not aimed towards any direction, and leaves behind only a ripple. There is no indication of the boat's movement, and the water is unusually quiet, which indicates that the girl has not yet made her decision, or that she does not know where she should go. Or perhaps she is simply dreaming of drifting along like the clouds. The painting *Long Trip* is similar; the low-hanging clouds and golden jackfruits remind us of the melancholic tropics, exoticism, and even Gauguin's primitivism style and his paintings of Tahiti. Ma Dan expresses an idea about the island and the distant place. It is not a real island and its background is suspended from any specific scene.

In *Long Trip No. 2*, the girl is staring at a yellow duck and a green goose, and the surface of the water is, as in other works, as calm as a mirror. However, a noticeable feature appears in this work – a roly-poly doll which cannot be pushed over. The smiling roly-poly doll appears in many of Ma Dan's works. Interestingly enough, the roly-poly doll very seldom looks directly at the girl. Also, instead of noticing the viewer's sight, it always

looks somewhere else. Ma Dan has explained this special feature:

Through depicting some of my childhood toys, I create a reality in which I recollect the shards of my childhood memories; it is in a way self-hypnosis to some degree. As for the roly-poly doll which appears frequently, it was the toy which I most desired but which I never got; however, it kept smiling at me. When I was little, it seemed to say: I am so pretty, don't you want me? Afterwards, I bought one and frequently painted it, and it seems to have different kinds of smiles. Sometime it to say: I don't want to smile, but I was made in this way. Other times it seems to say: I am mimicking a stylized smile; do you think that I am doing it well? Sometimes it would even say innocently: I smile, for there is much beauty in life. Therefore, the face of the roly-poly doll is imbued with multiple meanings, and with my curious spirit I continually discover implied meanings within its striped body. (Ma Dan's answer in respect of her 2016 solo exhibition *Life Is Short as if a Dream*)

Even though it is wrapped in several layers, we can still imagine the artist's initial inspiration, which relates to a sorrowful experience – an unfulfilled desire. The depiction of such an experience seems to reveal a secret of the artist's heart: the inherent feeling of sorrow, the being powerless to take an action, the thrilling experience of confronting a dazzling world, the confusion of sudden self-awareness, and the perplexed feeling of not knowing which direction to take in life.

We begin to be able to perceive what Ma Dan is trying to express in her works; moreover, we may even share those feelings. The work *Above the Cloud* is a very moving depiction. In my opinion, it initially appears to be calm and steady, however, when I notice the back of the girl, it expresses a sense of confusion as usual. One foot has stepped out, but her body is not leaning forward; apparently, she has not decided whether or not to step over the stairs of clouds. The clouds are definitely an illusion, just as everything else in the other works are an illusion. Perhaps what we may consider being common would be thrilling to someone with a sensitive spirit. Or, put yet another way, what may appear to us to be stable ground is actually a yawning abyss.

Above the Clouds - Exploration depicts this emotion even more deeply. The girl is lured by her most desired roly-poly doll in walking above the dangerous clouds. She opens her arms trying to keep her balance, but she is still hesitating. Should she pursue her desire, or back off and extinguish her fear, or should she do nothing and seek the greatest safety?

The artist has placed the girl a conundrum, in which a basic composition supports the design of the work. A girl who confronts an unfamiliar world, a distant and unreachable spectacle, is hesitating. That spectacle cannot be reached in an instant, and it is often hidden with dangers. This world may contain pain and danger, but it is be well concealed, so that the presentation of a delicate and fragile balance is remained. And the roly-poly doll is the most obvious symbol of this spectacle.

The few works which depict the front of the girl leave a stronger impression than the others. In *Self Portrait*, the girl covers her face with a sunflower, which indicates clearly that she is aware of the viewer's presence. Precisely, she notices that one is watching from outside of the painted world, and the camera is trying to capture her. She covers her face and hesitates whether to meet this world face to face. Ma Dan emphasizes her connection with her hometown, and it seems to connect with Mao Xuhui and other artists from Yunnan province. Many of her works are inspired by her sketches of nature at Kui mountain:

I sometimes feel that I am an artist with pastoral sentiments. I lived in a village from an early age and had quite absorbed its pastoral essence, where there are roosters which I like, scary geese pecking at people which I fear, and also many other birds which cannot be seen clearly. In the countryside, there are many other small animals that I could have chosen, but I seem to pick only the ones which had left me a deep impression. Initially, they were only supplementary to the composition or ambience of the work. Later on, they became among the main characters who transport me to another place which is alive and filled with sounds and energy. I do not have specific intentions to express with these elements, it is just that the consideration for each single work is different. Perhaps when many geese appear in a work, for example, *Gazing* (2013), it is to recreate a thrilling and ridiculous scene from my childhood when I was chased by geese. (Ma Dan's answer in respect of her 2016 solo exhibition *Life Is Short as if a Dream*)

These rural scenes have had a psychological connection with the artist, and have also changed her. The artist is influenced by primitivism, Naïve Art, and also post-modernism. Ma Dan has been honest in the past about her melancholy. When she tries to express something pure and beautiful, an inexplicable sense of loneliness, concern, curiosity, and even fear will inevitably follow along. These unrecognizable and inexplicable emotions have been pulling the young artist to move forward. So, perhaps we can infer that the girl in the painting has finally taken her first step forward.

Like all the artists of the same age, Ma Dan does not inherit the logic of the previous artistic generation. Her works are the representation of her visual knowledge and her true nature. When conceptual art prevails, where is the position for this type of art? Such questions are left to the critics. In fact, Ma Dan is not concerned with such questions; instead, she prioritizes her feelings and experience, as hinted above: her paintings in their elements certainly contain a lot of style and fun, and this seems to be enough. This is because the impression of this era has changed beyond recognition, and it cannot be defined by a certain style and trend. Ma Dan stands by her fundamental principle: As long as we maintain an honest attitude and a persistent spirit, it is possible to gain the favor of others!

9 January 2017

2017

作 品 Artworks

另一個她 Another Her　布面油畫 Oil on Canvas　130×90cm　2017

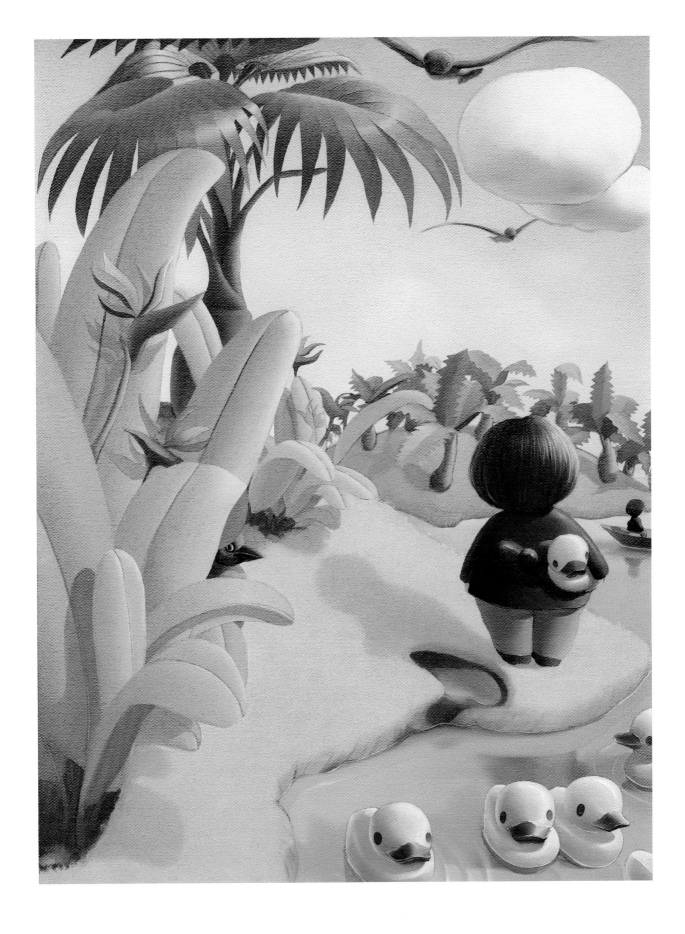

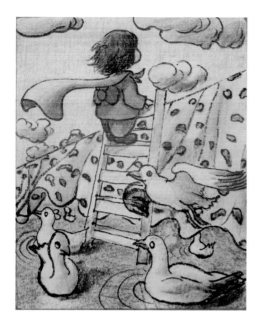

柔軟的窗子內外 In and Out of the Soft Curtain
布面油畫 Oil on Canvas　115×145cm　2017

羅曼·羅蘭說，世界上只有一種英雄主義，就是在認清生活真相後依然熱愛生活。在柔軟的簾子內外，我無法認清生活的真相，但仍然飽含期待地保留英雄主義，並且，我就是我的英雄。

Roman Roland once said:" There is only one true heroism in the world, and that is to still love life even after recognizing the truth about life. Whether within or beyond the soft curtain, I cannot figure out the truth about life. However, I still embrace the concept of heroism, and I am my own hero.

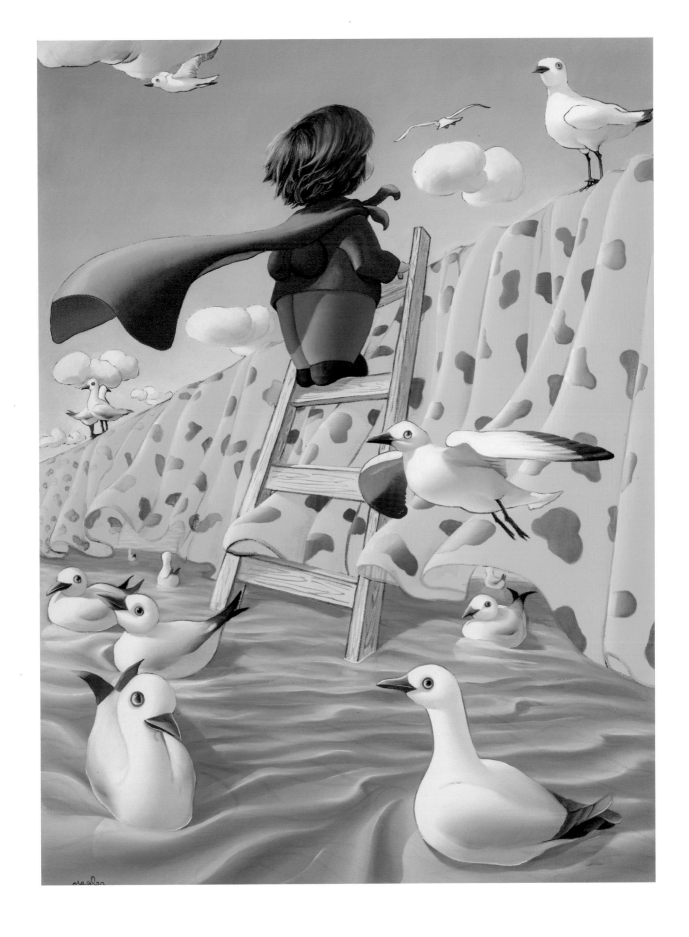

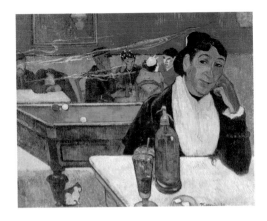

偶遇夜咖啡館 Encounter in the Coffee Shop at Night
布面油畫 Oil on Canvas　110×130cm　2017

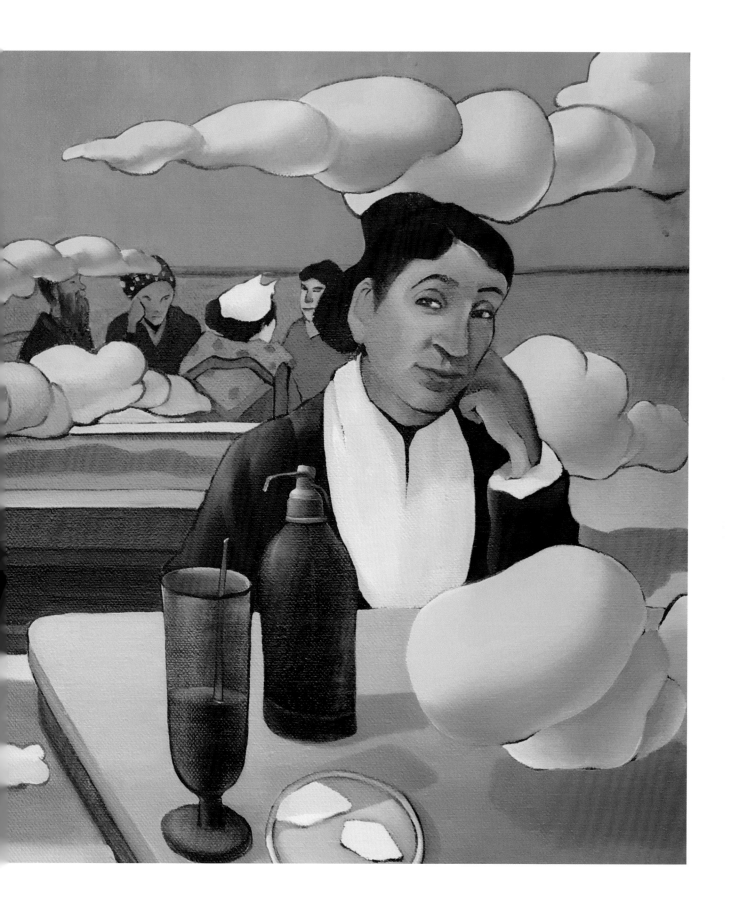

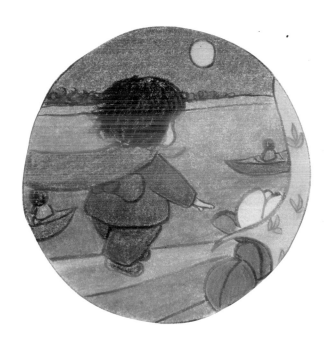

今年在圭山寫生的時候，旁邊很多寫生用的遮陽傘倒影灑落一地，當傘的藍色反光刺向眼睛，彷彿藍天被消解，變成別的不是藍的什麼顏色，這些藍傘有節奏地製造出一些晃眼的催眠曲，一瞬間，我目光呆滯，唯一在動的好像是耳朵裏聽到的遠方風中飄來的一秒寂寥。

When I was painting from nature at Gui Mountain, the shadows of the sun umbrellas used by other nearby artists were scattered on the ground. When the reflection of the blue umbrellas pierced my eyes, it was as if the blue sky had dissolved, turning into colors other than blue. It was as if the blue umbrellas had generated a dazzling lullaby. For an instant, I was astonished, and the only thing that moved appeared to be one second of desolation heard in the ear from afar.

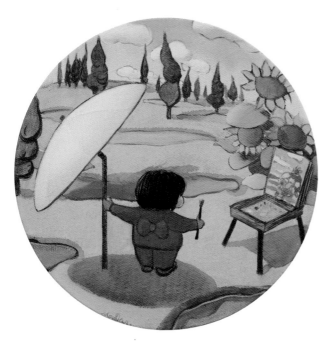

我畫你的樣子 The Way I Paint You
布面油畫 Oil on Canvas　直徑D: 25cm　2017

半夢—第一局 Unfinished Dream - First Round
布面油畫 Oil on Canvas　直徑D: 25cm　2017

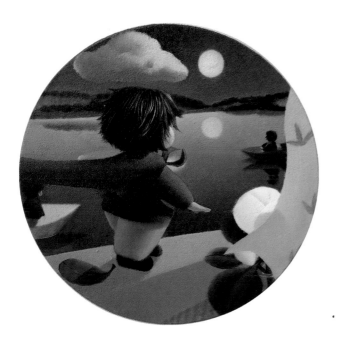

半夢—月夜裏我們也不曾相視
Unfinished Dream - We Haven't Meet each
other in the Moonlight
布面油畫 Oil on Canvas　直徑D: 50cm　2017

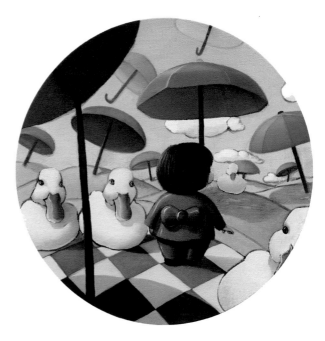

浮生—遠處傳來一秒寂寥1
Life Is Short as if A Dream -The Lonesome
Moment Comes from a Further Distance No.1
布面油畫 Oil on Canvas　直徑D: 35cm　2017

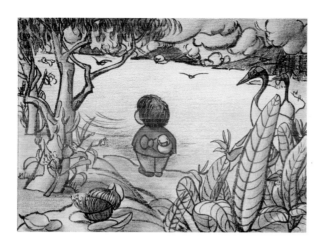

比湖面更近的是記憶 Memory is Closer than the Lake
布面油畫 Oil on Canvas　110×145cm　2017

記憶，於每個人而言，共生、共存、共行，但是你又瞭解它多少？它真實可靠嗎？腦海裏反覆重組，重塑後，裏挾著、分離著、消逝著，最終迎面而來的是眼前的藍天、白雲、還有離得更近的湖面。

Memories exist within every one of us, but how well do we understand them? Are they reliable? Our mind constantly reorganizes and reshapes them, and after that they get borne away, they get separated and they disappear. In the end, what we encounter directly is what is before our eyes –the blue sky, white clouds and the much closer lake.

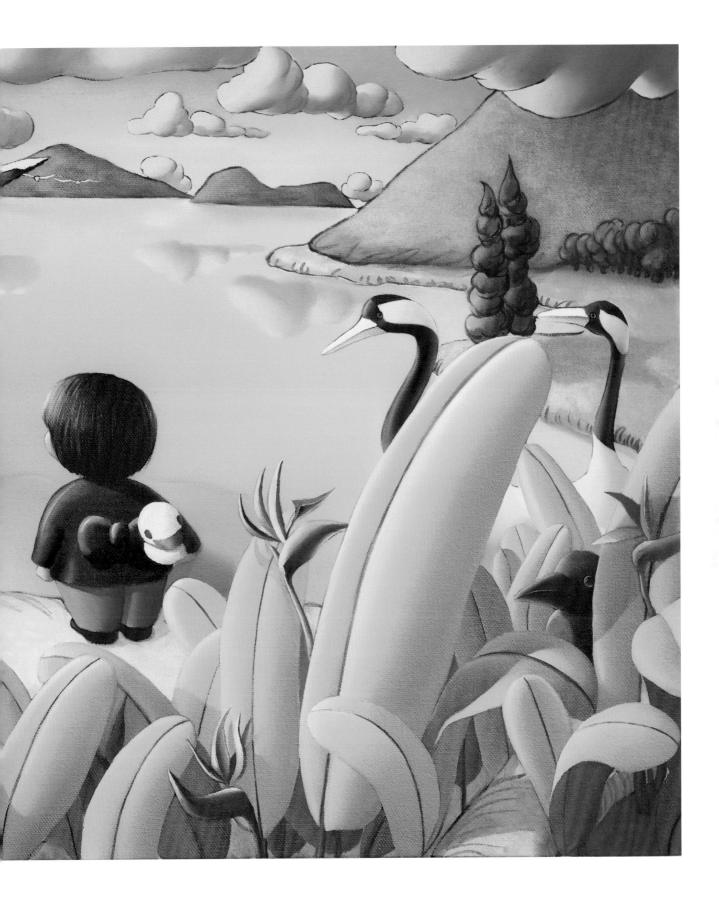

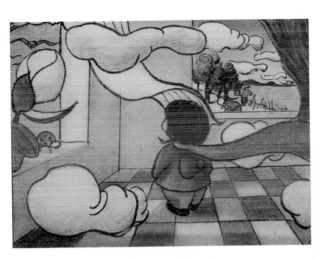

浮生—無序 Life Is Short as if A Dream - Dis-order
布面油畫 Oil on Canvas　80×100cm　2017

我們通常會借助一些外力來試圖理解我們是誰，我們所為是否有意義，
在這個過程中也許沒有具體的一個答案，但是記憶碎片會慢慢分解並按
照你改編後的樣貌重組，因為有了這些無序的呈現，儘管找尋答案時已
經誤入歧途，但是誰又知道，你為自己解答了什麼別的問題。

Sometimes, we rely on an external force to recognize and understand
who we are, and in this process we may not obtain a specific answer so
to whether there is meaning in our existence.　However, our fragments
of memories will slowly dissolve and reassemble according to how we
adapt them. Even if we embark on a wrong path while searching for
answers, but because these fragments appear randomly, who knows
what other questions we might answer instead.

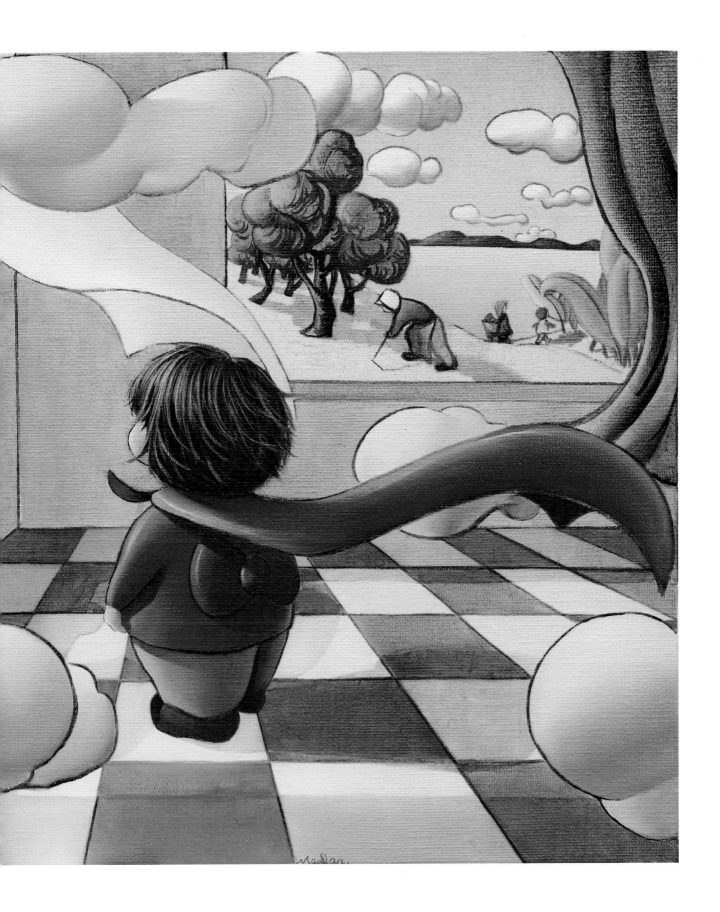

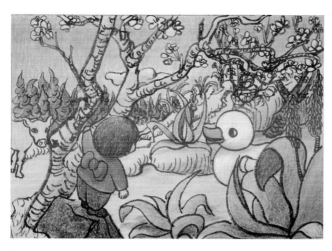

被送至異鄉的大黃鴨 The Yellow Duck Traveling Everywhere
布面油畫 Oil on Canvas 110×145cm 2017

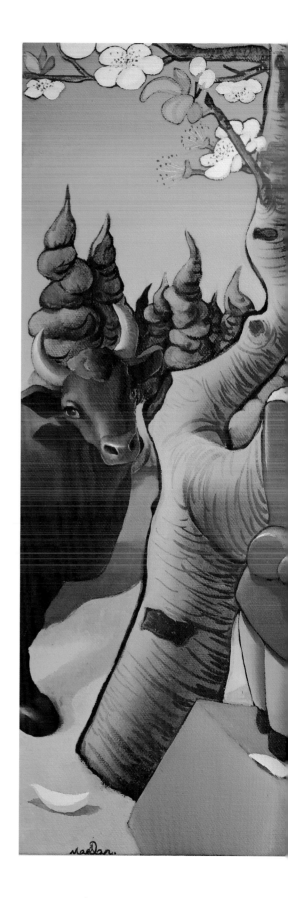

每次回想起兒時的鄉下時光，心裏總是有段莫名且微妙的距離，偶爾隱隱綽綽的提示我那股特別的泥土味沒有飄遠，偶爾又讓我糾結於分不清那是他鄉還是故鄉，於是，沒法妥貼地安放我的大黃鴨和取走我的溫暖，那頭外公的大黑牛也彷彿替我疑惑不解。

Every time I recall my childhood memory of living in the countryside, my heart always feels an inexplicable and subtle sense of distance. Occasionally, it is a faint reminder that I have not lost my special pastoral sensibility. Other times, it leads me to struggle with whether it is my hometown or not. As such, I cannot properly settle my big yellow duck or place my tender feelings, and my grandfather's big black cow seems to be puzzled for me.

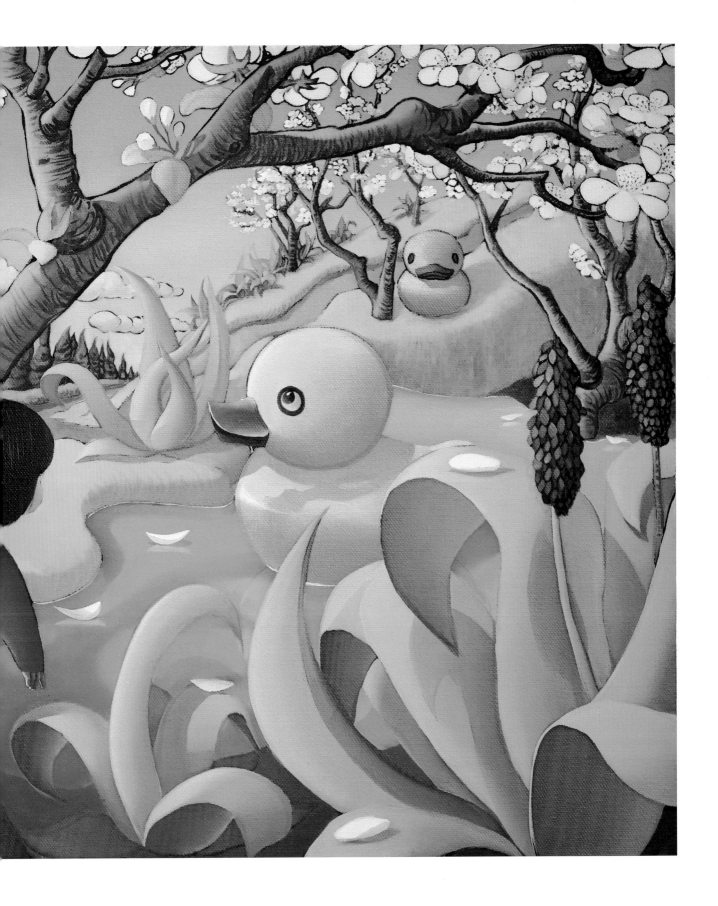

馬丹的繪畫：一個人的舞臺

夏可君

哲學博士、評論家、策展人

只有在繪畫藝術中，時間會停止下來，停頓在記憶的某一刻，這是恩賜的時刻，也是記憶仁慈的一面，對於一個女藝術家，如果被童年一直陪伴，如果童年燦爛的氣息一直縈繞在她的夢中，這是時間在承諾幸福的禮物。馬丹無疑是這樣的一個幸運的畫家。

在馬丹那一眼就可以辨識的畫面上，總有一個象徵她本人的袖珍版的小女童，如同一個布娃娃，甚至就如同一個可愛的小甲蟲，或者就是童話中的拇指公主？是的，是一個小公主的美妙形象。或者她帶有一點卡通的味道，個子矮矮的，似乎從小人書中走來。這個小公主與世界保持疏離的距離，並絕然走進了畫面之中。這還讓我想到本雅明在《柏林童年》中寫到的那個會唱歌的「駝背小人」，這個小人帶給了本雅明以拯救，在他幻視的目光中，這個小矮人吃著糊糊麥片，唱著歌，總是站在某處，只是從來不被人看到，但它卻總是盯著我們，而它盯上了誰，誰就會心不在焉，這個走神的片刻，也是拯救的機會，讓兒童可以突然進入一個特有的幻想與天真的世界。而這是成年後所喪失了的靈性，但在馬丹的繪畫上，這個童真的夢想一直被保留下來了，她保留了走神後那個出竅入神的姿態。

而且，還保留的如此完美無瑕，如此自然鮮嫩。這個小女童總是背對我們，這個姿勢是意味深長的，她有著她自己的世界，她並不與畫外的我們交流，因為她沉浸在那個屬於她的世界裏？這可能與女畫家自己的童年經驗相關，她兒時就是一個留守兒童，遠離父母親和都市，在一個小鎮上生活，想融入周圍小朋友的世界，但似乎不可能，就更加加強了自己的疏離感，鄉村生活也給她打開了一個自然世界，因此讓她在疏離之中，可以轉身看到另一個世界。因此，她孤寂地進入了那個自然的世界，她要去營造屬於她的世界，那個被童心主宰的世界，如同法國畫家盧梭的那種拙稚，那種與自然融為一體的夢幻，身體是從綠葉上長出來的，笨拙的侏儒以接近於動物的樣態激發無盡的喜愛。

幾年前，這個小女童，這個小公主，一開始出現在畫面上時，就被一種堅決的方向感所牽引，即向著遠方，向著畫的裏面眺望，那些早期焦點透視法的尖銳構圖，不過是直接表明藝術家對我們這個世界的漠視，對另一個童真單純世界的單純嚮往與義無反顧。正是因為有著如此的回轉，讓疏離打開一個間距的空間，調轉身體進入一個藝術和童真的世界，才有著馬丹回向一個自然的田園世界，才有一個翠綠欲滴的世界向我們敞開。

確實，這是一個詩意的、甜美的花園，這是一個植物花朵一直盛開，永遠不會衰敗的世界，「我們的世界是花園，花園的花朵真鮮艷。」這首兒歌縈繞在畫面上，這個小女童渴望進入到自然的田園風光之中，她渴望重新出生，繪畫對於女畫家而言，不過是再一次地重新出生，在畫面上，讓繪畫以童年的夢想重新出生，這是繪畫最初的歡愉。

這個重新出生的渴望是一種骨子裏的「盲從」，是小女童跟隨花朵的芬芳，跟隨小蟲子進入到花蕊的裏面，一個個小梯子，不過是暗示小公主試圖進入到花朵或植物的內核之中，更為裏面的內核，夢想的深處，渴望被花朵所包裹，所捲入，然後再次出生。

也許是因為童年體驗到了更多的孤寂與疏離，因而在這個田園詩的世界裏，永恆的童真帶有南國的溫暖，它一直給人溫暖，不僅僅顏色以鮮綠為基調，似乎是蔥鬱的熱帶氣候，陽光滲透到每一瓣花葉和每一根細草上，畫面上一片片葉子的圓形或橢圓形，似乎還在晃動，還在陽光中生長，畫面充滿了生機，伸手可摘，那綠意誘惑我們試圖去採擇，但又被一層薄紗所擋住了，這是一個綠鏡中的世

界，這是一個溫暖明媚的世界，這是詩意盎然的綠境。因此馬丹最近就畫出了〈暖丘〉系列，果子成熟了，柔軟的綠，鮮嫩的綠，一切都是新鮮的，好像世界第一次發芽，第一次盛開，這是綠意的存在，因此我們要做的是讓手停頓下來，在自然的甜美面前呼吸。

這是一座自然的舞臺，在這個舞臺上，小生命渴望被那個童真的世界所包裹，畫面上的構圖很多時候都體現出這個自然的生命姿態，如同嬰兒被母親懷抱，如同植物花瓣的合攏，畫面上的一群鵝也會把小女童圍繞起來，似乎她就是一朵花，這個被包裹的姿態，暗示兒童對被呵護的渴望？是對孤寂的內在回應？馬丹很好地保持了這種疏離與融入的張力。跟隨自然的姿態打開了畫面，在一片葵林中跟隨小公雞款款而行，或跟隨白天鵝遙望天際，在最近的這些作品中，「跟隨」的姿態更為明確，這更為表明了馬丹對自然之美的執著信念，自然的舞臺被這個跟隨更為豐富地打開。

畫家對童真田園世界的描繪，乃是對自然的信仰，馬丹以一個女性的本能，建立了自然與童真，自然與夢幻，夢幻與內心，內心與色彩，夢幻與舞臺，這之間的豐富關係。跟隨自然，相信自然，讓自然來引導自己的想像，小公主進入到自然之中，與那些花朵，植物，還有小動物一道，呢喃低語，這是另一個世界的語言，對於我們這個當下越來越浮躁和喧鬧的都市生活而言，無疑帶來凝視的淨化。

但這個小女童也有著另一種經驗，並不全是美好與夢幻，如果我們瞭解藝術家的童年，她生活在一個遠離父母親的小鎮，她實際上是通過繪畫在修復自己與同伴們的疏離感，因為疏離才有著接近的渴望，但渴望又是不可能的，因此才需要藝術來補救，似乎拒絕長大，只有藝術可以陪伴。

在這個張力中，馬丹不斷擴展她的這個自然詩意的童真世界，她甚至要把這個世界建造為一個永恆的舞臺，不僅僅在田園生活，也是在室內生活中，營造一個屬於自己內心的舞臺，一個讓自己的孤寂與疏離場景化的舞臺。

比如那幅名為〈舞臺〉的佳作，一排排的布娃娃靜默地觀看著一盒幕簾拉開的舞臺，舞臺上的小女童在一個仿生的公園裏打電話，似乎要建立與另一個世界的聯繫，但似乎聯繫中斷了，更為加強了疏離感。馬丹似乎在嘗試著讓人間的封閉的室內空間與自然的夢想空間之間建立夢中聯繫，夢簾打開了，舞臺上有著主角，那個小女童，但是也增加了其他角色，比如那些眼睛閃爍的布娃娃，她們之間的默語有著孩童們自己的語法，各自在孤立地冥想。

在馬丹的繪畫上，有著兩個空間，一個是自然的世界，一個是舞臺的空間，一個熱烈溫暖，一個暗冷沉靜，但都是馬丹內心生活的真切投射。

就自然的世界而言，這是一個還在生長的世界，有著親密的召喚，植物與動物在引導我們，還有雲朵，要把我們引向遠方與雲端，內心的渴望通過進入自然而變得輕盈。當然，這是通過美麗的自然色彩而實現的。馬丹繪畫色彩的自然性是唯一的：這是她反覆面對雲貴高原的自然景色，通過自己以小紙片反覆寫生與觀察，而慢慢發現與想像出來的。顏色有著細微的光線變化，但不是印象派的模糊性，而是有著清晰的色域區分，植物、草坪、花果，等等，各自的顏色都不同，都以一種純色的筆觸仔細描繪出來，柿子顏色似乎有著柿子剛熟的皮膚感，馬丹純然通過顏色及其細微的筆觸，把自然的世界區分開來，暖色調中的細微層次變化，陰影的迷人呼吸，都被馬丹捕捉到了，而且還帶有一種孩童特有的夢幻與想像的色彩，這是馬丹創造出來的色彩體系。

就舞臺的世界而言，這是一個室內的世界，藍色調的暗冷支配著這個靜默的世界，或者讓室內家具等等具有一種靜物一般的狀態，或者讓電視上的動漫安慰小女童，或者讓小女童凝望窗外的夜月，等等，這些靜默的場景並沒有戲劇性，無語而低調，在幾個布娃娃與小女童之間展開的是一個小戲劇的疏離空間，這裏有著對現實的逃避？這是馬丹童年記憶的寫照，是面對疏離與孤寂而想像出來的一個虛擬舞臺，這是一個人的舞臺，但似乎又有著某種調節與緩解，而畫面總體的冷光，還是讓這個舞臺空間充滿了寂寥的氣氛，反倒激發觀眾的進入，去安慰那個受傷的孩子。

從靜默中消解疏離的隱痛，童年的孤寂淨化我們的目光，進入到那個童真的舞臺，那個自然的田園世界，在疏離與接近之間的來回擺蕩，體現了藝術家內心的掙扎，繪畫在這個張力之中展開，從而更為迷人。

2014年5月21日

Ma Dan paintings: one artist's stage

Xia Ke-jun
Ph.D. Philosopher, Art Critic, Curator

It's only in the art of painting that time will stop, pause at a certain moment of memory, a favorable moment, but also a gentle side of memory; and for a female artist, if she has always been accompanied by her childhood, if the brilliant atmosphere of childhood is lingering in her dreams, this is time promising the gift of happiness. Ma Dan is undoubtedly that lucky a painter.

On Ma Dan pictures, identifiable at first glance, there is always a pocket-sized version of a small girl that represents her. Is she a rag doll, or just a cute little beetle, or even just like the fairy tale princess Thumbelina? Well yes, it is the wonderful image of a little princess. She is somewhat in the taste of comics cartoons, smallish, seemingly coming out of a child book. This little princess keeps her distance from the world, and steps decidedly into the comic strip. This reminds me of Benjamin in "*Berlin Childhood* around 1900" in which that "little hunchback" who can sing brings salvation to Benjamin; in his hallucinated vision, the little dwarf is eating gooey porridge, singing, always standing somewhere, yet never seen; but he is always watching us, and whoever he's watching will become distracted, and that divine moment is the salvation occasion, when children suddenly enter a unique world of fantasy and innocence. And this is the spirit that is lost when one becomes an adult, but in the Ma Dan paintings, this childhood dream is preserved, she keeps this out-of-body entranced posture that goes with distraction.

Moreover, she remains so perfectly flawless, so naturally fresh. The little girl always turns her back to us, which is deeply significant, she has her own world, and she does not communicate with us who are outside of the painting, because she is so immersed in the world that belongs to her. This may be related to Ma Dan's own childhood experience, which was that of a left-behind child, far away from her parents and the city, living in a small town, wanting to integrate the world of the children around her, though it seemed impossible, which in turn strengthened even more her alienation; rural life opened the world of nature to her, so that in her alienation she could turn around and see another world. So, she entered that natural world on her own, she wanted to build a world of her own, a world dominated by childish innocence, akin to that of the French painter Rousseau, clumsy and childish, with the illusion of merging with nature, in which bodies grow out of green leaves, and in which the attitude of awkward dwarfs getting close to animals stimulates an endless love.

A few years ago, this little girl, the little princess, when she began to appear on the canvas, was guided by a strong sense of direction towards a distant place, looking within the painting; those early sharp compositions focused on scenography, but they showed directly the artist's disregard for our world, choosing without hesitation a child's world of simple innocence. It is this very act of return, the fact that the alienation opens a separating gap, the transferring of the body into a world of art and innocence that triggers the return of Ma Dan back to an idyllic natural world, and makes for the creation of this glistening green world unveiled to us.

Indeed, this is a poetic, sweet garden, in which plants and flowers are always blooming, a world that will never decline: "our world is a garden, with very fresh flowers." This child song hovers on the canvas, this little girl is eager to enter into the idyllic nature, she craves to be born again; thus painting for Ma Dan is just being born once again, on the canvas, through childhood dreams, and this is the initial joy of painting.

This desire to be born again is a kind of bone-deep "blind following", the small girl follows the fragrance of flowers, she follows the insects inside the flowers, with a small ladder, suggesting that the little princess is trying to get into the kernel of flowers or plants, and more than that, into the depths of dreams, hoping to be wrapped up by the flowers, rolled into them, and then born again.

Because of loneliness and alienation, in this idyllic world, the eternal innocence of youth carries a southern warmth, it has been giving out warmth all along, just as the keynote color is bright green, it's as though the lush tropical climate and sunlight penetrate into each petal and each fine grass blade, on the canvas each round or oval leaf seems to be still shaking, to be still growing in the sunlight, the picture is full of life, it seems that one could reach out and pick the flowers, one is tempted to pick them; yet a layer of tulle prevents that, this is a green mirror world, a world of warmth and splendor, a poetic world of greenness. Thus Ma Dan recently painted the "*Warm Mound*" series, in which the fruits are

60

ripe, of a tender and fresh green, as if the world's was burgeoning and blooming for the first time. That's the existence of greenness, so what we have to do is to stop our hands before the sweet nature and take a breath.

This is a natural stage, on which the little life that desires to be wrapped in the world of childhood, the composition of the picture very often reflects the natural life stance, as the baby in his mother's bosom, like petals folding up, a flock of geese on the canvas surrounding the little girl, she looks like a flower, and her posture suggests the need of children to be taken care of. Is it an inherent response to loneliness? Ma Dan maintains very well this tension between alienation and integration. She opens the paintings with a "following nature" stance, like strutting about following a rooster in a small wood, or following a white swan looking to the sky; in these recent works, the "following" attitude is clearer, which indicates Ma Dan persistent faith in natural beauty, and this stage of nature is more richly opened with this "following".

The painter depicts the world of innocence, but on the nature of faith, Ma Dan, with a feminine instinct, establishes a rich relationship between nature and innocence, nature and fantasy, fantasy and heart, heart and color, fantasy and the stage. Following nature, believing in nature, letting nature guide her imagination, letting the little princess enter into the nature among those flowers, plants, and little animals, whispering, this is the language of another world, and for us, in this era of ever more impetuous and bustling city life, it undoubtedly brings purification to our gaze.

But this little girl has another experience, which is not all beautiful or fantasy, if we understand the artist's childhood, she lived in a small village far from her parents, she indeed used painting to repair her isolation feeling from her friends, because isolation only gives the hope of proximity, an hope that is however impossible, which is why art is necessary to compensate, as though she was refusing to grow up, only art could accompany her.

In this tension, Ma Dan is ceaselessly expanding this poetic world of childhood innocence, she even sets it up as a permanent stage, not only in the countryside life but also in the indoor life, creating one inner stage that belongs to her, a stage on which she can dramatize her own loneliness and alienation.

Precisely in the fine work titled "*Stage*", in which rows of tumbler dolls silently watch the raise of the curtain to see a small girl in a bionic park making a phone call, as if trying to establish contact with another world, but as if that contact was broken, the sense of alienation is much stronger. Ma Dan seems to try to establish a link between the enclosed indoor space and the imaginary natural space; the dream curtain opens, the main character, the little girl, is on the stage, but she also increases the other characters, such as those flashing eyes tumbler dolls, and the silent language between them has its own syntax, like children language, each in solitary meditation.

On Ma Dan's paintings, there are two spaces, one is the natural world, the other is the stage space, one is warm or even hot, the other cold and quiet, and that is a projection of Ma Dan's own inner life.

As for the "natural world", it is still developing, it has an intimate calling, the flora and fauna are leading us, there are clouds who want to take us far away up in the sky, the inner desires become lithe and lissom when they enter the nature. Of course, this is achieved through the use of beautiful natural colors. The naturalness of Ma Dan's colors is unique: she has been facing the natural scenery of Yunnan and Guizhou plateaus and sketching them repeatedly on little pieces of paper, and thus slowly discovered and imagined them. There are subtle changes in the color lighting, but it is not as blurred as with the impressionists, the colors are quite clearly distinguishable, the plants, the grasses, the fruits, etc., have all different colors, they are all painted with a kind of colorful pure pencil strokes, the kakis color looks just like the soft skin of freshly ripened fruits; with the use of color and fine brush strokes, she divides nature, she captures the subtle gradations of the warm colors and the charm of shaded breathing, and moreover she gives it a tint of childish fantasy and imagination. That is what constitutes the gist of Ma Dan creativity.

As for the "stage world", it is an interior world, in which the coldness of blue tones dominates, in which the furniture and objects have a still life attitude, or in which the cartoons in the TV set give solace to the child, or in which the child gazes at the moon through the window, etc., quiet scenes that bear no drama, silent and low key, a small drama unfolding between the little girl and the dolls, is there here any escape from reality? This is a portrayal of Ma Dan's childhood memories, it is an imaginary stage to face alienation and isolation, it is a one-man stage, but it seems that there is an adjustment and relief, and the cold light of the painting fills the stage with an atmosphere of solitude, inciting the audience to get into it and comfort the hurt child.

The pain of alienation is alleviated through silence, meanwhile, the childhood loneliness purifies our look, the entering onto these childhood innocence stage, into this natural bucolic world, the balancing between loneliness and proximity, all this embody the artist's inner struggles, and the tension that arises there from the painting makes it all more attractive.

May 21, 2014

2016

作品 Artworks

浮生7 Life Is Short as if a Dream No.7　布面油畫 Oil on Canvas　直徑D: 120cm　2016

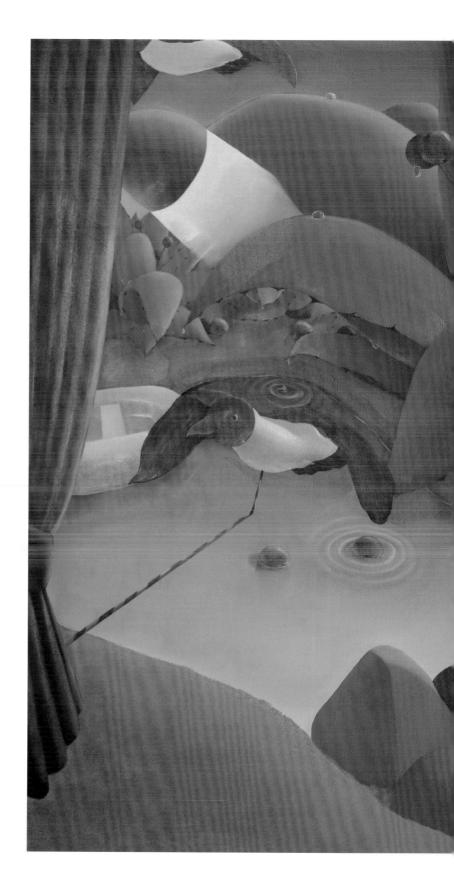

不受限的旅行，不小心迷失在我的身體裏。不知所措的用慣有思維安排著來龍去脈，我非得找到迷宮的出口不可。

In an endless voyage, I accidentally get lost within myself. Perplexed, I attempt to sort things out in a conventional way, and I have to find the labyrinth's exit.

半夢—舞臺1 Unfinished Dream - Stage No.1
布面油畫 Oil on Canvas
150×200cm（雙聯畫Diptych） 2016

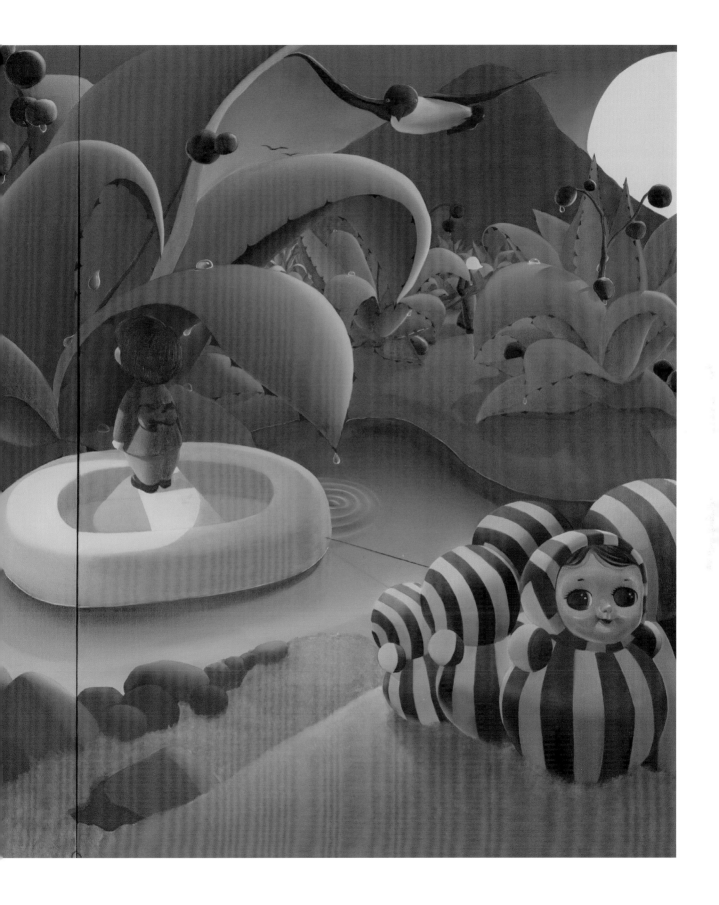

核桃林之約5 Date in Walnut Grove
布面油畫 Oil on Canvas　直徑D:140cm　2016

「存在即感知」並非絕對有效，有些趨於「永恆」的東西會不斷支配著你，去尋覓來自更遠處的圖像，擺脫那些我們慣有的空間和時間，還有邏輯。

"To exist is to be perceived" is not always correct. There are those things which tend towards the eternal which will continually dominate us, and search for images that are from further away and break free from what we deem to be conventional space and time and also logic.

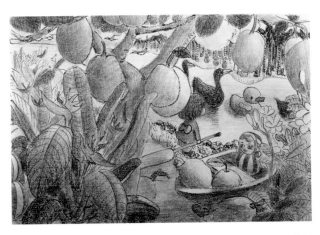

遠遊2 Long Trip No.2　布面油畫 Oil on Canvas　150×200cm　2016

我如何對我的日子說：「我住在你那裏，卻未曾撫摸你，我周遊了你的疆域，卻未曾見過你」——阿多尼斯《我的孤獨是一座花園》

What shall I say to my days: "I live with you, but I have not touched you. I have traveled around your territory, but I have never seen you." Adonis, *My Loneliness is a Flower Garden*

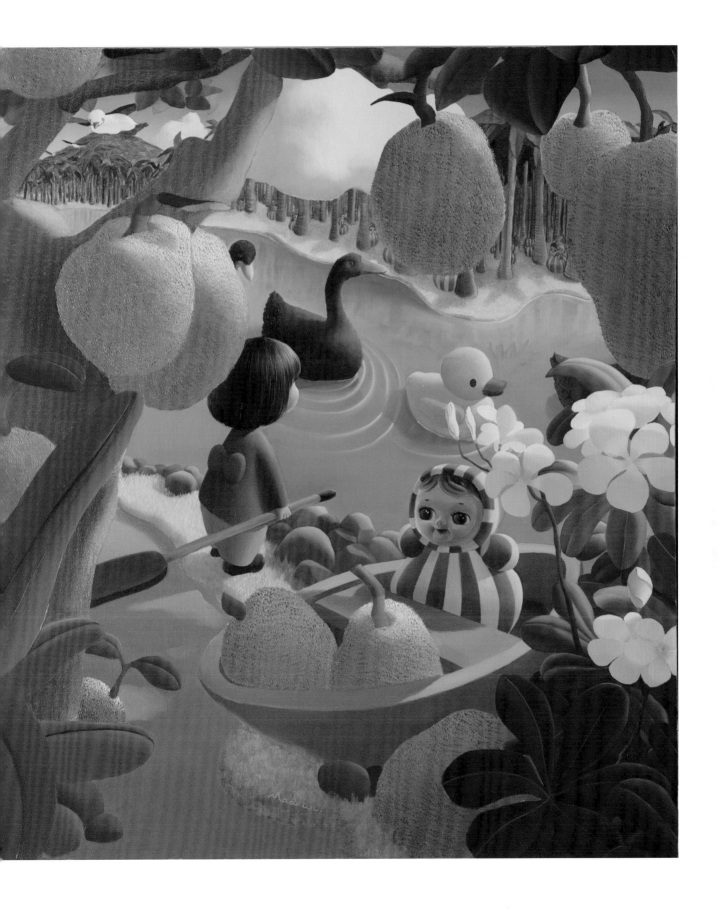

雲，對於一個愛幻想的人來說，實在包涵了太多內容。我時常覺得，當懷抱一朵雲時，我會擁有另外一種看世界的眼光，比如，更輕或是更重。

For someone who enjoys fantasy, clouds have too many meanings. I often believe that when hugging a cloud, I will have another way of seeing the world, like lighter or heavier.

半夢一追3 Unfinished Dream-Chasing No.1
布面油畫 Oil on Canvas　90×130cm　2016

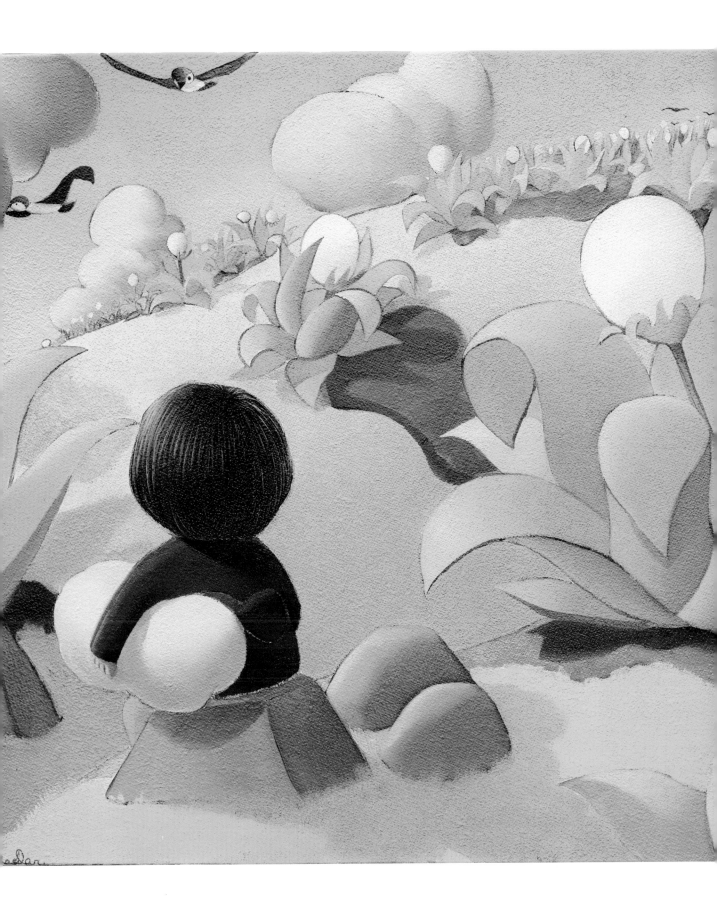

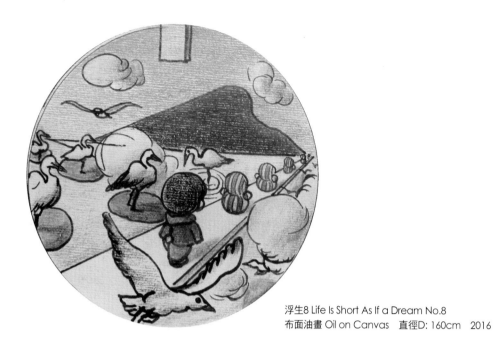

浮生8 Life Is Short As If a Dream No.8
布面油畫 Oil on Canvas　直徑D: 160cm　2016

沒有什麼是為自身而存在。如果一樣事物帶有其他事物的特性，就能擁有最大的潛力，
擁有活力和意義，從而能超越自身，成為造就整體和諧的零件。—— 羅伯特 · 亨利

Nothing exists solely for itself, but if each thing partakes of the special qualities of other things, it can then have the greatest possibility, possessed of vitality and meaning, and can transcend itself and be part of the making of a great unity. – Robert Henri

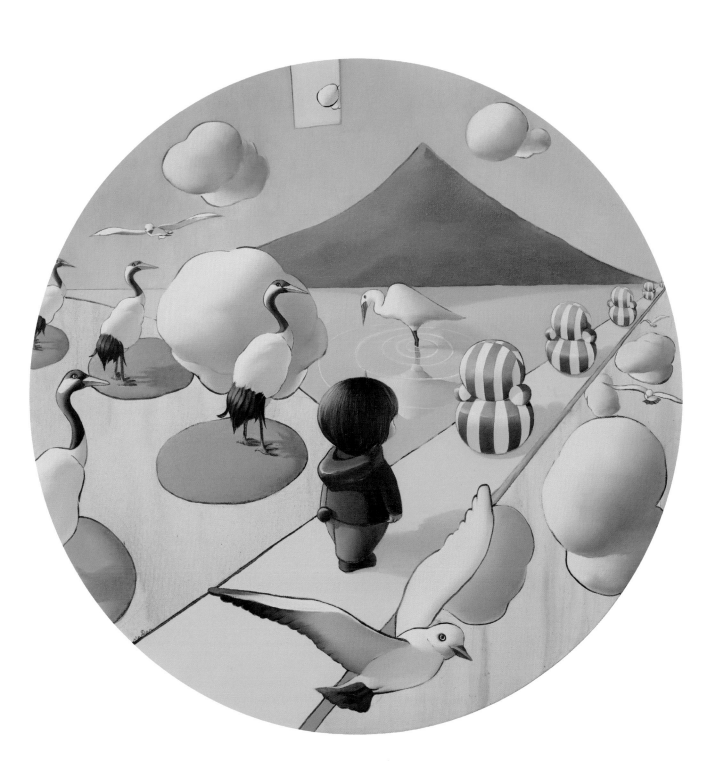

永恆的綠園

述山
旅法策展人、藝評人

從古希臘到文藝復興，再到印象派，繪畫一直在被對客觀世界的模仿（Mimesis）所主導。到了塞尚（Cézanne），他就不再滿足於印象派專注畫面結構的色彩的構成，而更關心手握畫筆時內心面對大自然的感知。梅洛龐蒂在他的知覺現象學理論中多次提及塞尚的這種繪畫經驗，他在《眼睛與精神》提到：藝術，尤其是繪畫，是從最源初和自然荒蕪的意義地面中吸取養料……藝術和繪畫甚至就是這樣天真行事的唯一門類。

梅洛龐蒂提到的這種「天真行事」的精神正是納比派（Nabis）在繪畫中尋找精神超越的核心思想。他們希望通過對自然和生活的觀察，體察內心的變化，並由平面視圖和相對簡單的色彩表達出來。這種平塗色的方法源自當時流行的日本套色版畫和中世紀歐洲教堂玻璃彩繪，有很強的裝飾效果。在精神方面，納比派通過繪畫向內自省，也正是西方世界所認為的東方哲學思想。盧梭在發現高更和納比派的繪畫後，更加堅定地放下了當時學院派所堅持的寫實現實主義，去追隨畫家自身的感知和繪畫中的自由表達意願。盧梭正是因為這種面對自然和面對繪畫的真實，被後人稱為「素人藝術」（Art naïf）的鼻祖。

波德萊爾的浪漫主義現代性的基礎是「瞬時與永恆」（éphémère et éternel），把握「現在」（présent）才可能抓住美和浪漫主義精神。以現代的方法再現傳統文化，就是把歷史拉進現在。他的這種現在就是第一感受，甚至是沒有觸及理性的直覺。這種感受往往通過一種反差表現出來，就如瞬時和永恆。這與老師毛旭輝談到馬丹作品時的感受不謀而合：「我覺得馬丹一直在堅持一種東西，就是面對自然，面對一個很乾淨、很純潔的世界。這也可能是我們心靈裏面最原始的一種烏托邦，這種堅持我覺得有很強的針對性。作品都是在一定的現實裏面產生的，她和我們的現實反差很大……」。在面對自然時，馬丹依然堅守內心的世界。

如果毛旭輝說馬丹的繪畫「從現實中產生，卻與現實反差很大」，那正是因為馬丹在中國接受了學院派的幾何透視法的繪畫教育之後，卻一直像納比派的畫家「反現實」地描繪著自己的內心。馬丹一直處於由寫實主義的繪畫技法和自由表達繪畫意願的衝突所產生的張力中。就如她所生活的小世界是綠色的，藍天白雲；而同時在網絡和媒體中看到的是污染和疾病。馬丹並沒有把她看到的、聽到的所有信息，在繪畫中表現出來，而是選擇用裝飾繪畫的方法來訴說她對這個世界的感受。畫面中簡單而美好的感受正是她面對這個生活的言說，是她面對災難的力量。畫面中經常出現的那個女孩背影，或許並非是對現實的逃避，而是引導觀眾去進入她的世界，體驗她內心的對生活的感知，對美的執著。

這種對自然和對生命的感知與馬丹在雲南的成長和生活經歷密不可分。兒時後山坡的記憶在她的心中建起了一座神秘的綠色花園。馬丹則在現實生活與內心神秘世界之間穿行、交錯，把她所處雲南的山川河流、花草樹木、風土人情都收納到畫面中，不斷擴大她的精神花園。現實世界中的時空不斷變化，馬丹通過繪畫讓每一個「現在」成為永恆。

2019年3月31日，於巴黎

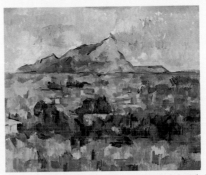

塞尚　聖維克多山 Cézanne, Mont Sainte-Victoire
油彩畫布 Oil on Canvas　65×81cm　1904-1906
蘇黎世比爾勒基金會藏 FondationE.G.Bührle, Zurich

The Everlasting Green Garden

Joseph Cui
Curator and Art Critic

From ancient Greece to the Renaissance to Impressionism, painting has been dominated by the imitation of the objective world (Mimesis). Cézanne, however, was not satisfied with the Impressionism's composition and structure of color. Rather, Cézanne was concerned with how he felt about nature when he was holding the brush. Merleau-Ponty often mentioned Cézanne's painting experience in his theory of the phenomenology of perception; in his treatise Eye and Mind, he said that art, especially painting, draws nourishment from the earliest sources and naturally arid meaning.... Indeed, art and painting are the only ones that do this innocently.

The spirit of this "innocent act" mentioned by Merleau-Ponty is the core idea of the Nabis in the search for spiritual transcendence. They hoped to observe the changes in the heart through observations of nature and life and expressed them from a planular view and relatively simple colors. This method of flat coloring originated from the popular Japanese color prints and the medieval European church glass paintings, which had a strong decorative effect. In terms of spirituality, the Nabis' quest for introspection through painting is also aligned with what the Western world considers to be Eastern philosophical thought. After discovering the paintings of Gauguin and the Nabis, Rousseau even more resolutely turned away from the idea of realism that the academics insisted on at that time, in order to pursue the artist's own perceptions and feelings and the freedom of expression in painting. Because of such attitudes, Rousseau is regarded as the founder of Naïve Art.

Baudelaire's romantic modernity is based on "éphémère et éternel", which holds that only by grasping the "present" can one capture the spirit of beauty and romanticism. To use contemporary methods to reproduce traditional culture is to pull history into the present. His idea of "present" is the first or most immediate feeling, even to the exclusion of any rational intuition. This feeling is often expressed in a contradictory way, such as an instant and the eternal. This coincides with the teacher Mao Xuhui's feelings about Ma Dan's works: "I think that Ma Dan has always been insisting on one thing, that is, to face nature, and to face a very clean and pure world. This may also be the most original utopia in our mind. I think this kind of insistence is very focused. The works are produced in a certain reality, and her reality is very different from our reality... ". When facing nature, Ma Dan still adheres to an inner world.

If Mao Xuhui said that Ma Dan's paintings "originate from reality, but they are very different from reality", it

盧梭 Henri Rousseau　瀑布 La Cascade
油彩畫布 Oil on Canvas　116.2×150.2cm　1910
美國芝加哥藝術協會藏 Chicago, the Art Institute of Chacago

is precisely because after Ma Dan had accepted the academic training on geometric perspective taught in art education in China, she nevertheless has always been like one of the Nabis in turning away from reality and depicting instead what is in her heart. Ma Dan has always existed in the tension created by the conflict between realistic painting techniques and the desire to freely express herself through painting. Just as the small world in which she lives is green, with blue sky and white clouds; at the same time, but what are seen on the internet and in the media are pollution and disease. Ma Dan does not depict in her paintings all the information that she sees and hears; instead she employs decorative painting methods to tell us how she feels about this world. The simple and beautiful feeling in the painting is exactly what she has to say about this life, and also her strength to face adversity. Perhaps the girl's back that often appears in the paintings may not be an escape from reality, but is to guide the audience into her world, to experience her heart's perception of life, and her obsession with beauty.

This perception of nature and life is inextricably linked to Ma Dan's growth and life experiences in Yunnan. The memory of the hillside in her childhood has been built into a mysterious green flower garden in her heart. Ma Dan traverses between real life and a mysterious introspective world; and what she has absorbed of the mountains and rivers, flowers, trees and customs of Yunnan is gathered in her works. Ma Dan is constantly expanding her spiritual garden. The real world is constantly changing. Through painting, Ma Dan allows every "present" to become eternal.

March 31 2019, Paris

2015-2010

作品 Artworks

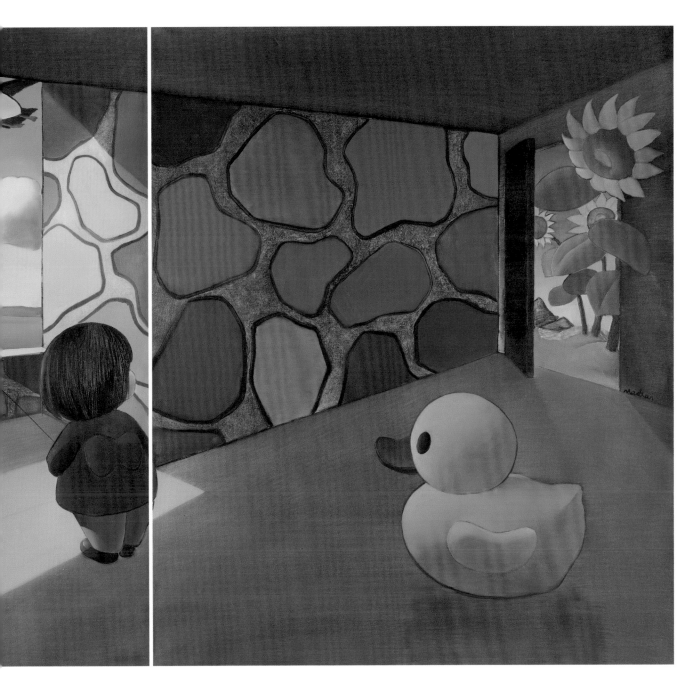

半夢3 Unfinished Dream No.3　布面油畫 Oil on Canvas　120×200cm（雙聯畫Diptych）　2015

有一種靜謐，只能聽到你想聽到的；有一種風景，只能看到你想看到的。

One kind of serenity is to hear only what you want to hear; one kind of scenery is to see only what you want to see.

Under the happy sunshine, you are intoxicated in summer's joy, even breathing is not easy, the sky seems to be indulged in your flowerbed, the breeze blows the tuff of your body. If the wind can blow away the sins and pains of my soul, then I shall become your brother and spend time with you. Hermann Hesse, Freude am Garten

伴6 Companion No.6　布面油畫 Oil on Canvas　100×125cm　2015

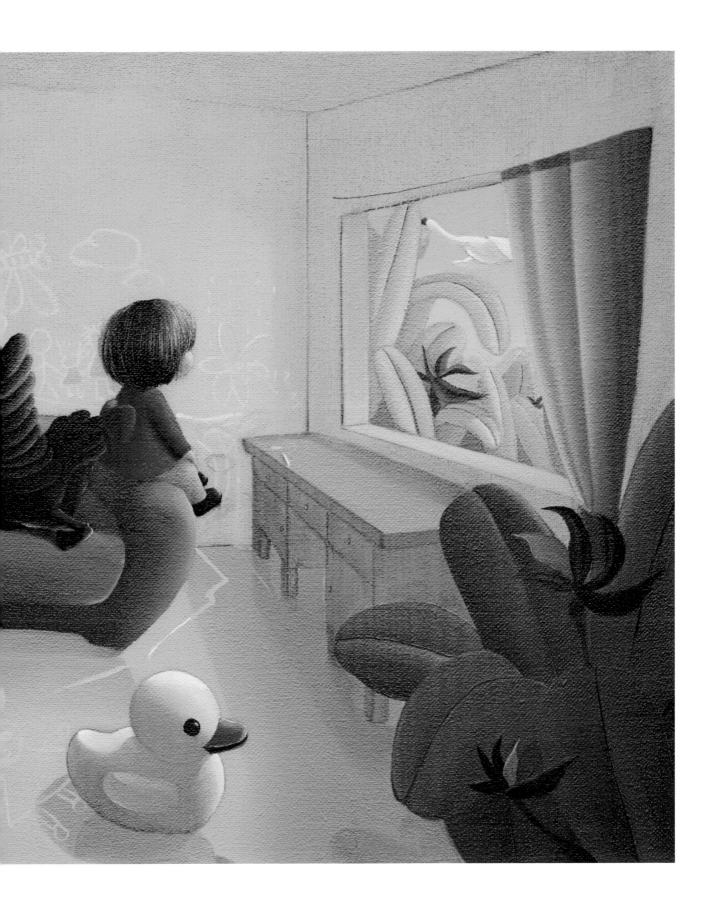

有些冥想將我們突然帶到歷史之外，哪怕是在短暫的一刻，而那一刻，無論是希冀還是懷舊，總是消極性的。美學享受就像吸管那樣，通過積極和愉悅的滿足，驅除意識中的虛無，將過去與將來濃縮在神奇的當今。（選自《圖像的生與死》【法】雷吉斯‧德布雷著）

Some meditations suddenly bring us outside of history, even if it is just for a short moment, and at that moment, whether it is hope or nostalgia, it is always negative. Aesthetic enjoyment is like a straw, expelling the emptiness of consciousness through positive and joyful satisfaction, and condensing the past and the future into a magical present. Régis Debray, *Vie et Mort de l'image*

半夢—撒尼寨 Unfinished Dream - Sani Village　布面油畫 Oil on Canvas　180×200cm　2015

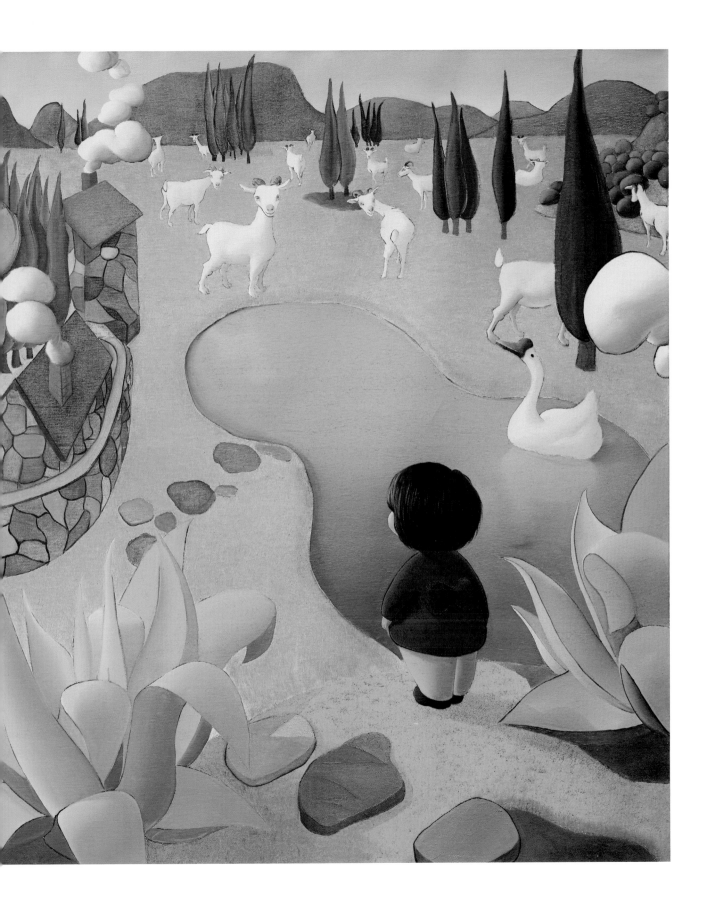

半夢—花開 Unfinished Dream - Blooming Flower
布面油畫 Oil on Canvas 165×200cm 2015

有些我們深信的感受或事物,在不斷的過往中被加強著它的附著力,並慢慢賦予其力量從而達到牢不可破的程度,比如面對父親遠去的背影,我總是欲言又止;還比如身邊的葉子花鳥,我總是覺得它們一天比一天碩大,大到可以撐起我的孤獨和所有幻想。無法判斷這些感受或事物對於成長中的我是好是壞,無可否認,它們已生根發芽。

The perceptions and things we deeply believe in are continuously strengthened and gradually become unbreakable. For example, my tongue is tangled when I face the disappearing silhouette of my father. Another example, I feel that the birds and flowers by my side are growing bigger daily, to the point where they are big enough to contain all my loneliness and fantasies. I cannot distinguish whether these feelings and things are good or bad for me as I was growing up, but they have undeniably germinated and taken root in my mind.

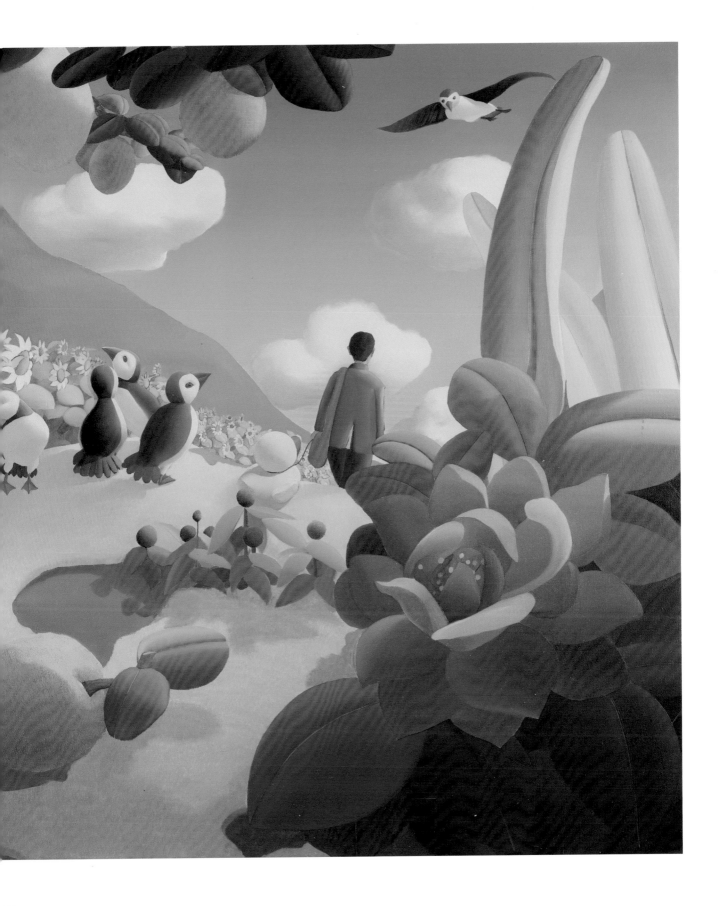

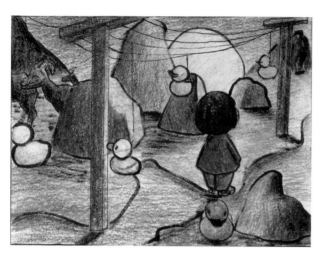

夜歸 Return Late　布面油畫 Oil on Canvas　155×200cm　2015

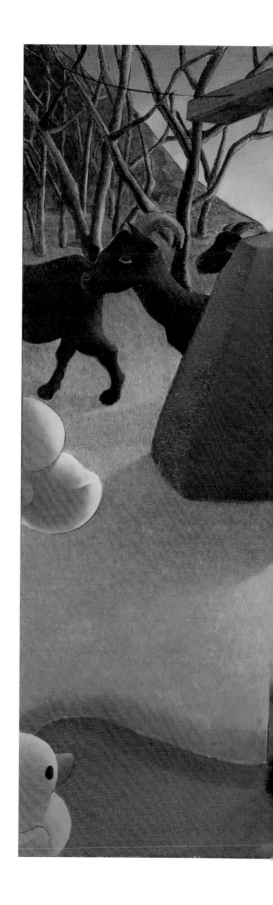

在那裏，沒有邊界，但存在著軌道，出走和回歸都有跡可循。
我靜靜的分辨著那些明裏暗裏的路，自己卻迷了路。

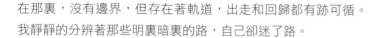

Over there, there are no boundaries, but paths do exist; the exit
and return are traceable. I distinguish in silence between the
obscure and obvious paths, but I got lost.

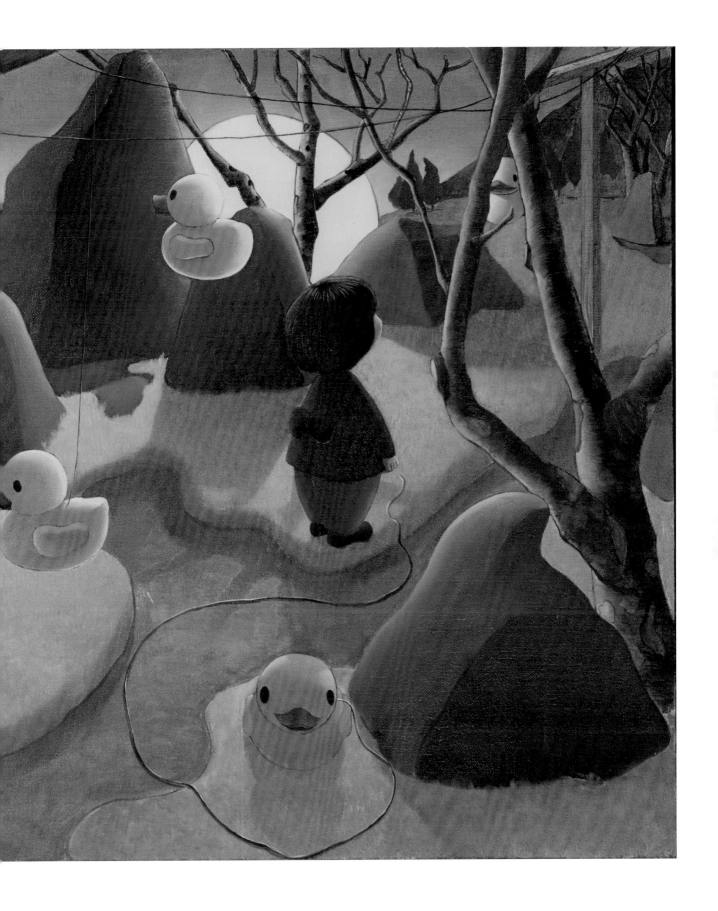

通往內心之路並不受限於某個特定的年份，它們是所有擺脫不了之情愫的交集與發酵。

The path toward one's inner self is not confined to a certain age. They are the intensification and accumulation of sentiments which we never got rid of.

對話 3 Dialogue No.3　布面油畫 Oil on Canvas　55×46cm　2015

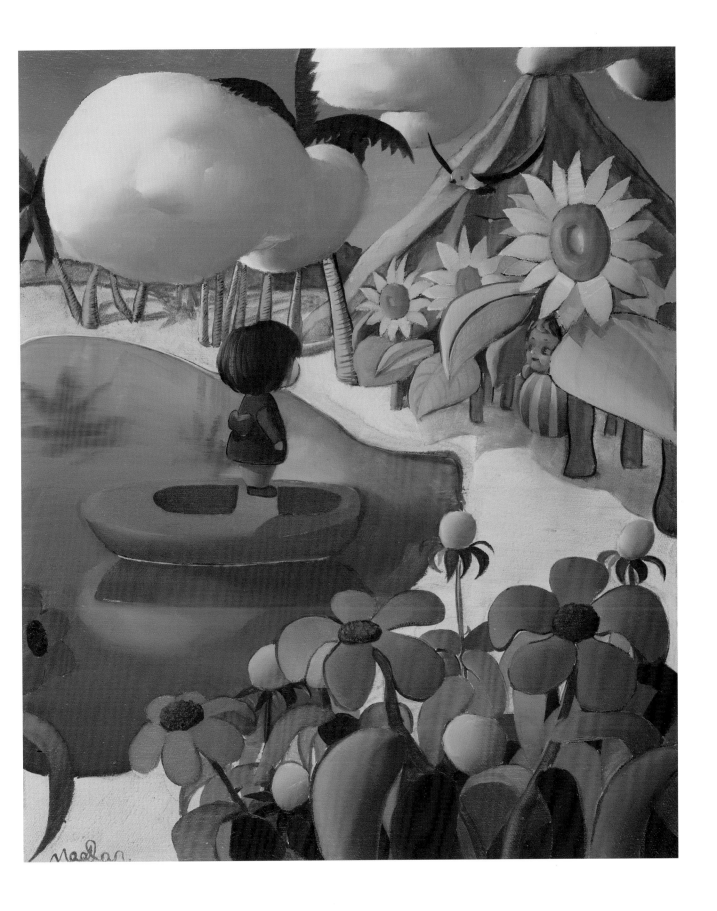

我們所經歷的生活和我們敘述的生活，永遠隔著一面牆或是一扇窗，也許你永遠看不清牆那邊的自己；也可能，你打開窗戶時，另外一面的「你」已經被定格。

What we had experienced in life and the life we narrate are always divided by a wall or window; perhaps you might never be able to see clearly your other self behind the wall. It is also possible that when you open the window, a different form of you has already been fixed in place.

對話9 Dialogue No.9　布面油畫 Oil on Canvas　46×55cm　2015

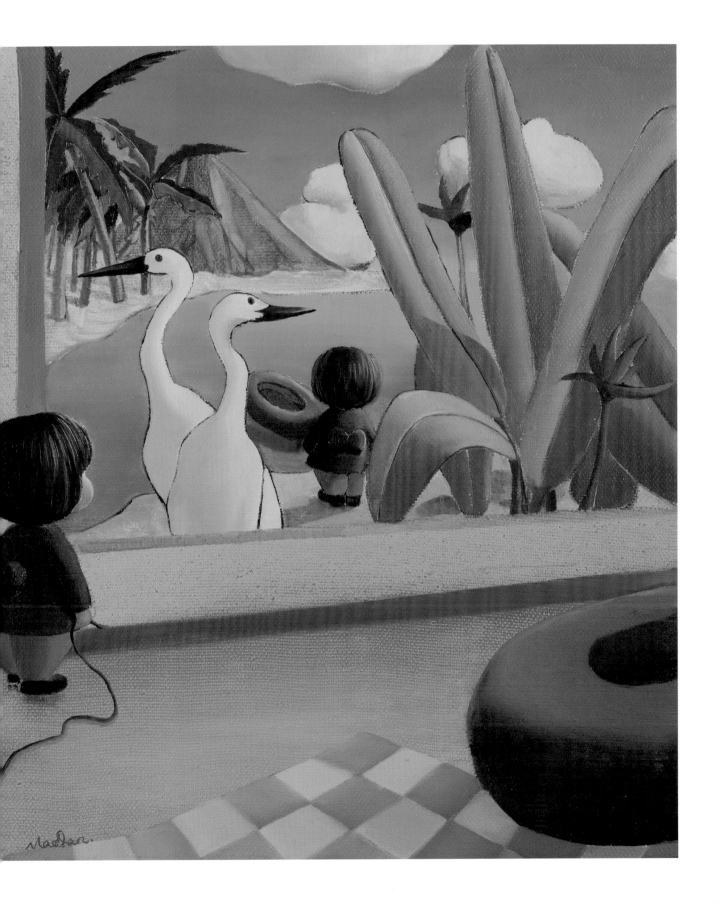

遇見高更先生 Encounter Mr. Gauguin
布面油畫 Oil on Canvas　120×100cm　2015

2015年3月的一天，當我站在〈早安！高更先生〉這幅畫面前時，高更的傲慢、拒絕、孤寂突然襲面而來，那一刻我的腳底彷彿踩了強力膠，動彈不得。定定的，我恍惚中將自己替換了畫裏那個匆忙而落寞的中年婦女，想要更近地窺探高更斜視的眼神裏的內容，最終，依然模糊不清，隱隱覺得，不止是愛或恨，自由或牽絆，月亮或六便士。

One day in March, 2015, as I was standing before the work Morning, Mr. Gauguin, the pride, rejection, and loneliness of Gauguin suddenly washed over me. I was immobilized in that moment, as if the soles of my feet were spread with strong glue. Steadily, and in a trance, I substituted myself for the hurried and lonely middle aged women in the painting, wanting to peep at the reflection in Gauguin's eyes. Finally, still foggy, faintly I could feel more than love or hatred, freedom or confinement.

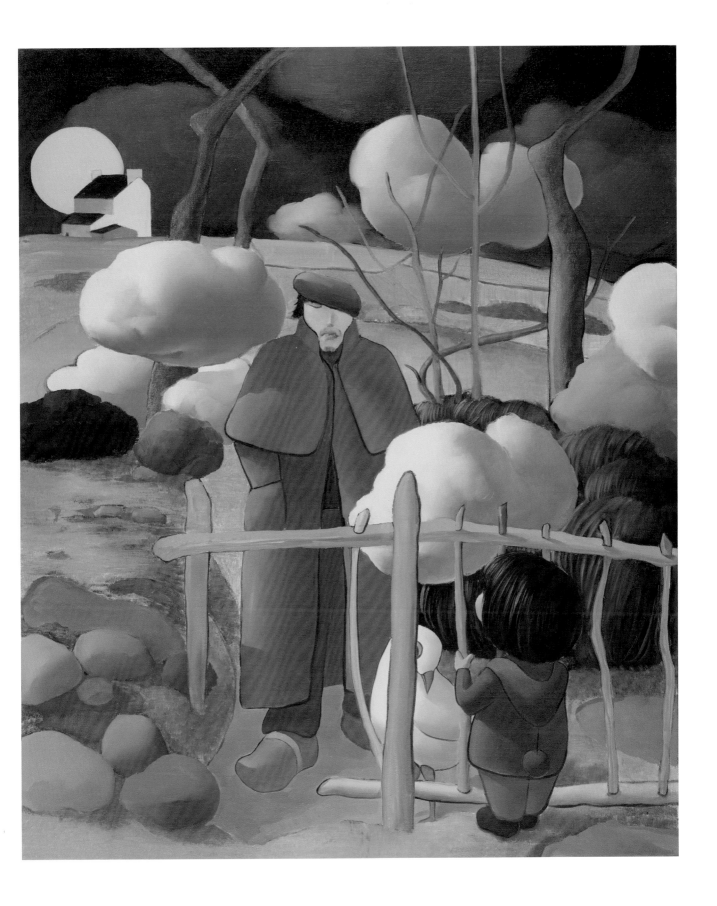

「在幸福的陽光下，你陶醉於，夏日的歡樂，連呼吸都不易，天空似在你的花萼中沉迷，微風吹拂你周身的絨絮。倘若風能將我靈魂的罪孽與痛苦，全部吹得不見踪影，那我就可以成為你的兄弟，與你共度平靜的光陰。」（選自《園圃之樂》〔德〕赫爾曼‧黑塞）

Under the happy sunshine, you are intoxicated in summer's joy, even breathing is not easy. The sky seems to be indulged in your flowerbed, and the breeze blows through the tuff of your body. If the wind can blow away the sins and pains of my soul, then I shall become your brother and spend time with you. – Hermann Hesse, *Freude am Garten*

無憂 Carefree　布面油畫 Oil on Canvas　90×130cm　2015

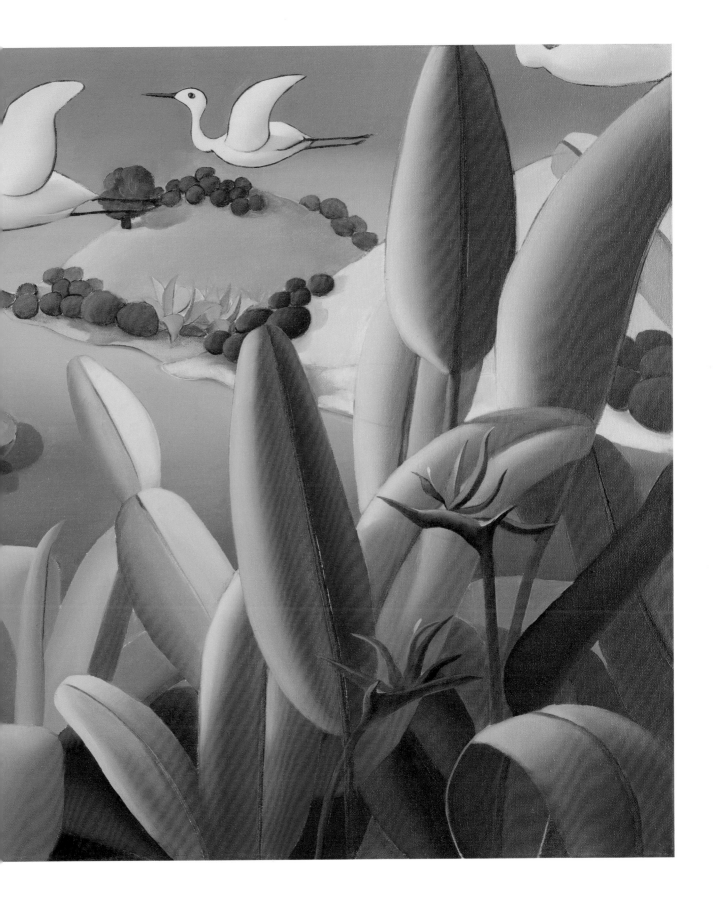

核桃林之約2 Date in Walnut Grove N0.2
布面油畫 Oil on Canvas 155×200cm 2015

屹立於陽光下的樹木、風化的石頭、一頭野獸、一座山等，都
有它們的生命，也有它們的歷史，它們各自生存，有痛苦，有
逆境，也有快樂，然後逐漸死亡。然而，我們幾乎沒有了瞭解
它們的力量。——赫爾曼‧黑塞《彼得‧卡門》

A tree bathed in sunlight, a weathered stone, a wild animal,
a mountain, etc., each has its own life and its own history.
Each exists on its own, and there is pain and suffering, there is
adversity, and there is also joy, and it eventually dies – but we do
not understand its strength. – Hermann Hesse, *Peter Camenzind*

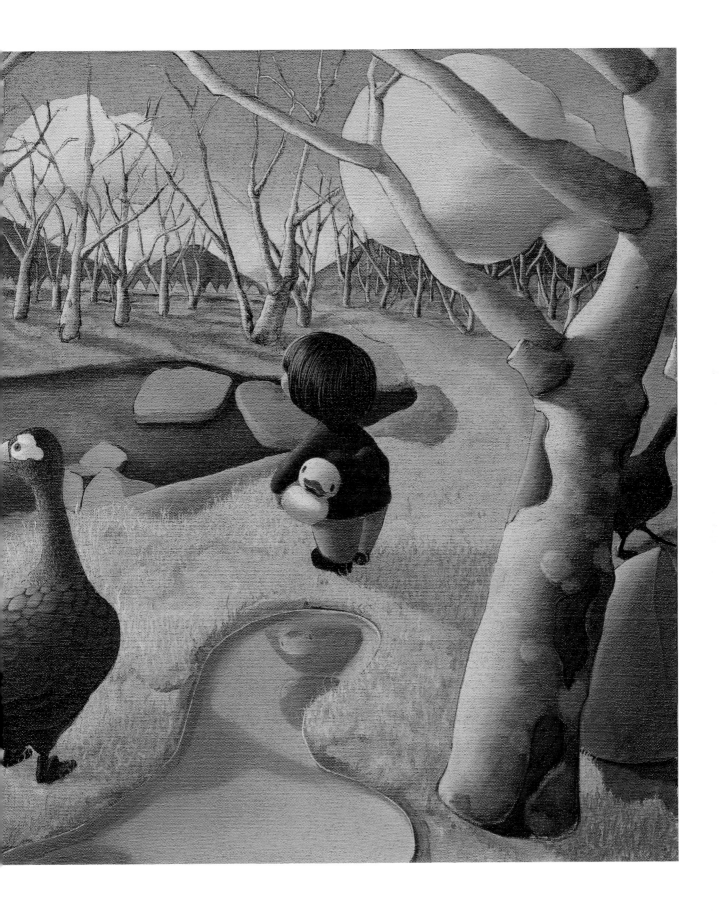

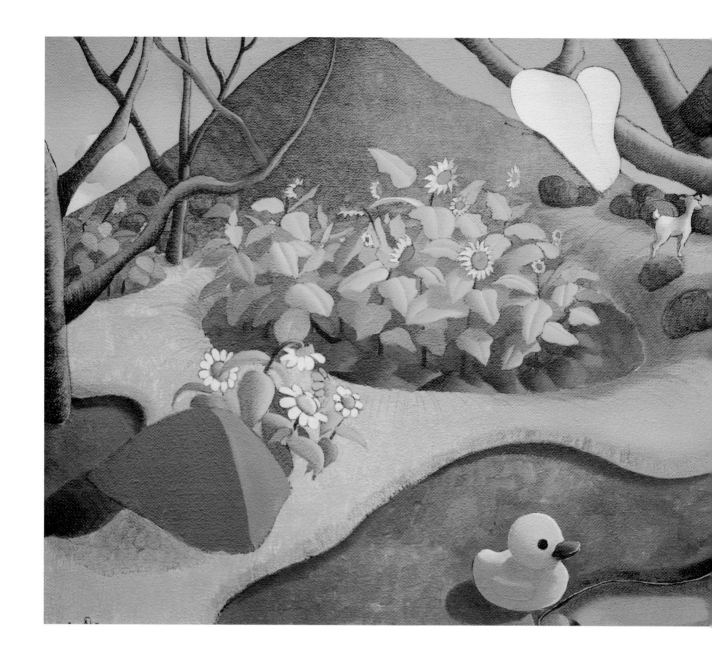

蝴蝶們開始翩翩起舞，亮晶晶，一閃一閃，像微風、像溪水，更像幸福，一閃而過，
忽而片刻停留。

Butterflies start dancing, shimmering and flashing, like a breeze, like a brook, but even
more like happiness that flashed by and stopped briefly.

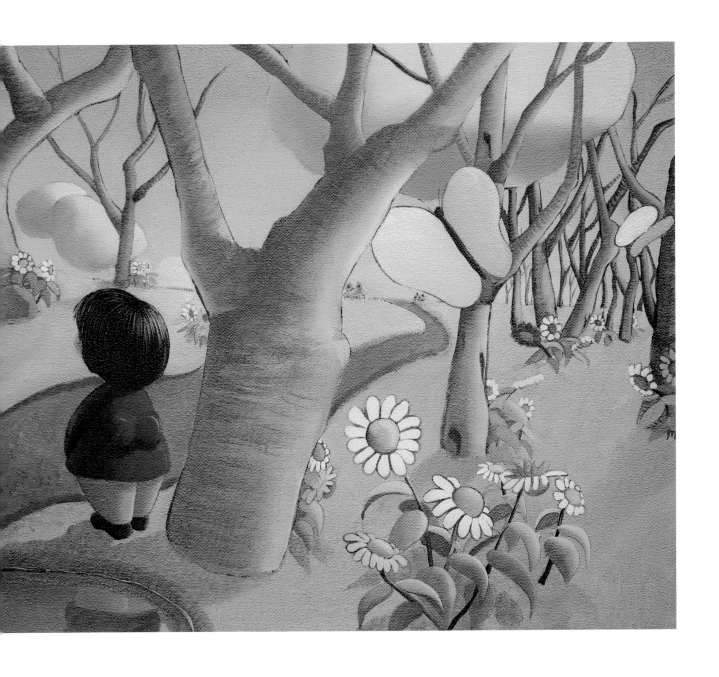

核桃林之約3 Date in Walnut Grove No.3
布面油畫 Oil on Canvas
100×250cm（雙聯畫Diptych） 2015

心靈處在本性的中心，越過了人們的意志……對我們每個人都會有指引，謙遜的聽，我們就能聽到正確的詞語……對於你，有一處現實，一處愜意的處所和一些合適的任務。把自己放在力量和智慧之溪中間，這條小溪給每個浮在水上的人以活力，毫不費力就將你推向真理，推向公正，推向完美的滿足狀態……

——拉爾夫·瓦爾多·愛默生

There is a soul at the center of nature, and over the will of every man…There is guidance for each of us, and by listening humbly we shall hear the right word…For you there is a reality, a fit place and suitable duties. Place yourself in the middle of the stream of power and wisdom which animates all whom it floats, and you are without effort impelled to truth, to right, and perfect contentment…. - Ralph Waldo Emerson

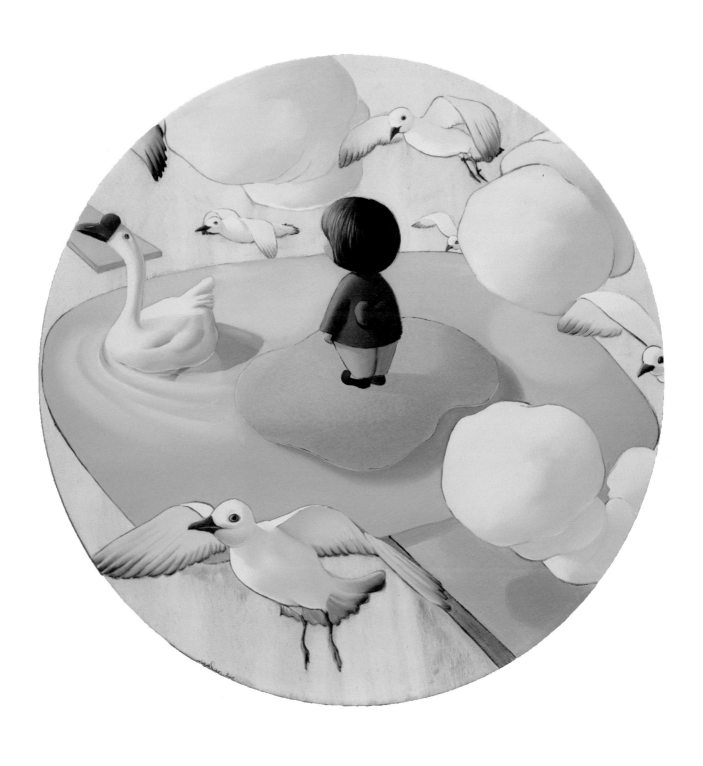

浮生1 Life Is a Dream as If a Dream No.1　布面油畫 Oil on Canvas　直徑D: 120cm　2015

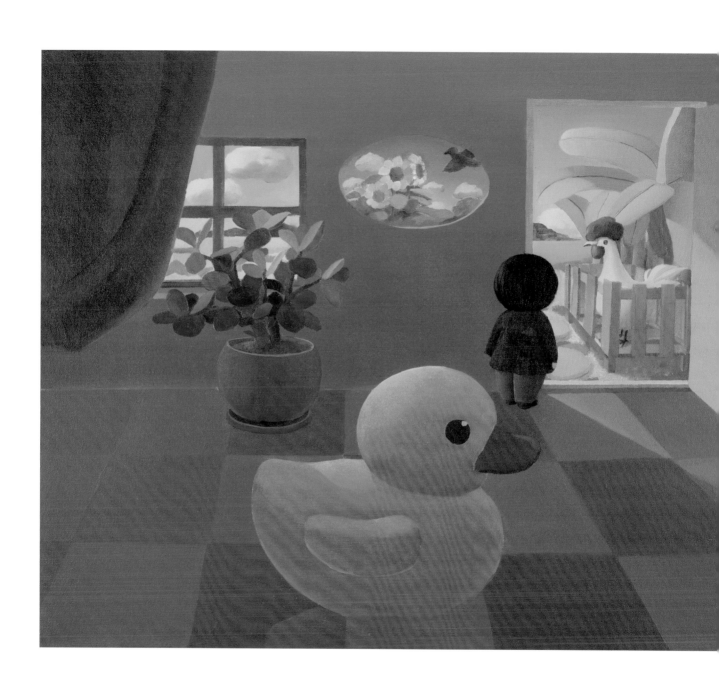

伴5 Companion No.5　布面油畫 Oil on Canvas　80×100cm　2014

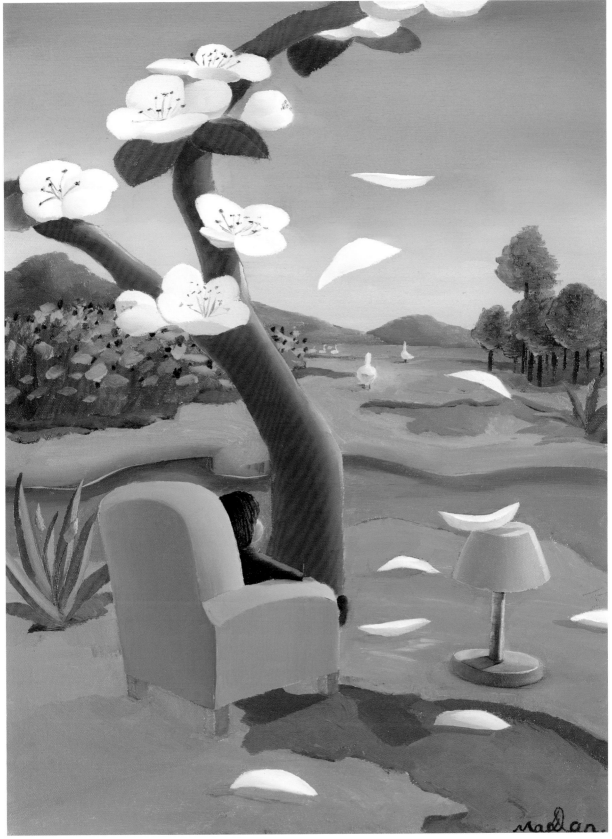

守望寂静1 Watch in Silence No.1　布面油畫 Oil on Canvas　80×60cm　2014

偶爾切斷思考，然後深深的沉浸在單純的直覺中，也許萬物皆在喘息、低語。

To withdraw from thinking, and then deeply immerse ourselves in pure intuition, perhaps all beings are gasping and whispering.

聽雲 Listen to the Clouds　布面油畫 Oil on Canvas　120×100cm　2014

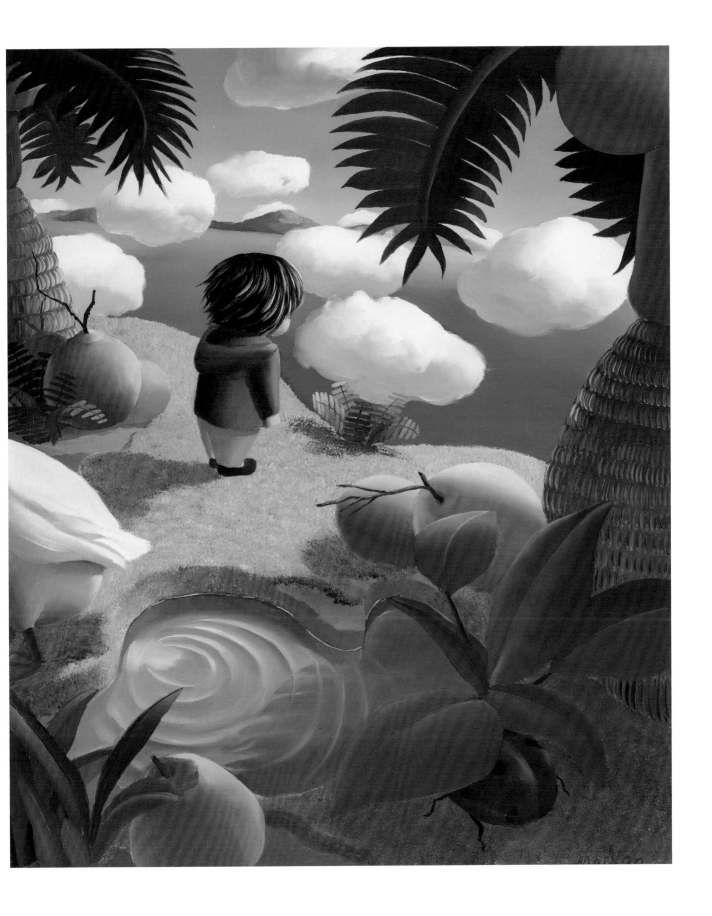

寂靜和平靜統治著一切，此刻，所有的事物都變得神秘、安詳，同時所有的事物都用柔和但卻質疑的眼光注視著我，我試圖找尋這注視的出處，意外發現，窗簾、樹葉、暗河、夜遊的大白鵝都有一個無法穿透的心靈……

Silence and calm ruled everything. At this moment, everything became mysterious and serene, and everything looked at me with a soft but questionable look. I tried to find the source of this gaze, and unexpectedly discovered that the curtains, leaves, the underground river, and the big white geese out at night all have an inseparable mind...

守望寂靜一夜 Watch in Silence - Night　布面油畫 Oil on Canvas　100×80cm　2014

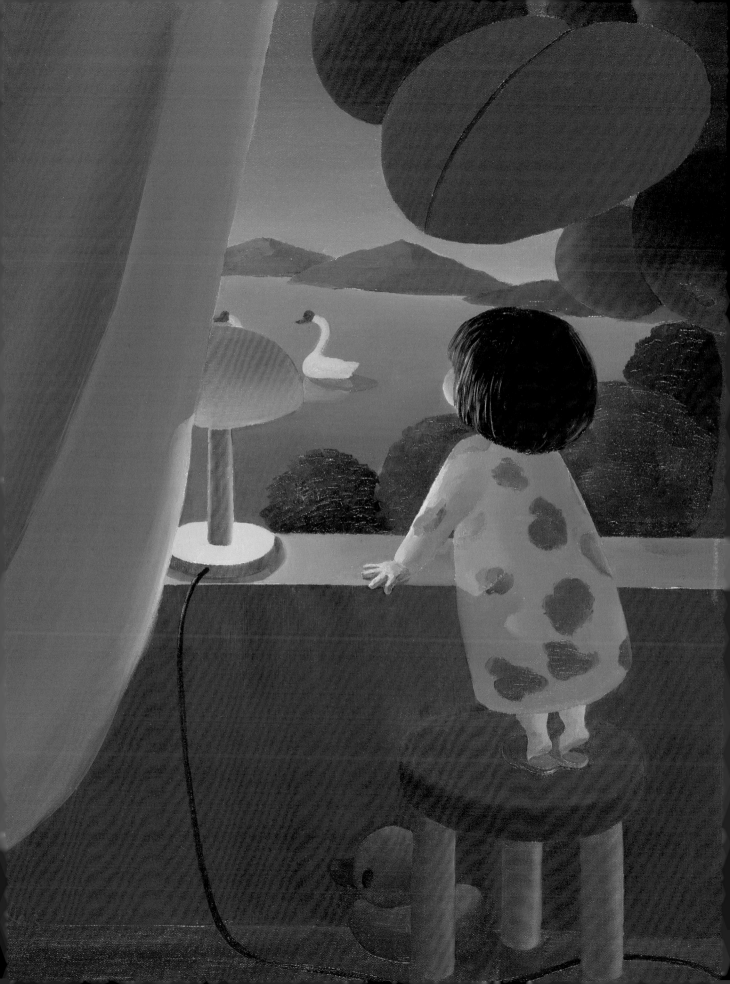

秋，總是溫文爾雅，不激烈，不遲鈍。她的優雅不時也會激起層層漣漪，想要快速定格、封存她，因為她滲透著春夏秋，我倉促而且貪心地想要打包帶走所有，並試圖不留痕跡。

Autumn is always gentle, and not intense or dull. Her elegance will frequently arouse layers of emotions, and I want to freeze her in place as quickly as possible, and to seal her up, because she permeates the other seasons. With haste and greed, I want to pack up and take away everything, and not leave behind any trace.

拾秋1 Harvest Autumn No.1　布面油畫 Oil on Canvas　80×100cm　2014

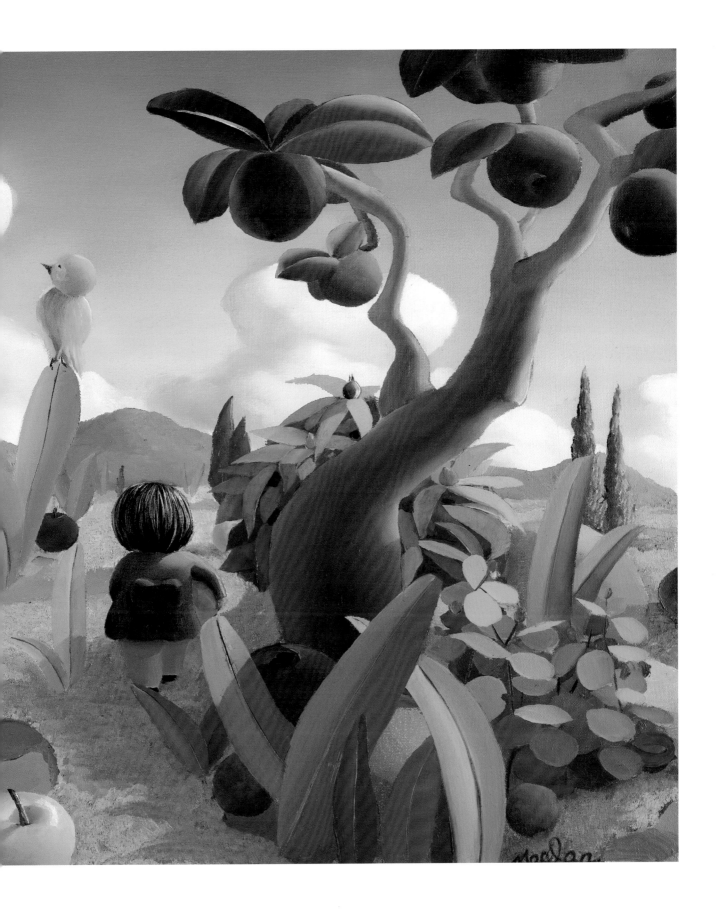

動植物是我們能與大自然直接對話的生命，儘管有些對話都是無稽之談，但是我試圖用我的方式與它們融入，至少我的存在不會顯得那麼突兀。

Animals and plants are living things through which we can have a direct dialogue with nature. Even if some of these dialogues may be nonsensical, I still try to use my own method to be one with them, so that at least my existence will not appear so incongruous.

暖丘—跟蹤 Warm Mound - Following　布面油畫 Oil on Canvas　130×160cm　2014

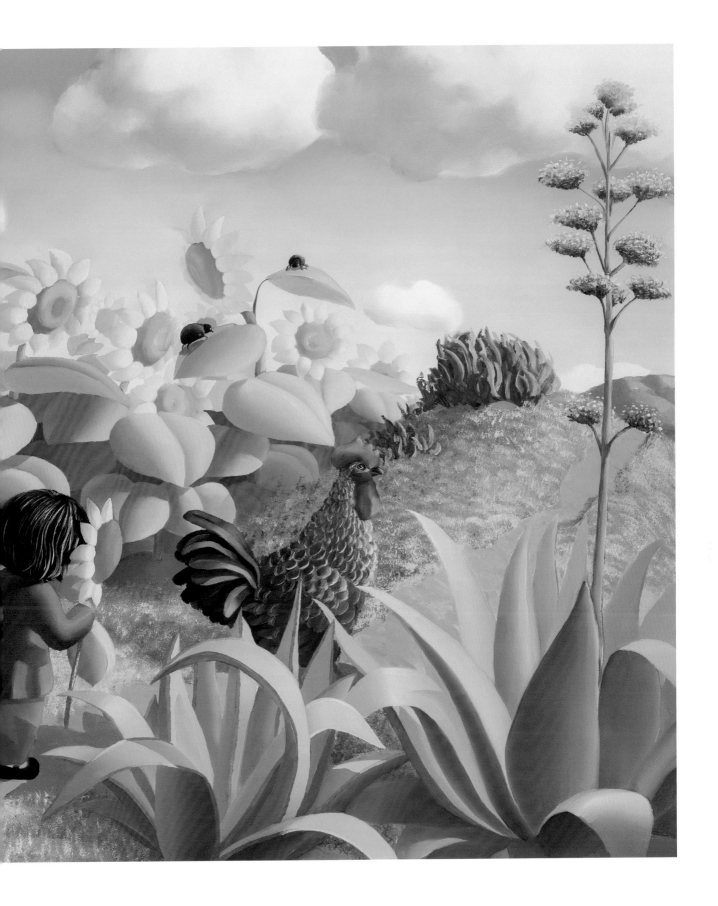

有些回憶，你越是想要逃離，卻越是走不出邊界，無論你走得有多遠，它甚至會更加清晰，使得你不得不回頭、再回頭。

There are certain memories for which the more you want to escape, the more you cannot go beyond their borders no matter how far you go; instead they will become even clearer, so that you are forced to look back continually.

河岸惑 Riverbank Confusion　布面油畫 Oil on Canvas　180×200cm　2014

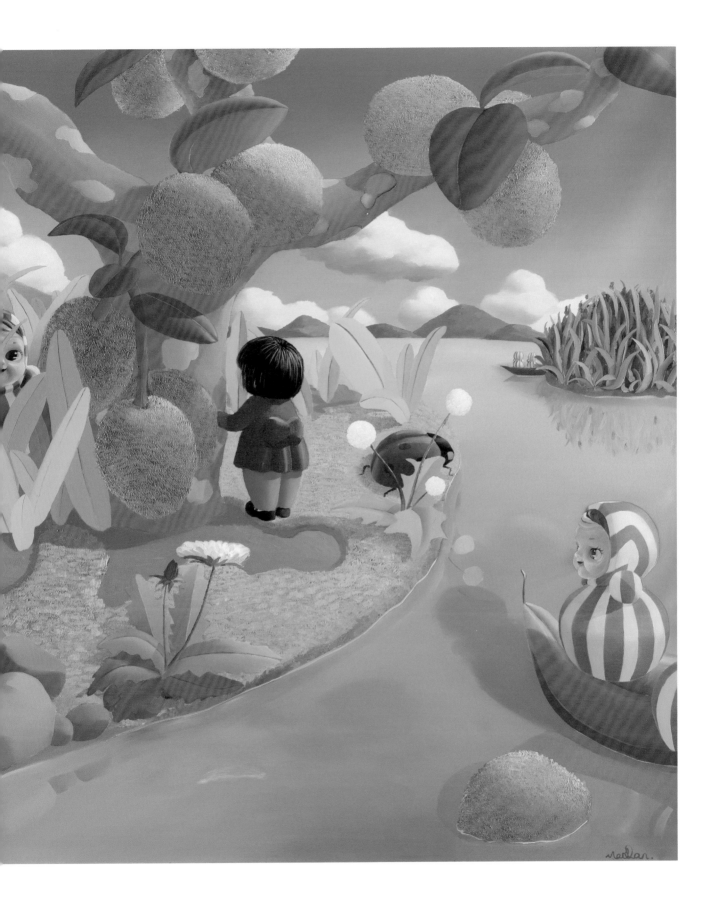

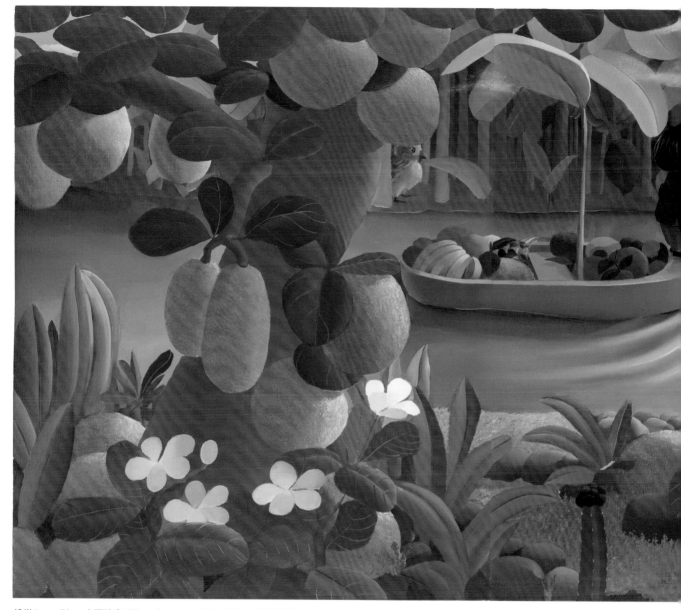

遠遊 Long Trip　布面油畫 Oil on Canvas　120×300cm（三聯畫Triptych）　2014

在壯麗的寧靜中，所有生命都成了永恆，平庸被擱在遙遠的天際，與我共存的只有幾近失真的神秘氣流。我喜歡在這樣的靜謐中追尋某些獨特的美。對美的熱愛是每個人內心具有的，只是在大多數人的體內被壓抑、窒悶、或遮遮掩掩，而我，選擇了用最質樸的心來放肆地感受與暢想。

In majestic tranquility, all life becomes eternal, mediocrity is relegated to the distant horizon, and there remains with me only almost distorted mysterious air currents. I like to search for some special beauty while I am in this kind of quietude. Each one of us loves beauty; it is just that in most people it is suppressed, suffocated, or simply concealed, whereas with me, I choose to enjoy it and imagine freely with the simplest heart.

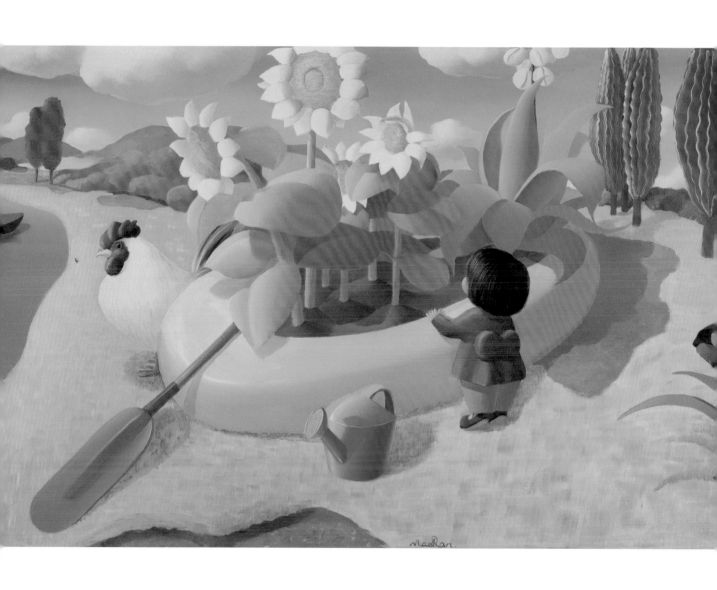

隨行 4 Accompanion No.4　布面油畫 Oil on Canvas　100×160cm　2014

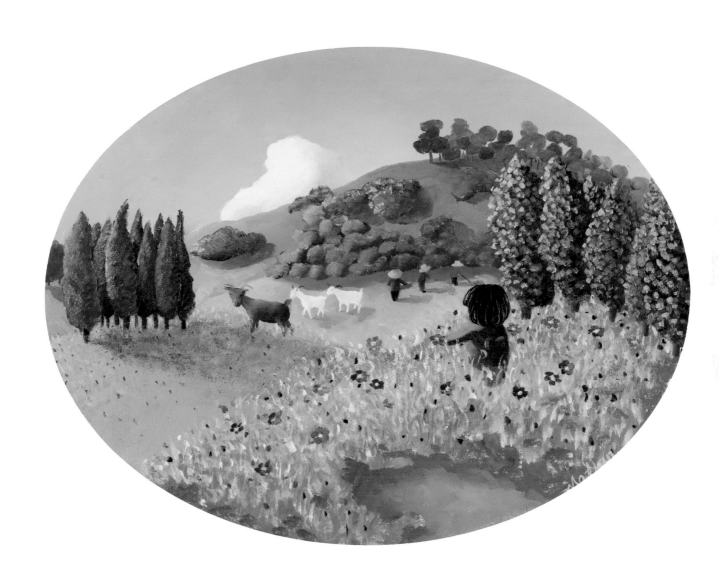

紅土・覓10 Red Soil・Searching No.10　布面油畫 Oil on Canvas　80×60cm　2014

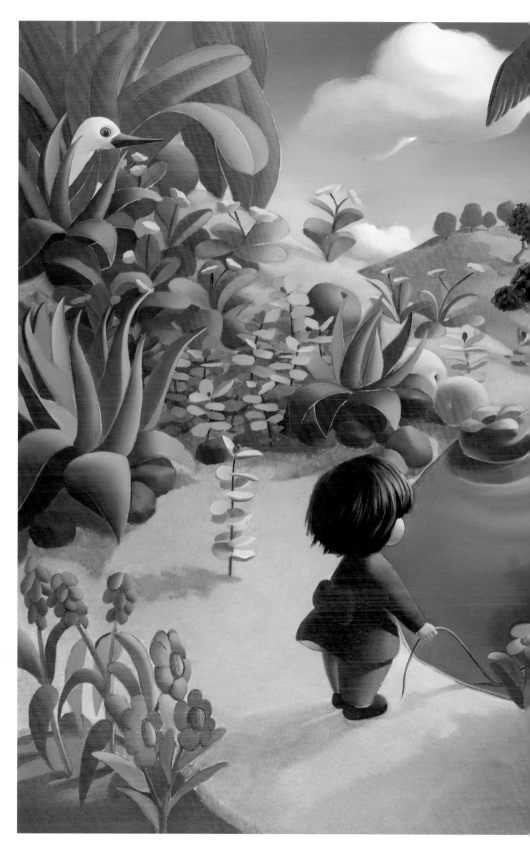

隨行5 Accompanion No.5
布面油畫 Oil on Canvas
160×260cm（雙聯畫Diptych）
2014

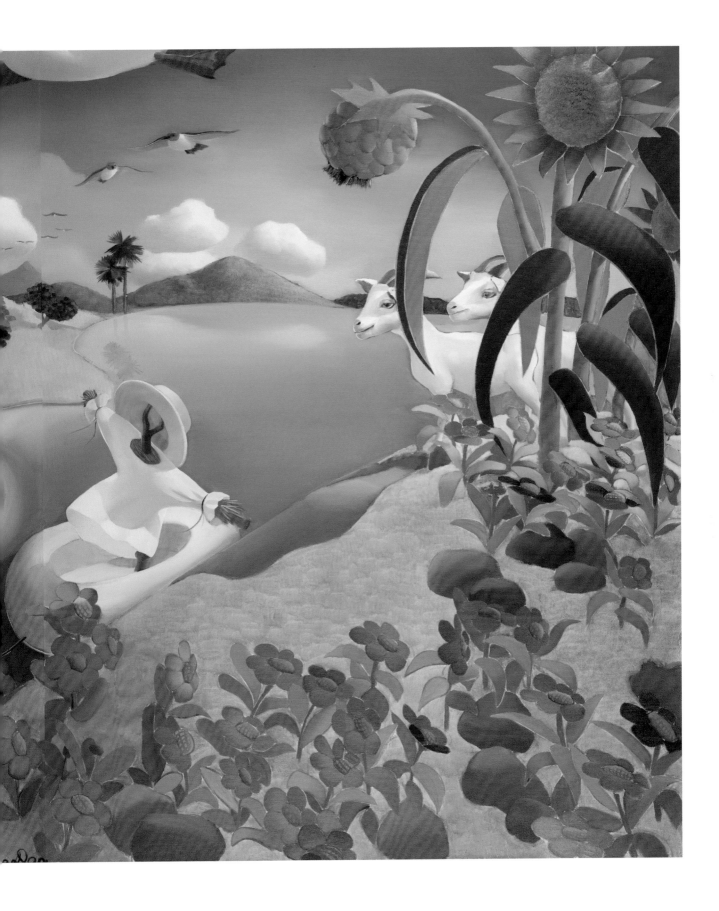

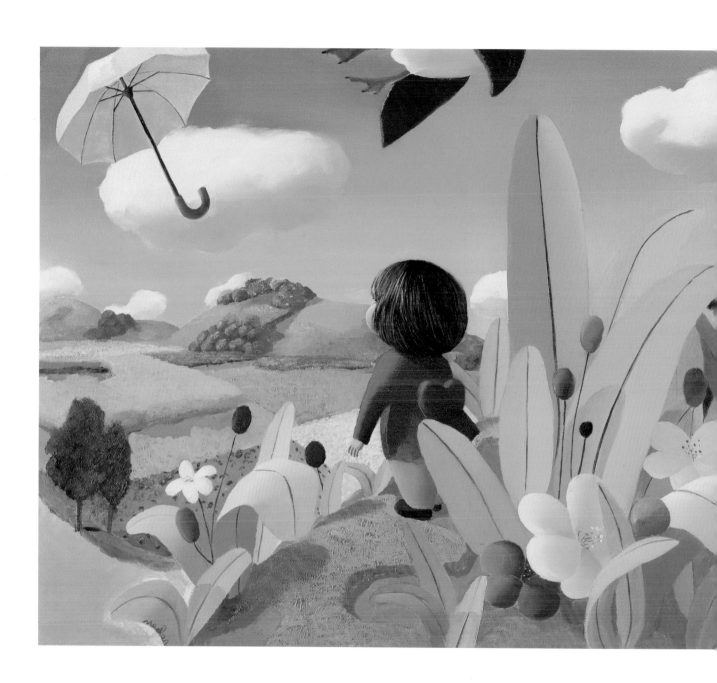

暖丘—隨風2 Warm Mound- Gone with the Wind No.2　布面油畫 Oil on Canvas　80×100cm　2014

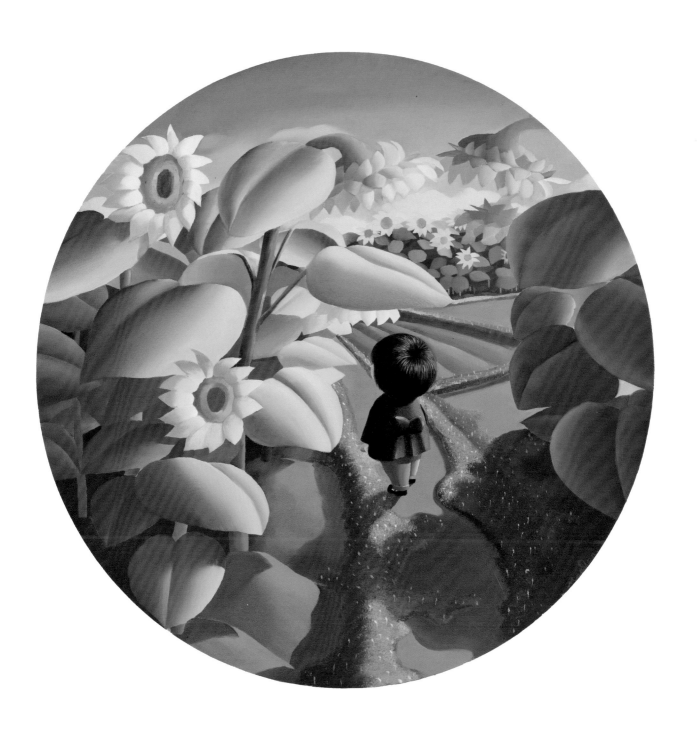

暖丘—聞 Warm Mound - Sniffing　布面油畫 Oil on Canvas　直徑D: 120cm　2013

小時候上學，總要經過一戶養鵝的人家，這是我的噩夢，因為我無數次被鵝「追殺」，它們壓低脖子，以迅雷不及掩耳之勢衝向背著大書包還跑不快的我，於是我無數次被鵝啄到，現在看到鵝群我還是很害怕。儘管被鵝群圍攻，但是我仍然很喜歡鵝，它們那種桀驁不馴的姿態，永遠高傲的伸著長長的脖子，總叫我有一種想要接近仔細看看它們眼神的衝動，於是，我只能在畫面裏實現，哪怕只是凝固的瞬間，它們旁若無我，而我可以感受鵝群裏那股看似緊張卻也很自在的暖流。

When going to school as a child, I would have to pass before a house where they raised geese. This was my nightmare, because the geese used to "run to kill" after me so many times. They would lower their necks, and rush like a bolt towards me who was burdened with a big satchel and could not run fast, and so I was very often pecked by them; to date when I see a flock of geese I will be scared. though Nevertheless, even if I am surrounded by geese, I still like them, with their arrogant and unyielding attitude, always stretching their long necks high; I am invariably filled with a desire to get nearer and observe the impulse in their gaze. But, I can only realize this on a canvas, even if it is just for a split second, they are near me but as if I was not there, and I can feel the warmth of their flock that looks tense but is actually very comfortable.

凝 Gazing　布面油畫 Oil on Canvas　125×100cm　2013

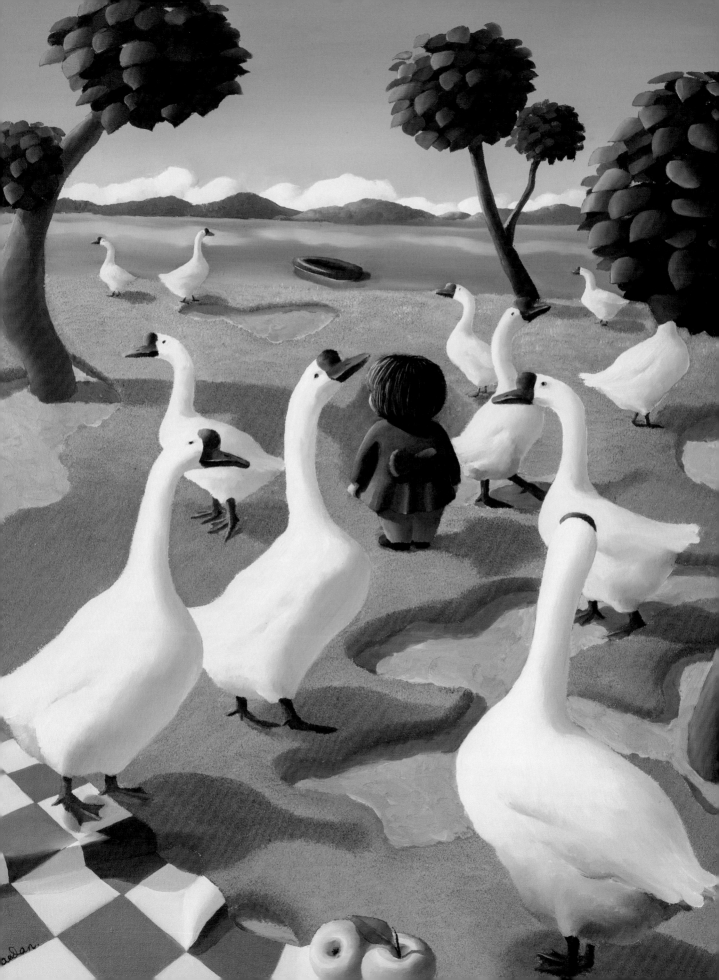

記不清那似夢裏還是童年的記憶裏，在滿是我不知名的植物中穿梭，游離，陽光隨意撒落在無際的大地上，快樂隨著空氣蔓延，一切都是那麼的順其自然。

I cannot remember if this is a dream or a memory from childhood. I am shuttling among plants whose names I do not know, and drifting away, while the sun is spreading its rays on the ground, and joy is as diffuse as the air. Everything is so in accordance with nature.

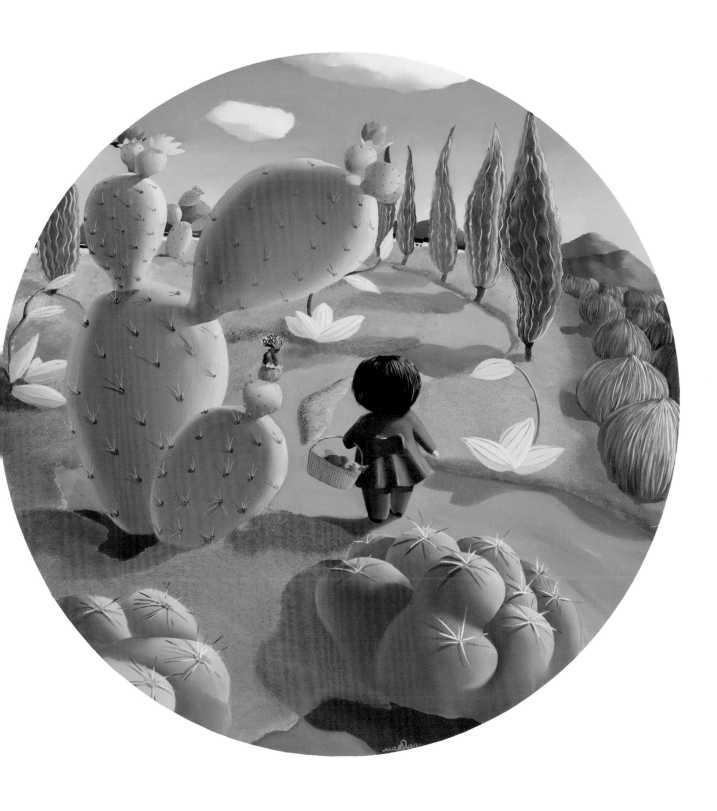

暖丘一回程2 Warm Mound - Way Home No.2　布面油畫 Oil on Canvas　直徑D:120cm　2013

那個我未曾得到的玩具，用它一貫的假笑陪我度過了無數個幽靜的夜，它或許未曾來過，不過好似聽到了它肚子裏的鈴鐺偶爾作響。正如弗蘭茲‧卡夫卡所説：你不必離開房間。坐在桌前聆聽。你甚至不必聆聽，只需等待，只需學會保持安靜、靜止和孤寂。世界會大方地揭開面紗給你看。它沒有其他選擇，只能在你腳下高興地滾動。

That toy that I never obtained, its fake smile helped me get through innumerable lonely quiet nights. Perhaps it never came over, but I still seem to have heard occasionally the tinkling of the bell in its belly. As Franz Kafka said: You do not need to leave your room. Remain sitting at your table and listen. You do not even have to listen, simply wait, be quiet, still and solitary. The world will freely offer itself to you to be unmasked. It has no choice but to roll in ecstasy at your feet."

伴1 Companion No.1　布面油畫 Oil on Canvas　110×150cm　2013

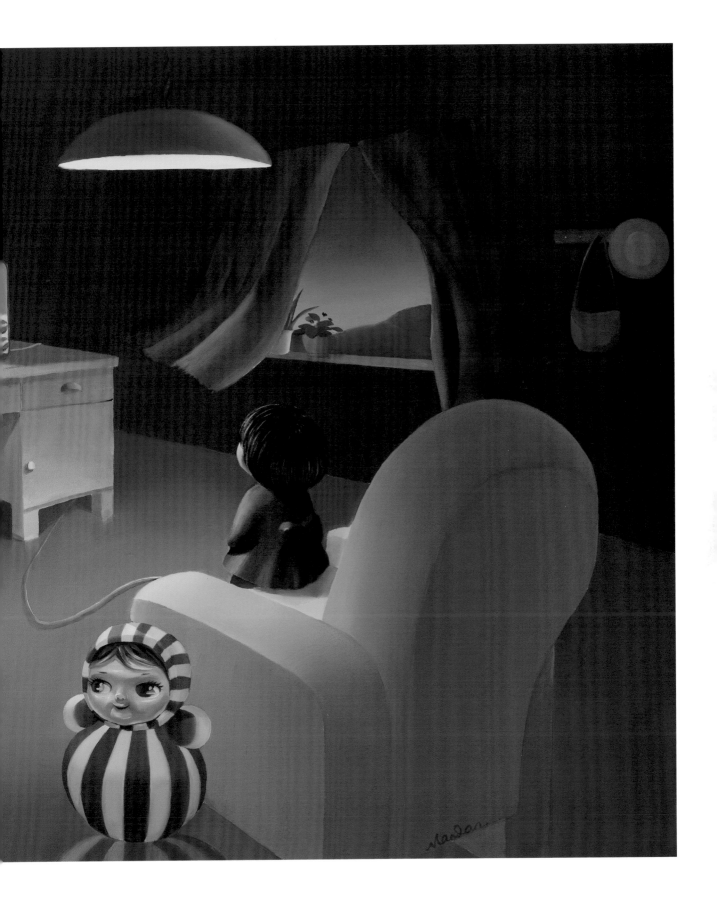

又是那個未到手的不倒翁，時刻縈繞身旁，有時它們被我藉以抵禦一個人的恐懼，因為夜太深太靜，動畫片的熱鬧還是避免不了小空間裏我無限被延伸的孤寂。

It is again the roly-poly dolls which I never obtained, hovering at my side. Sometimes I use them to counter a solitary person's fear, because the night is too deep and too quiet, and the liveliness of the cartoons cannot help me escape the infinite loneliness of the little room.

伴2 Companion No.2　布面油畫 Oil on Canvas　110×150cm　2013

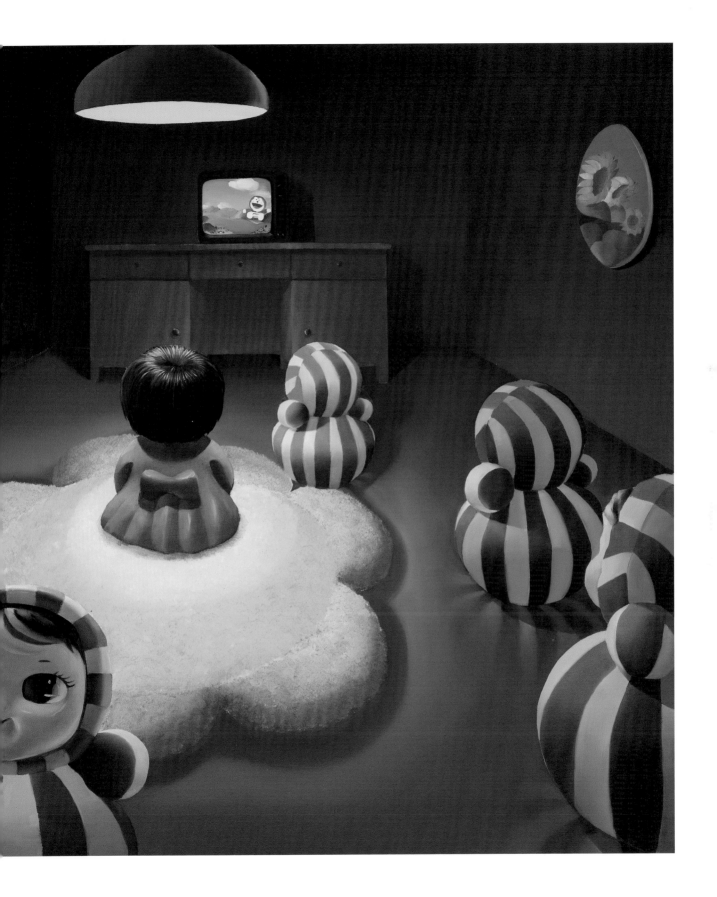

對於它們，好像已經有了某種並無安全感的依賴，我走不近它們，它們也走不近我，就這樣，我們互相依存，還好伴著一份無私的童真。艾德加·竇加曾說：如果當今藝術家想要嚴肅地為自己挖一小塊原始的壁龕，或是必須保持天真純潔的品質，他必須再次沉浸在孤獨中。

As for them, it seems that there is a kind of unsafe dependency; I cannot walk near them, and they cannot walk near me, and just like that, we depend mutually on each other, and they have accompanied me through a selfless childhood. Edgar Degas said: "It seems to me today that if the artist wishes to be serious – to carve out a little original niche for himself, or at least preserve his own innocence and pure personality – he must once more sink himself in solitude."

伴3 Companion No.3　布面油畫 Oil on Canvas　110×150cm　2013

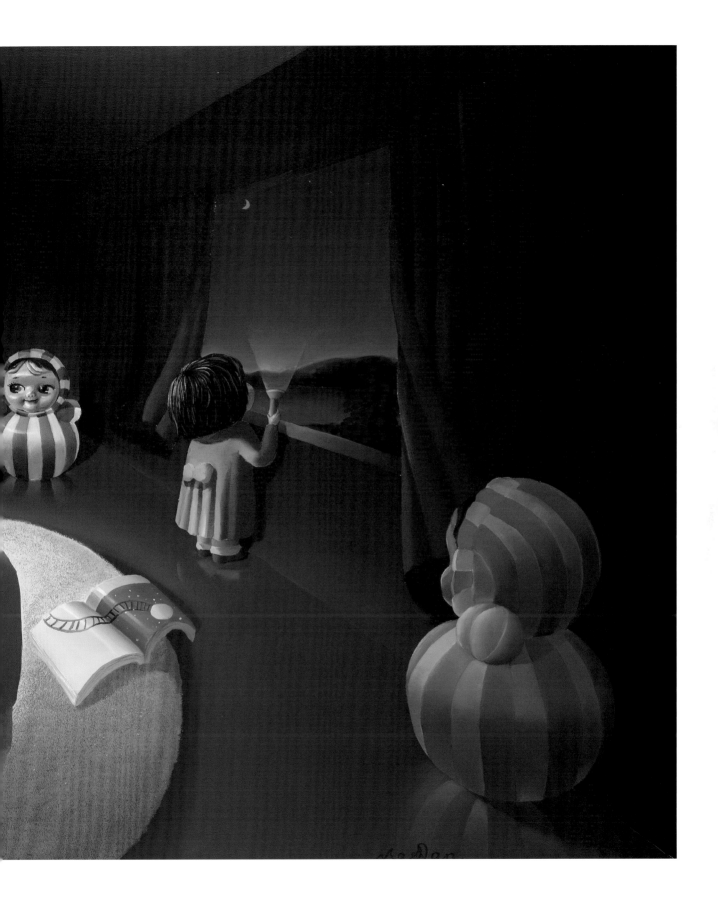

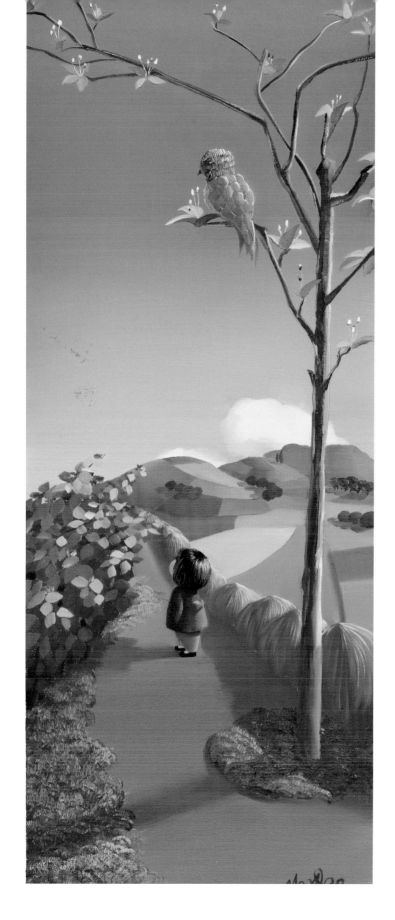

站在大自然裏，我始終只是個局外人，或許放空時的那麼一秒一刻，我貌似能和它們融為一體，相互傾聽，對話。

喚1 Call No.1　布面油畫 Oil on Canvas　100×40cm　2013

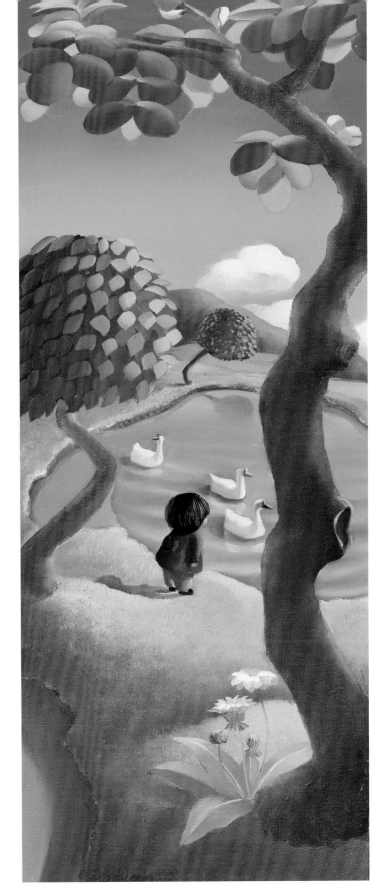

Standing amidst nature, I am just an outsider. Perhaps in that instant when I daydream, I seem to be able to be at one with nature, and we can lend an ear to each other and have a conversation.

喚2 Call No.2　布面油畫 Oil on Canvas　100×40cm　2013

很著迷俄羅斯方塊裏的絢麗體積，盯著某一處很久後，一不小心就
進入了它們的空間，於是生拉硬拽進來幾個伴，這樣也許容易找到
出口。

Fascinated by the gorgeous game Tetris, I can gaze at it for a long
time, and inadvertently enter their space. Pulling and dragging some
companions in as well, it will perhaps then be easier to find the way
out.

當時1 At the Moment No.1　布面油畫 Oil on Canvas　100×130cm　2013

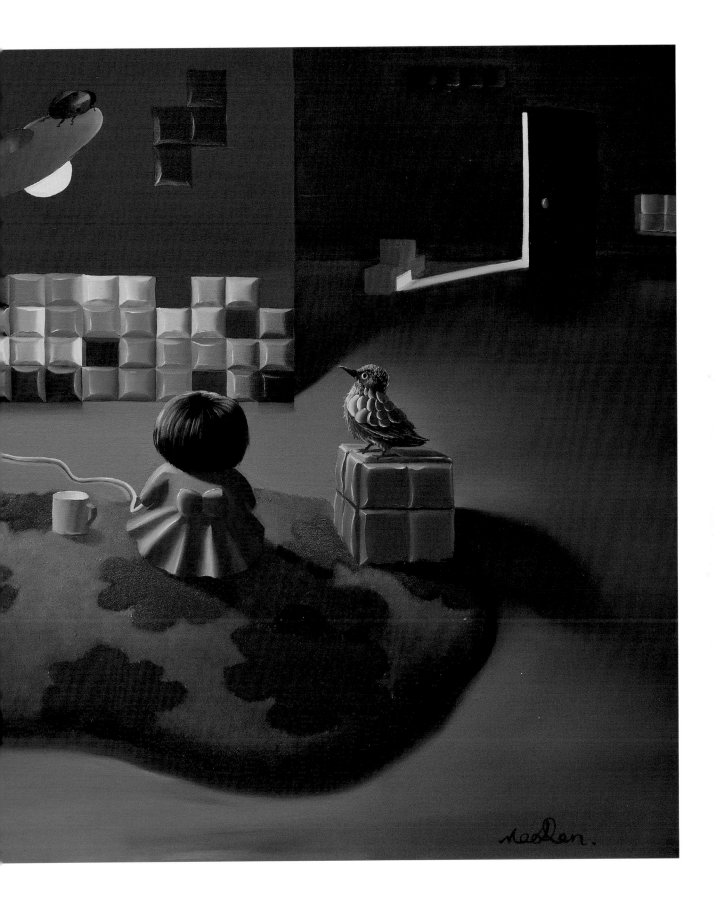

「顏色存在於自身，擁有自己的美。純潔的顏色⋯⋯不依附於它們要表達的事物，而是在內部產生重要的反應，影響那些看著顏色的人們的感覺。」——亨利・馬諦斯

Colors exist in themselves and have their own beauty. Pure colors… have in themselves, independently of the objects they serve to express, a significant influence on the feelings of those who look at them. - Henri Matisse

暖丘—午後 Warm Mound - Afternoon　布面油畫 Oil on Canvas　130×160cm　2013

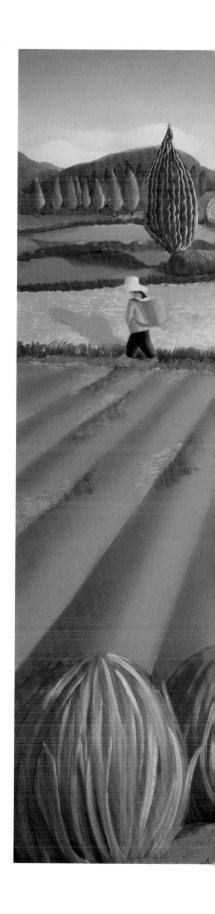

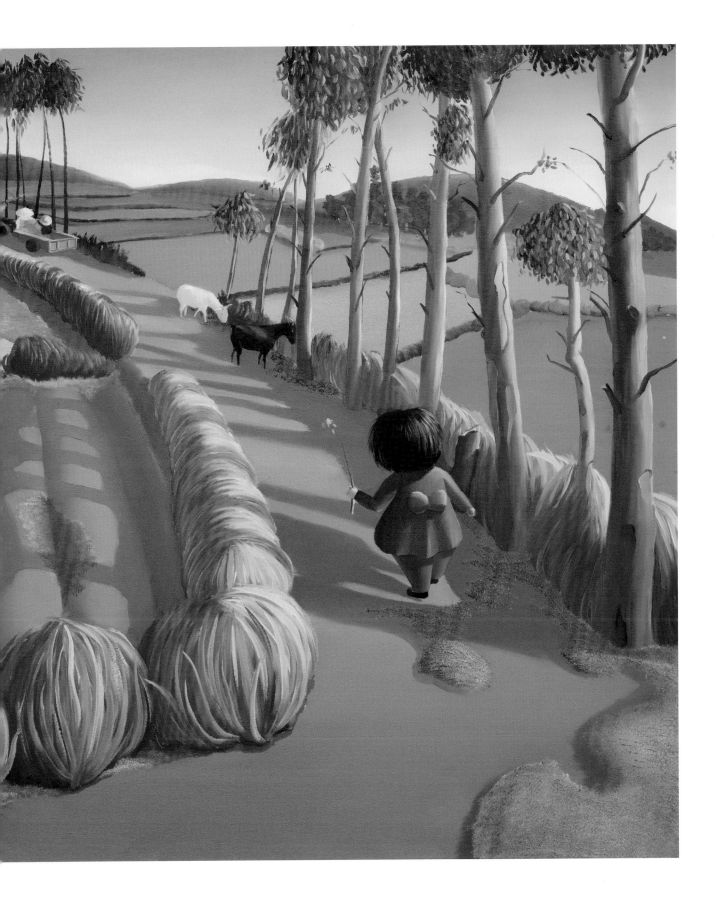

説不上來為什麼突然柿子樹出現於畫面，如同在即興哼唱一曲。她也悄然站在柿子樹下，獨享著孤寂後大自然賞賜的興奮與驚喜。

I cannot explain why a persimmon tree suddenly appear in the painting; it is like humming impromptu tune. She quietly stands behind the persimmon tree and enjoys alone the excitement and pleasant surprise offered by nature.

暖丘—摘 Warm Mound - Picking　布面油畫 Oil on Canvas　100×80cm　2013

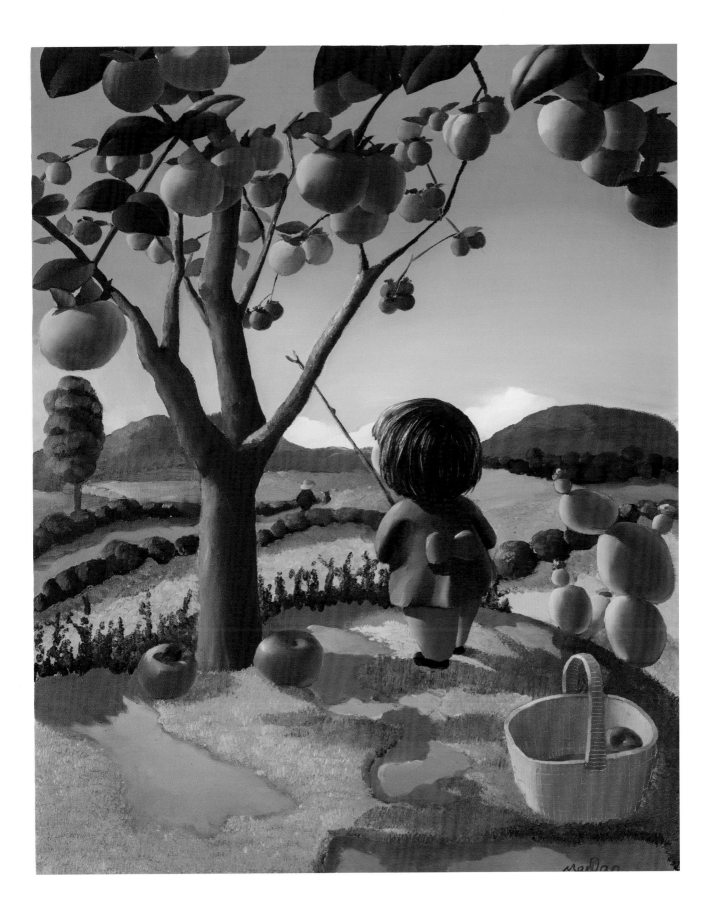

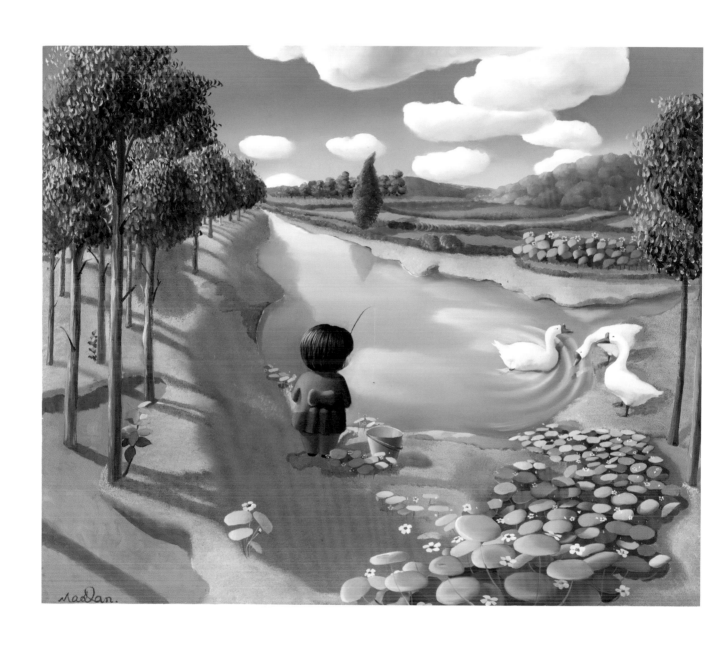

暖丘—釣 Warm Mound - Fishing　布面油畫 Oil on Canvas　130×160cm　2013

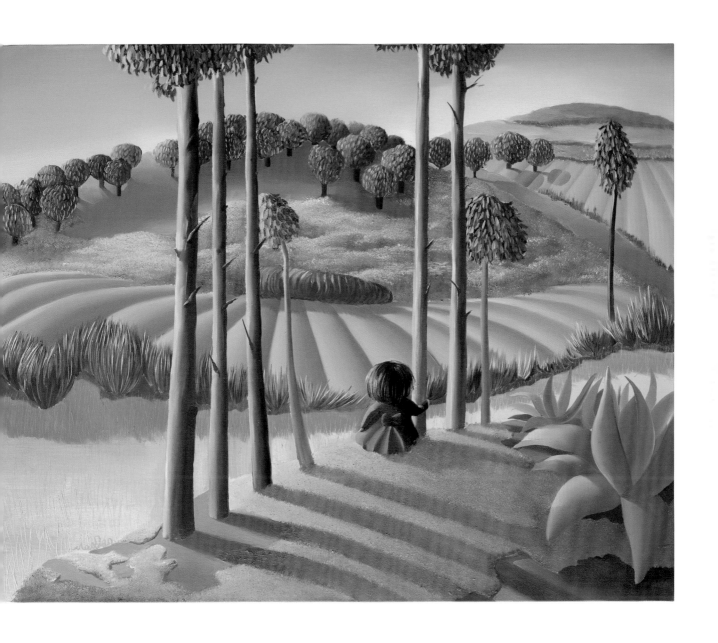

暖丘—停留 Warm Mound - Staying　布面油畫 Oil on Canvas　100×125cm　2013

總是很享受走在田間地裏，沐浴著大把大把落地有聲的陽光，眼前的每一塊顏色的搭配都是那麼和諧華麗，山羊們優雅的步履輕踏著鬆軟的紅土，用祥和的眼神掃視著路邊的青草，我試圖用我盡可能顧全的視角描述著陽光午後的暖丘，竭力拉近我與它們的距離，在釋放孤寂的同時尋求生命中的新維度。

I always enjoy walking in the fields, bathing in big swaths of noisy sunlight. All the colors before me are arrayed so harmoniously and so beautifully. The goats' elegant steps fall gently on the red earth, and they gaze peacefully at the grass along the road. I try to depict the afternoon mound in the sun with my widest visual sweep, sparing no effort to narrow the distance between them and me, and looking for a new dimension to life while breaking free from solitude.

暖丘—秋1 Warm Mound - Autumn No.1　布面油畫 Oil on Canvas　130×160cm　2013

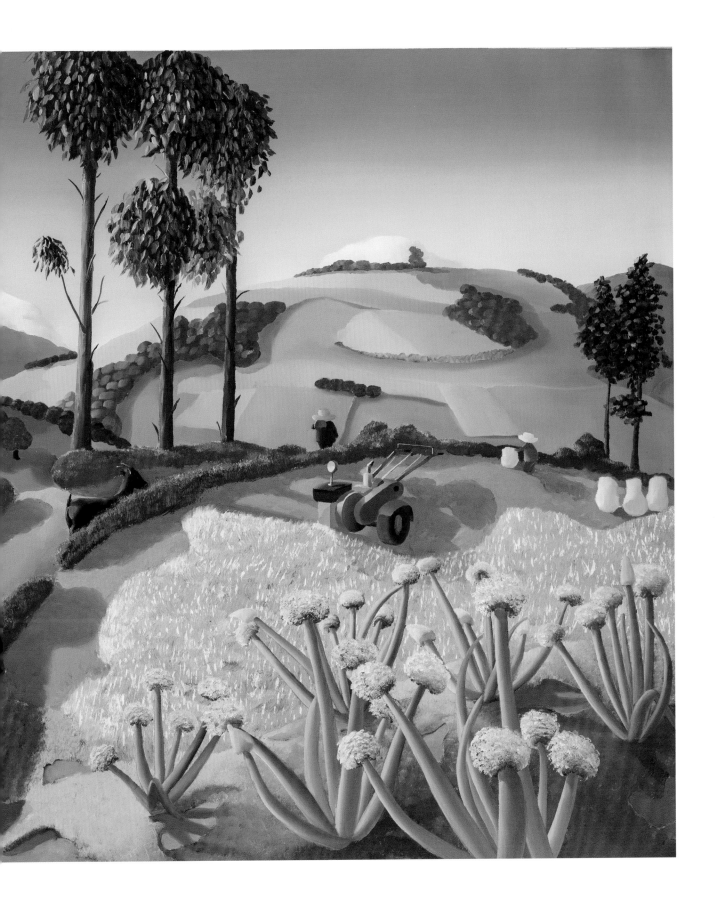

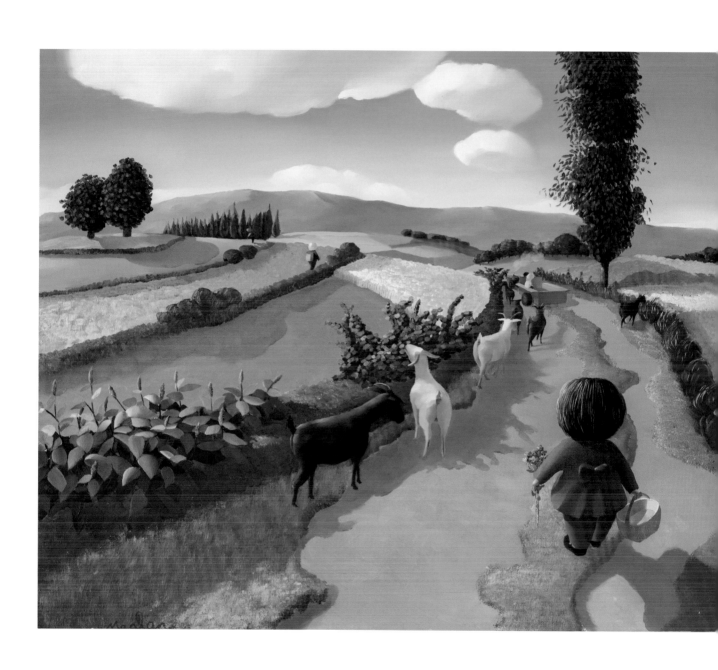

暖丘一秋2 Warm Mound - Autumn No.2　布面油畫 Oil on Canvas　130×160cm　2013

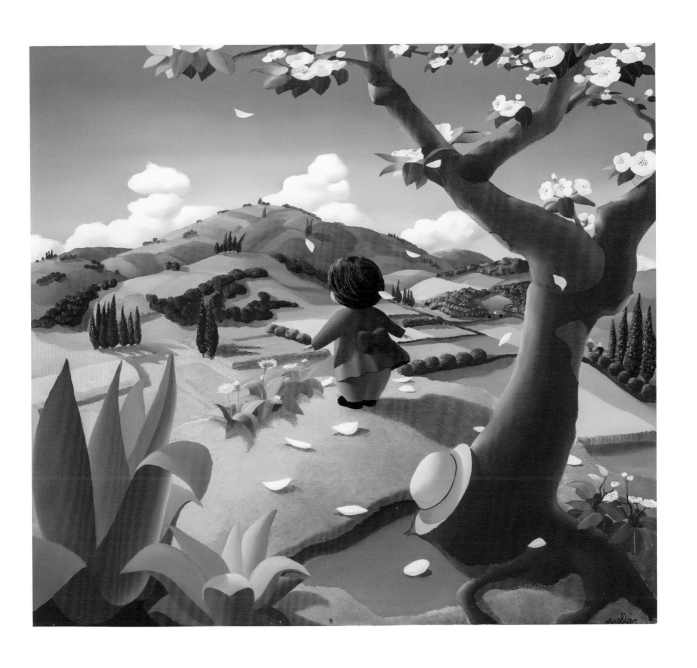

暖丘—隨風1 Warm Mound - Gone with the Wind No.1　布面油畫 Oil on Canvas　180×200cm　2013

喜歡在湖邊吹著風，大口的呼吸著濕潤的空氣，那一刻迎面而來的除了優雅的寧靜外還携著一縷無私的天真，整個人隨意漂浮在空氣的夾層裏快活而自由。

I like to feel the breeze on the shore of a lake and to greedily gulp the humid air. In that moment, apart from the graceful calm there is also a selfless innocence, and I am totally floating in mid-air, happy and free.

隨風2 Gone with the Wind No.2　布面油畫 Oil on Canvas　100×130cm　2013

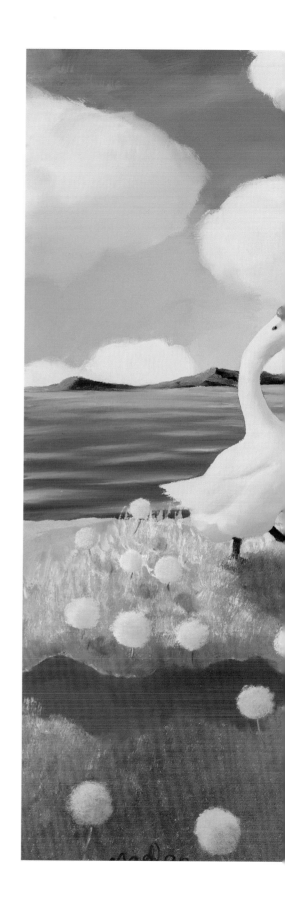

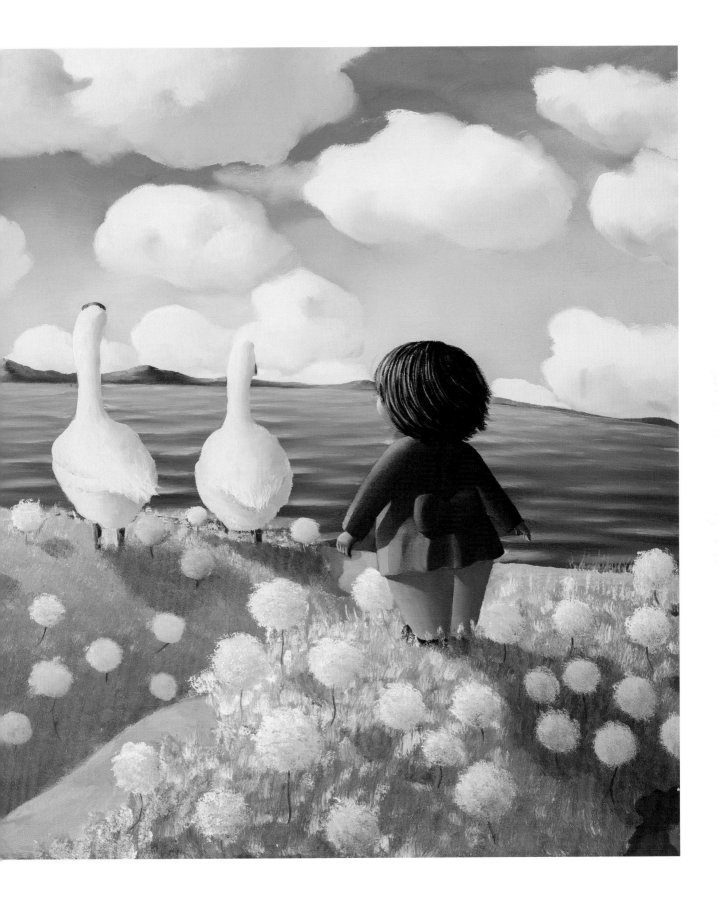

紅土・覓3 Red Soil・Searching No.3　布面油畫 Oil on Canvas　80×60cm（橢圓Oval）　2013

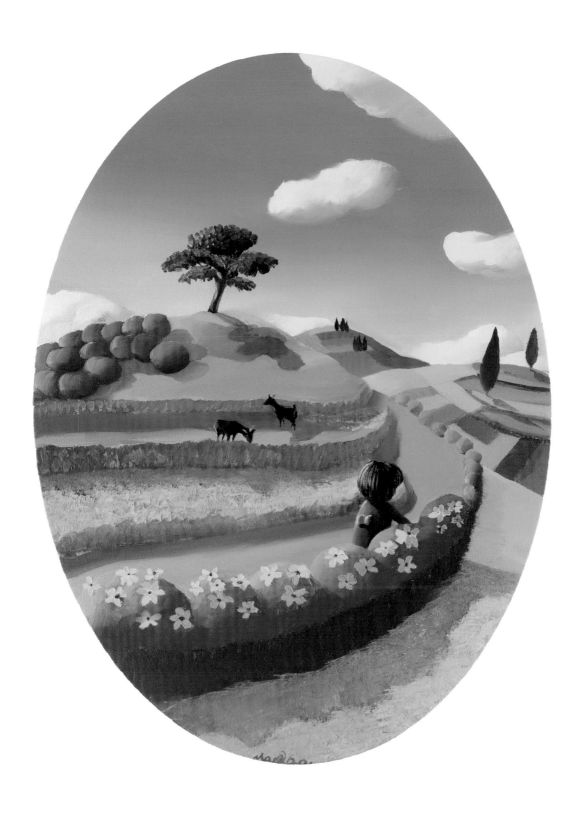

紅土‧覓5 Red Soil‧Searching No.5　布面油畫 Oil on Canvas　80×60cm（橢圓Oval）　2013

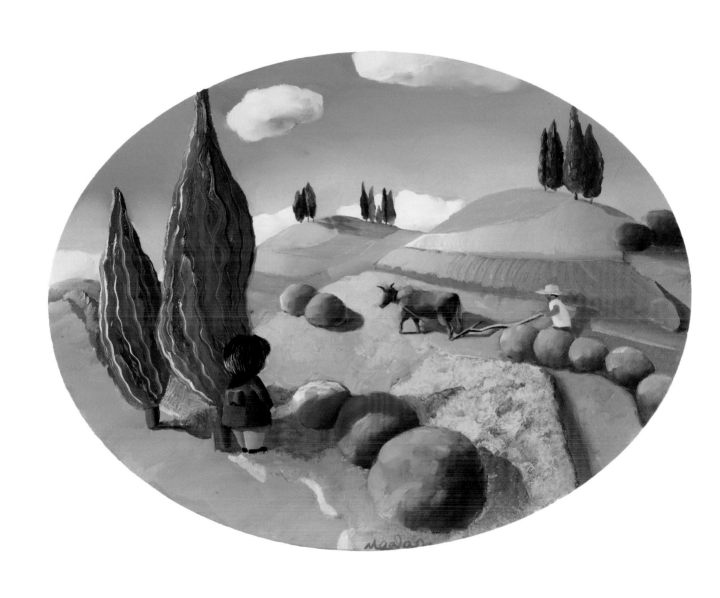

紅土・覓6 Red Soil・Searching No.6　布面油畫 Oil on Canvas　60×80cm（橢圓Oval）　2013

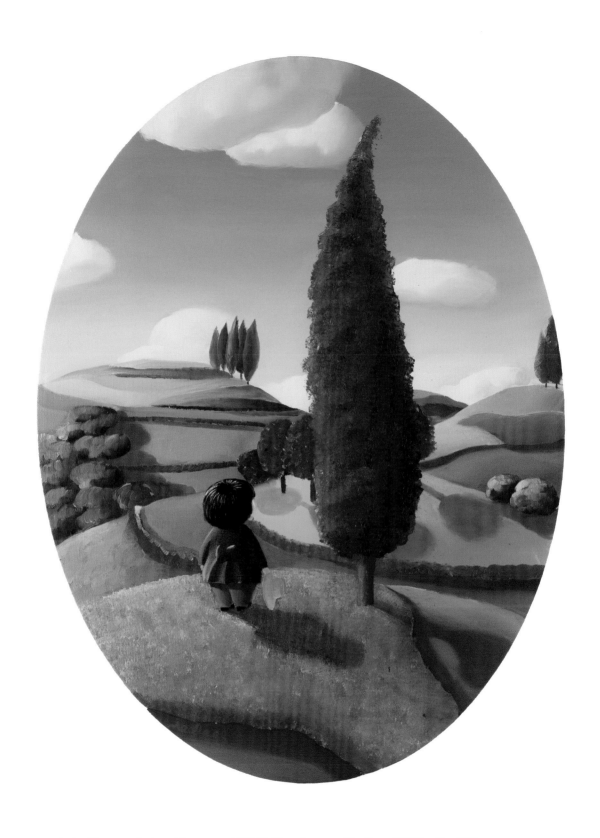

紅土・覓8 Red Soil・Searching No.8　布面油畫 Oil on Canvas　80×60cm（橢圓Oval）　2013

有這樣一個特別的舞臺，全部都按照我的節拍演奏，不光是我還有我身邊所有人。當演奏步調如了我的願時，其實只有我的存在，於是有了多個模仿我的自己出現，那個另外的自己或者另外的幾個自己偶爾與你同行、爭辯、妥協，而我，從未做自己的旁觀著，或許根本沒有旁觀者。馬克 · 羅斯科曾說：「我的畫作不表達自我，我表達「非自我」。只有在尋找真理的過程中除去自我，「瞭解你自己」這句格言才有價值」。我獨自布置著我的空間，用「模仿自己」的方式來試圖瞭解自己，在無知領域中找尋那些一度被忽略但卻珍貴的東西。

There is such a special stage on which the performance is entirely according to my rhythm, not only me but the people around me as well. When the cadence is in accordance with my wishes, in fact I am the only one that exists, and so there are several selves imitating me which appear, and this other self or these several other selves occasionally accompany, debate, compromise with you while I have never been an onlooker of myself, and perhaps there are no onlookers. Mark Rothko said: "I do not express myself in my paintings. I express my 'anti - self'". It is only when you are searching for the truth that the ego can be eliminated."Understand yourself" is a really valuable maxim. I prepare my space by myself, and I use the "imitations of myself" method to try to understand myself; I search unknown territories to find those precious but neglected things.

舞臺1 Stage No.1　布面油畫 Oil on Canvas　180×200cm　2013

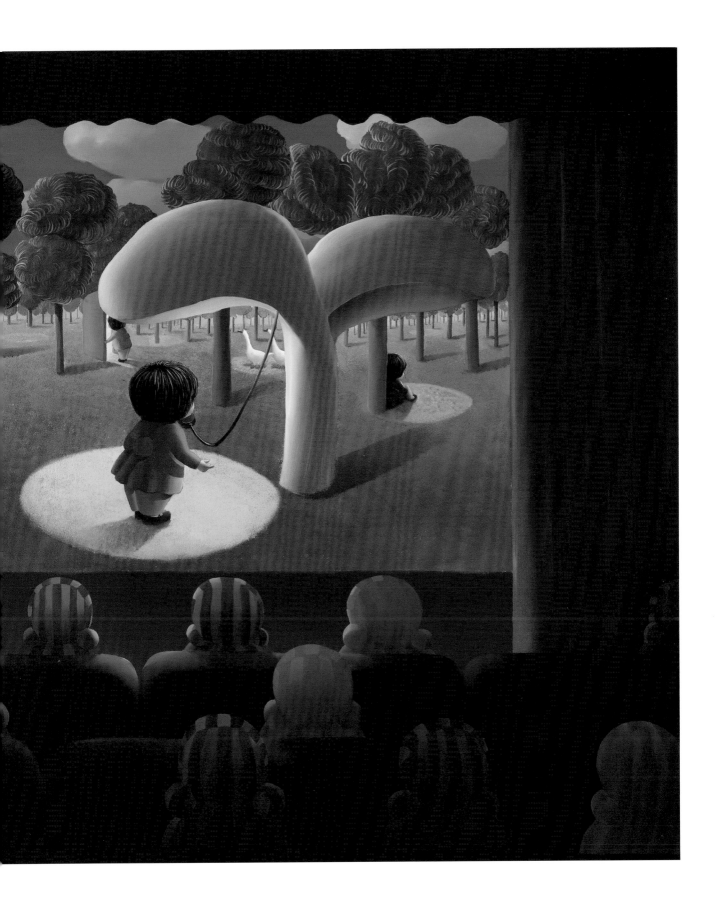

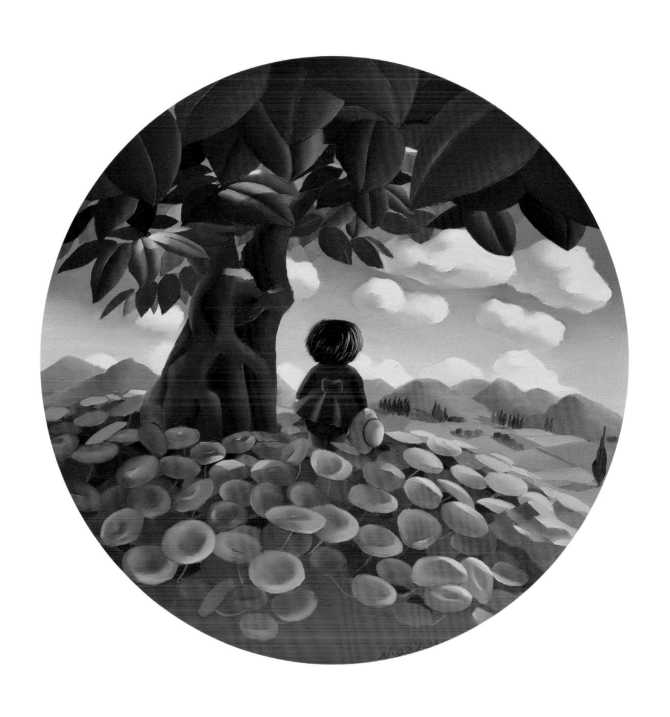

微風輕撫 Sweat Breeze　布面油畫 Oil on Canvas　直徑D: 80cm　2013

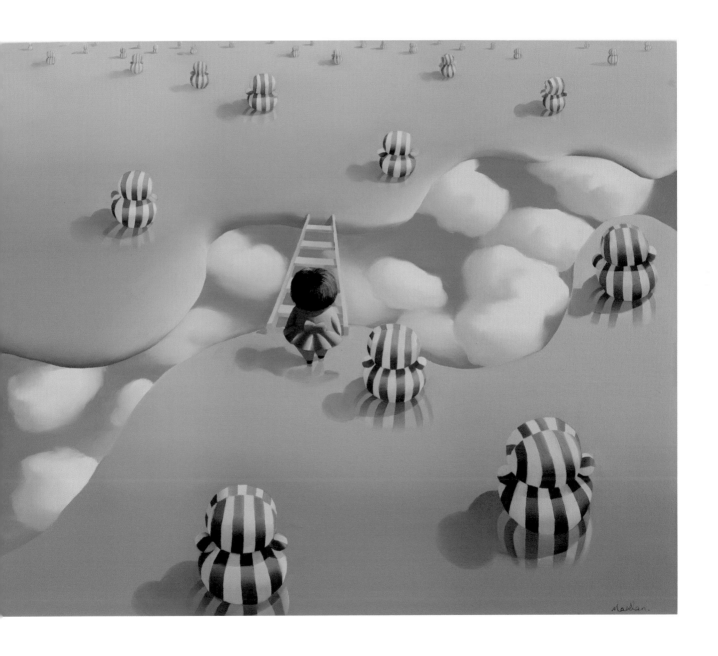

雲上—向北 Upon the Clouds - Northward　布面油畫 Oil on Canvas　130×160cm　2012

想像活動通常能讓我們通往一個神秘的想像空間，先前可能被零散事物填滿的我們，進入了這個空間，就能覺察到一種來自遠方的整體和神聖，先前那些瑣碎無序，在這裏都統統被賦予秩序和生命。

Imaginary activities usually lead us to a mysterious imaginative space. We may have been filled with scattered things before entering this space. After entering the space, we can perceive a complete and sacred being which had travelled from afar, and what was previously trivial and disorderly is given order and life in this space.

暖丘—獨自聆聽 Warm Mound - Listening Alone　布面油畫 Oil on Canvas　180×200cm　2012

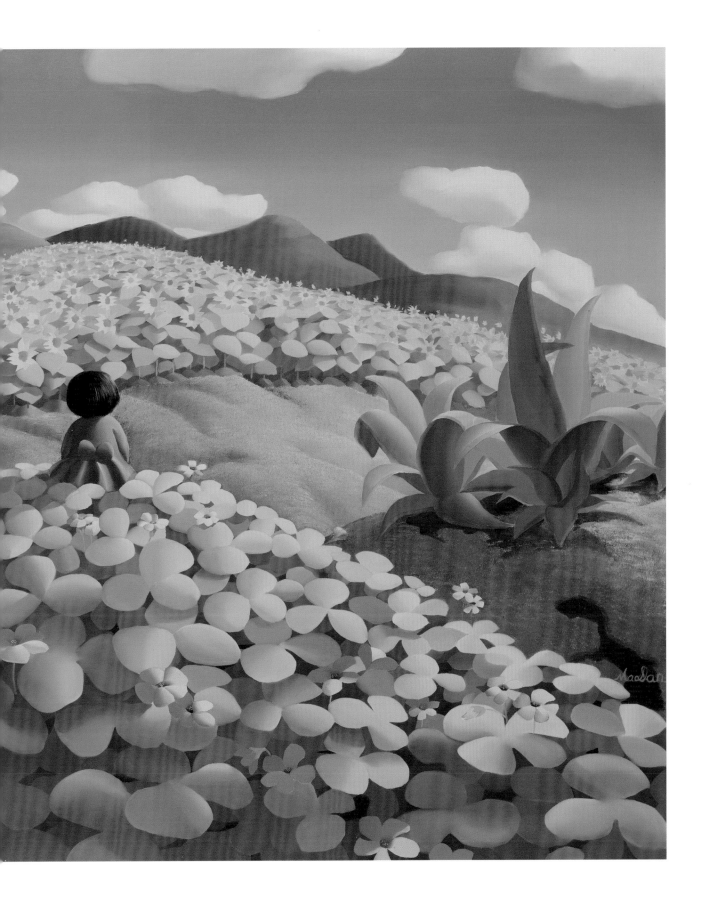

生命的力和能量隱藏在暗物質中，躲藏在深不可測的人類本性的深處。——
艾玲・賴斯・佩雷拉

Life's force and energy lie hidden in the dark mass of creation, concealed
from man in the unfathomable recesses of his being. – Irene Rice Pereira

暖丘—密語 Warm Mound - Whisper　布面油畫 Oil on Canvas　180×200cm　2012

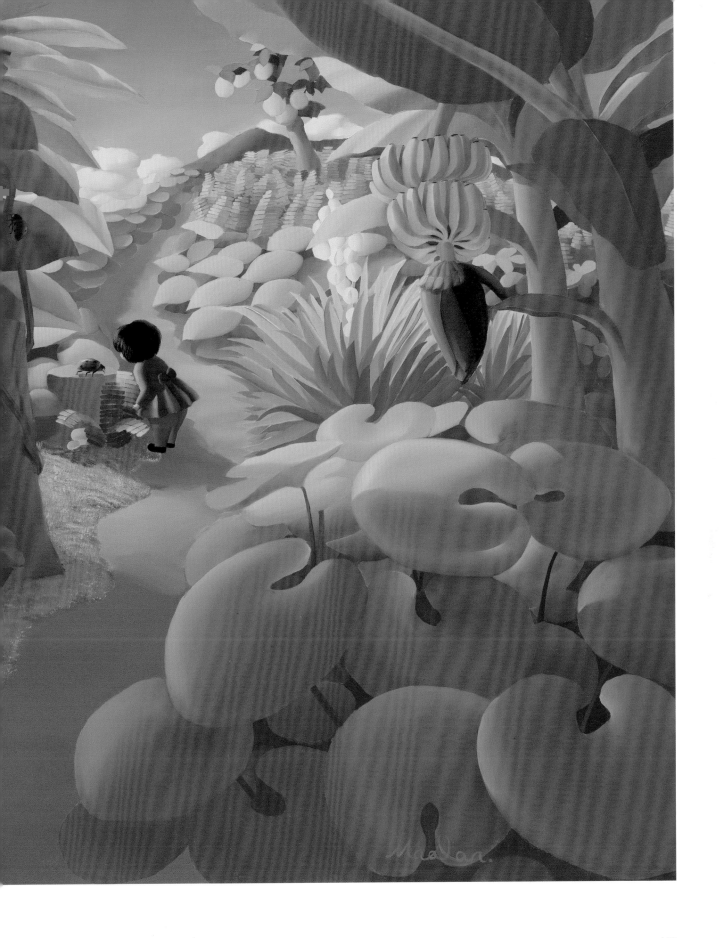

這是我在某一座山上放空時腦海中突顯的世外桃源。這樣的樂園會在某些觸動我的事或物中突如其來，也或許是在某個夜晚的夢裏恍然一現，也許自己也說不清這樣的樂園是不是足夠「樂」，但就是想到它的一瞬間，心裏的某個角落得到了大大滿足。「一隻大公雞的陪伴，一片不大的菜地，一間彩色的小屋，一望無際的綿延山脈，一個只屬於我個人的冥想之地」。

This is a "land of peach blossoms" that appeared suddenly in my head as I was daydreaming on a certain mountain. This kind of paradise would appear when I am touched by something, or perhaps in a dream at night. Perhaps I am not too sure if such a paradise is sufficiently joyful. But in the moment that I think about it, a corner of my heart feels greatly satisfied. "The company of a large rooster, a small vegetable field, a little colorful house, an infinite mountain range, a place to meditate that belongs only to me."

暖丘一 樂 Warm Mound-Joy　布面油畫 Oil on Canvas　130×160cm　2012

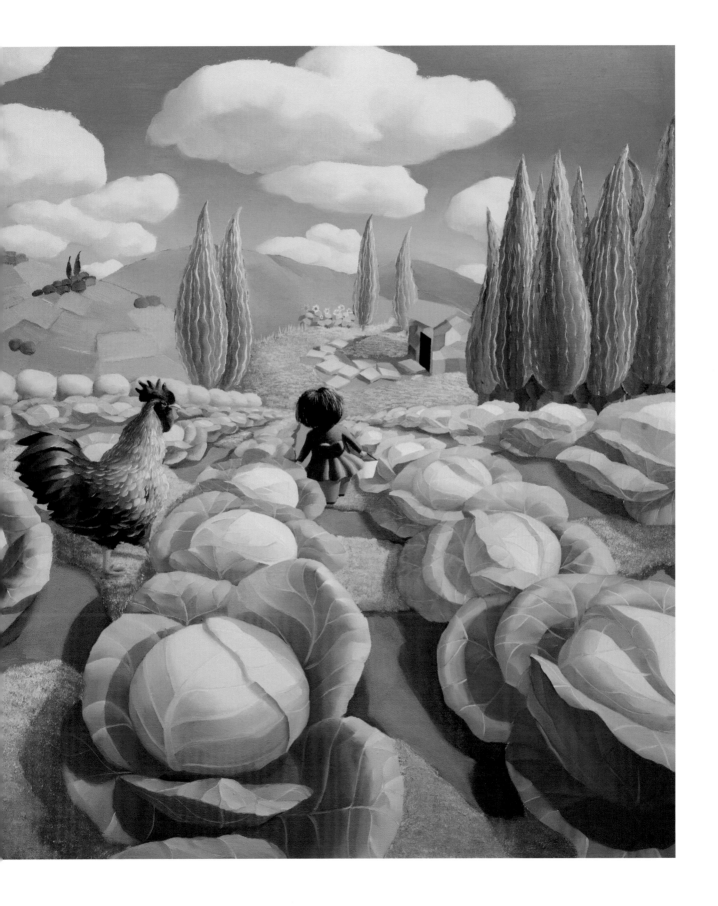

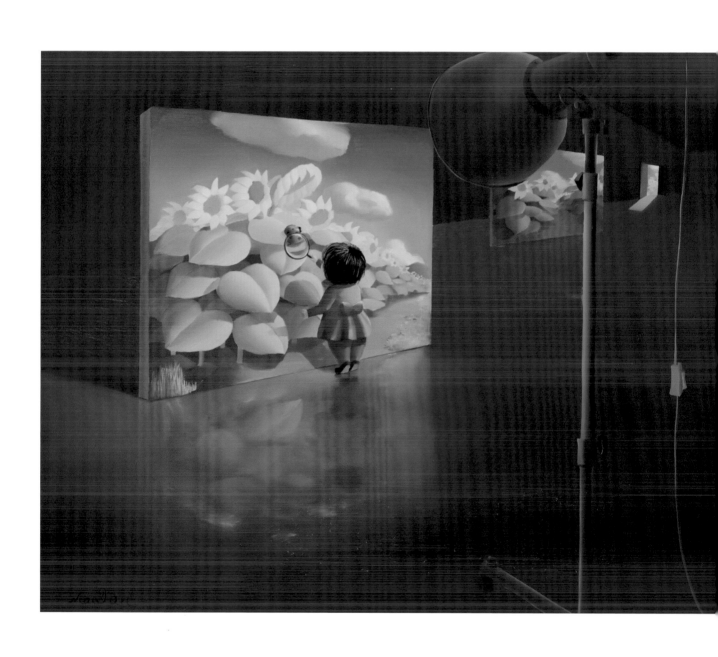

探秘 Discovery　布面油畫 Oil on Canvas　80×100cm　2012

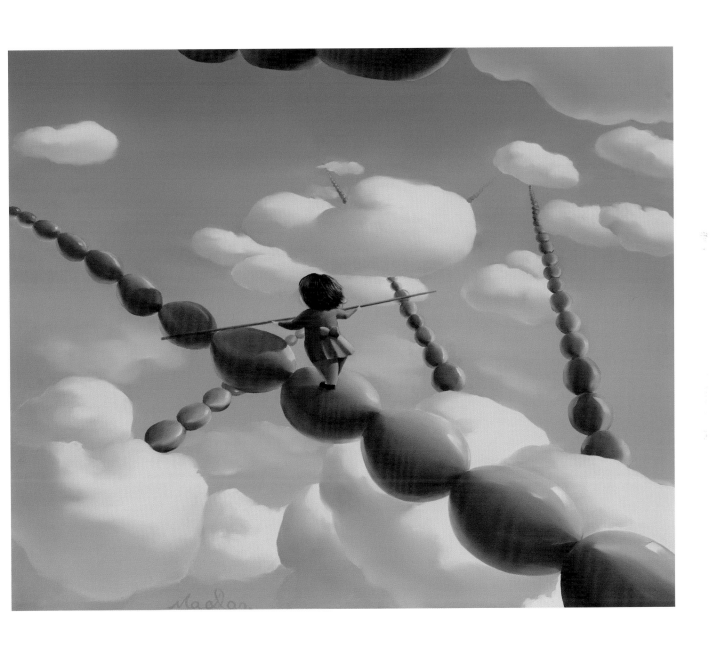

雲上—紅豆之旅 Upon the Clouds - Red Bean Tour　布面油畫 Oil on Canvas　130×160cm　2012

我想，如果可以看到，雲上應該有過這樣一個遊樂場，它是凝固的、某種甜甜的柔軟材質組成，裏邊堆滿了真真假假的笑臉，整個遊樂場存在於你的邏輯、直覺之外，它彌漫著的靜與遼，超出了言語所能描述的範圍，身處這裏時唯一能做的是無感的跟隨、旋轉，用除了味覺之外的感官嚐出它的甜。

I think, if it can be seen, there should be such a playground on the clouds. It is solid and composed of sweet and soft materials. It is full of real and fake smiling faces. The whole playground exists beyond your logic and intuition, it is suffused with a distant calmness that is beyond description. The only thing that can be done here is to follow and spin without feeling and to experience its sweetness without using the sense of taste.

雲上—旋轉 Upon the Clouds- Rotation　布面油畫 Oil on Canvas　200×180cm　2012

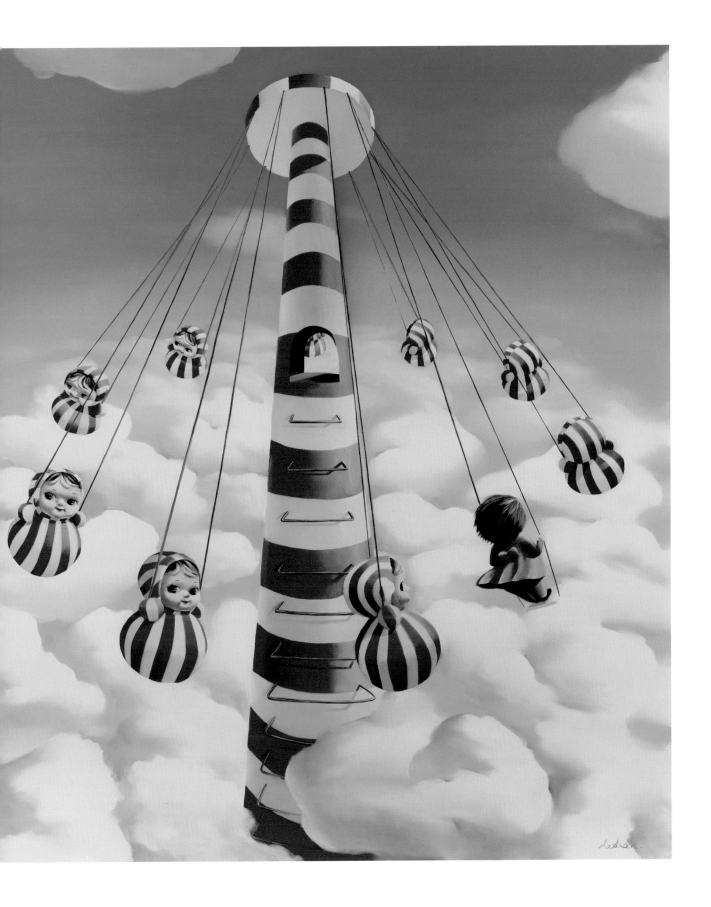

我們自己的存在就如同我們生存的這個世界，它以我們無法理解的方式誕生於自由和必要性。選擇哪一條軌跡，以什麼樣的方式，這些都不是我們預先可以設定的，也許意志會提示著什麼，但每條道都充滿著各類突然襲擊，我們無力選擇，只能一面謹慎探險，一面從容前行。

Our own existence is like the world we live in. It is born of freedom and necessity in ways we cannot understand. Which way to choose, and in what way, are not choices we can set in advance, maybe our will can remind us, but each road is full of all kinds of sudden attacks, we cannot choose in advance. We should take it easy.

雲上—探險 Upon the Clouds - Explore　布面油畫 Oil on Canvas　130×160cm　2012

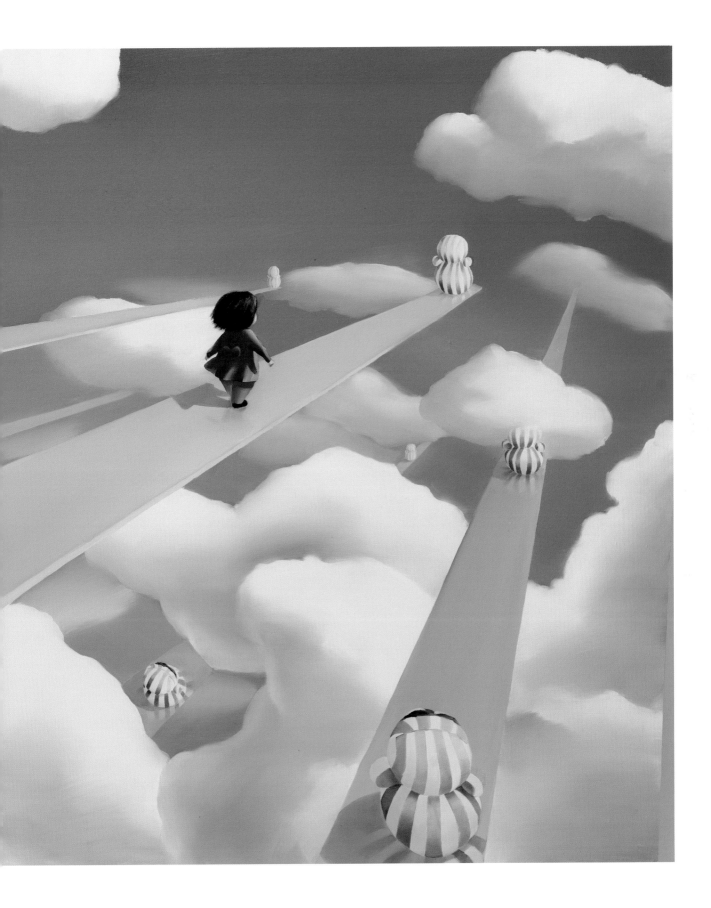

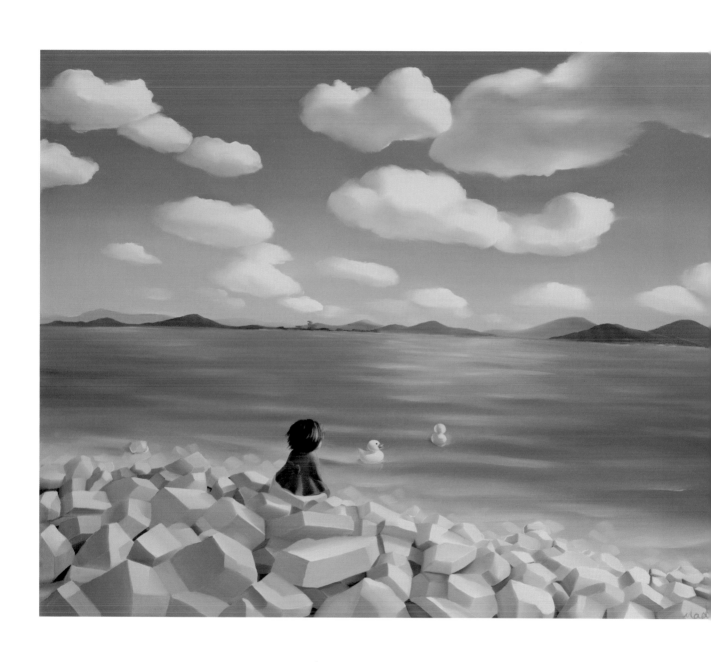

放生 Released　布面油畫 Oil on Canvas　100×130cm　2012

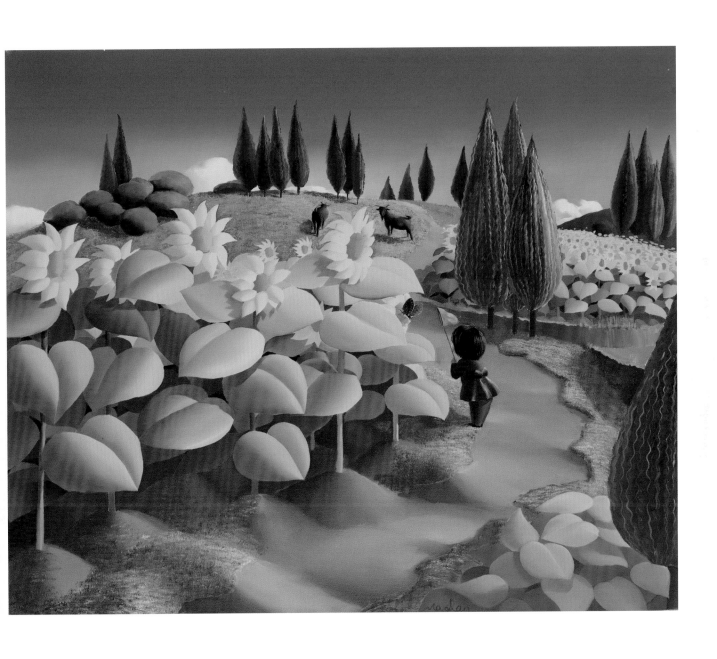

暖丘—捕蝶 Warm Mound - Flapping Butterfly 布面油畫 Oil on Canvas 130×160cm 2012

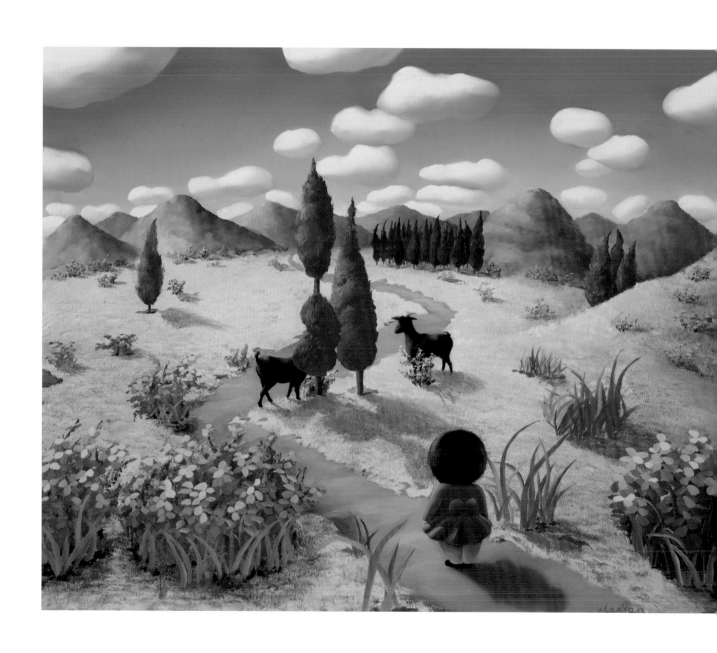

暖丘8 Warm Mound No.8　布面油畫 Oil on Canvas　100×130cm　2012

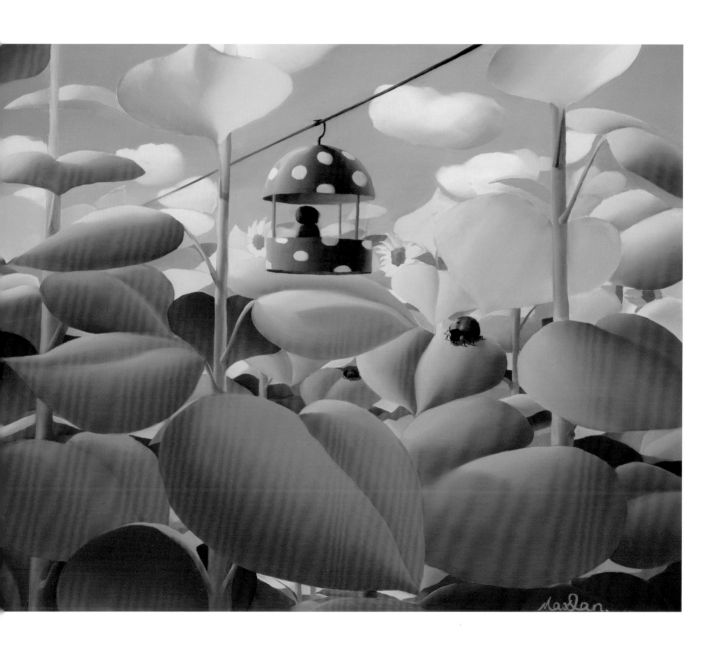

向陽 Toward the Sunshine　布面油畫 Oil on Canvas　100×130cm　2012

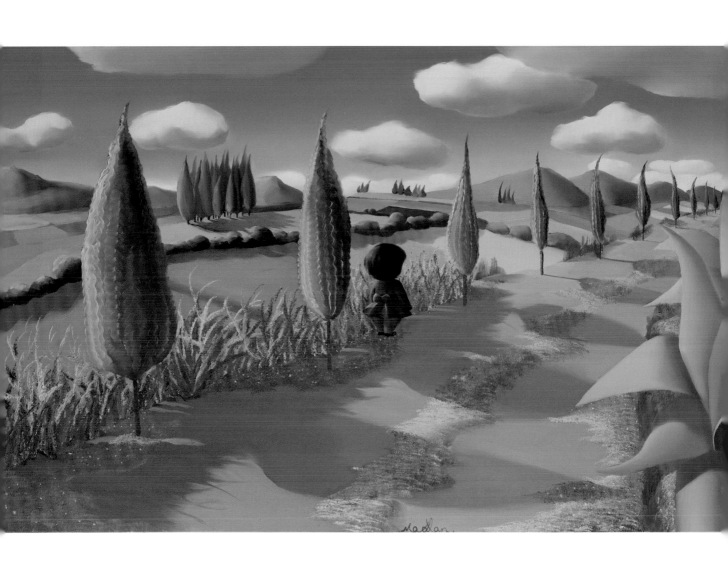

等 Waiting　布面油畫 Oil on Canvas　90×150cm　2012

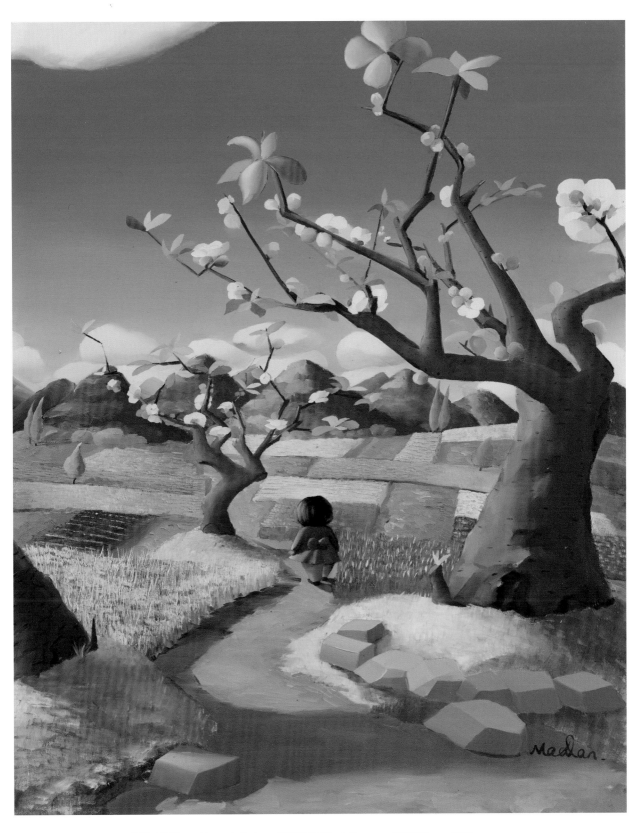

暖丘—春 Warm Mound - Spring　布面油畫 Oil on Canvas　100×80cm　2011

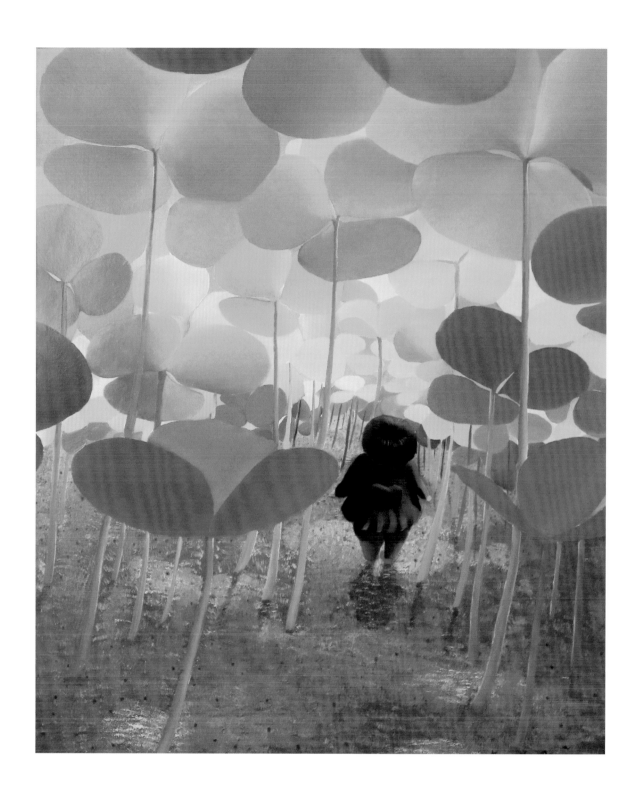

詫異之林 Wonderland　布面油畫 Oil on Canvas　100×80cm　2011

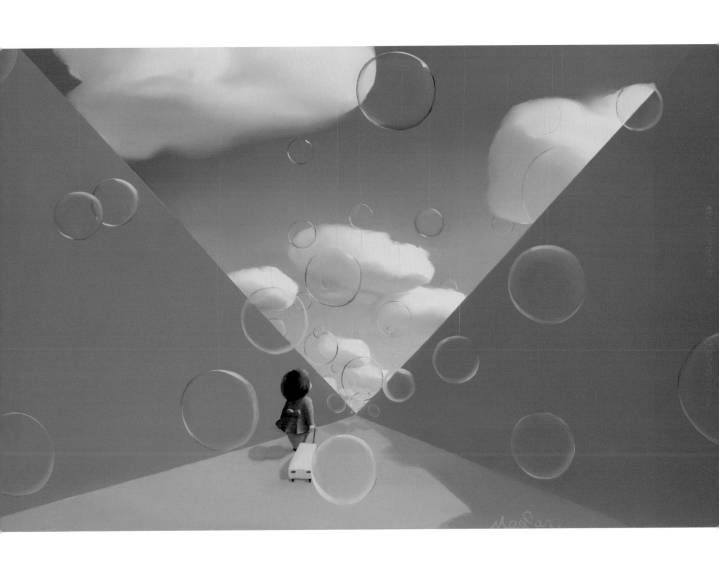

深巷 Corridor 布面油畫 Oil on Canvas 90×150cm 2011

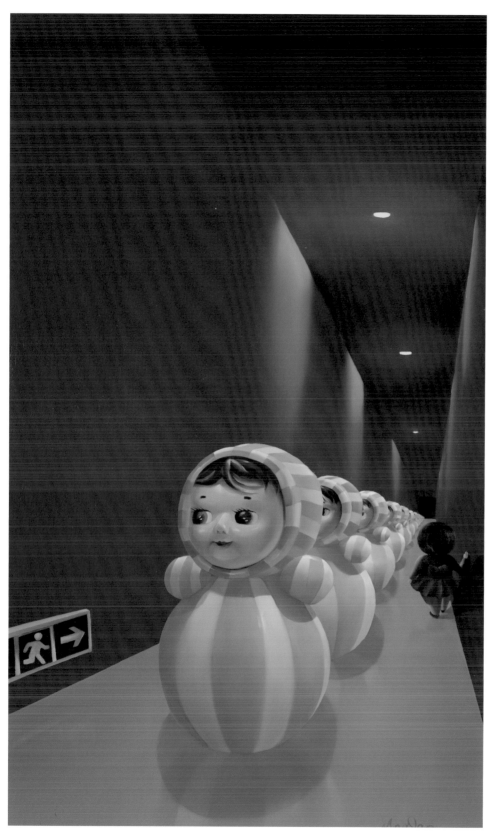

與微笑奇遇1 Encounter with Smile No.1
布面油畫 Oil on Canvas
150×90cm　2011

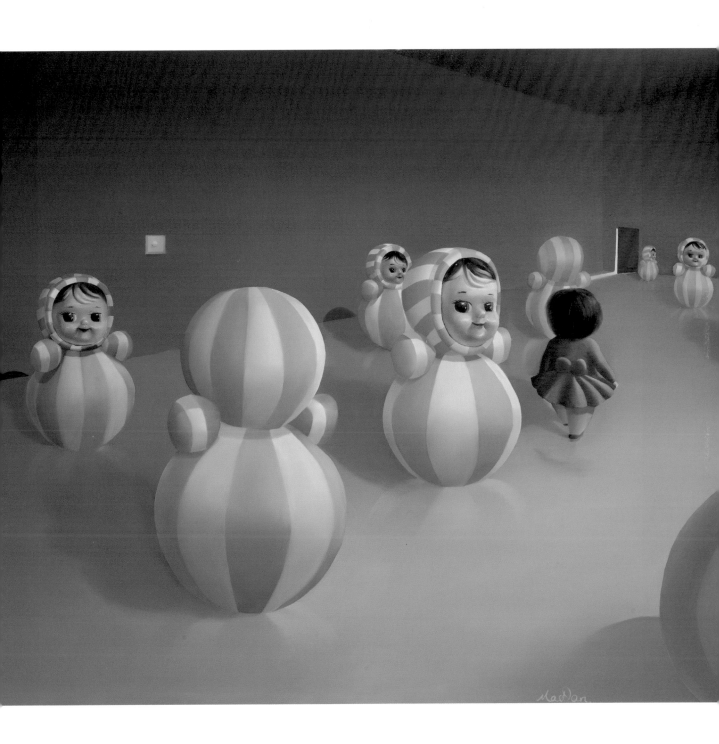

與微笑奇遇2 Encounter with Smile No.2　布面油畫 Oil on Canvas　130×160cm　2011

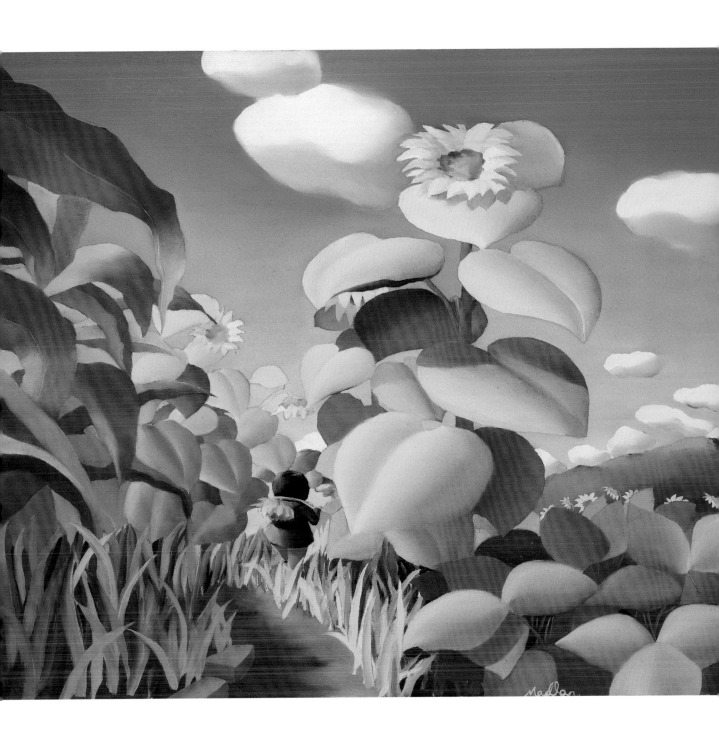

收穫陽光 Harvest the Sunshine　布面油畫 Oil on Canvas　80×100cm　2011

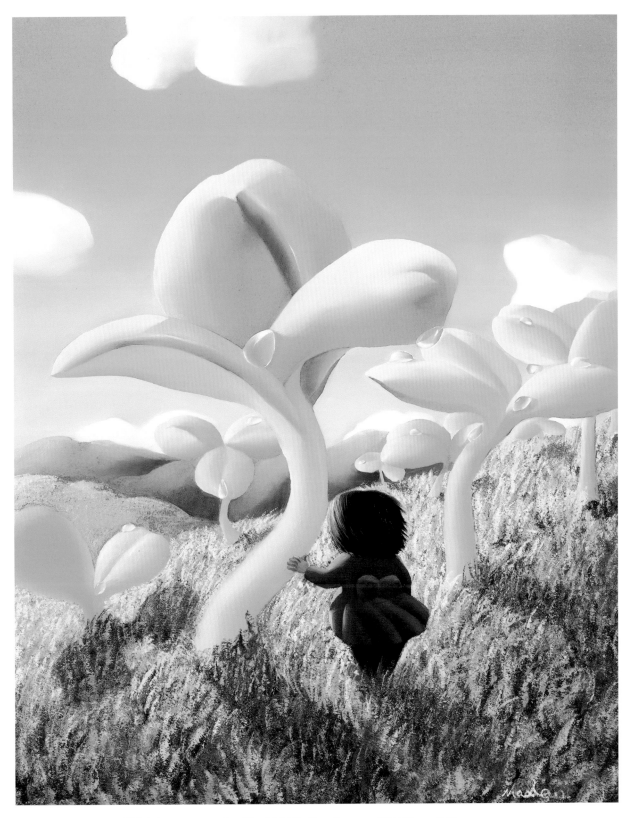

嫩芽山上 Burgeons on the Hill　布面油畫 Oil on Canvas　100×80cm　2011

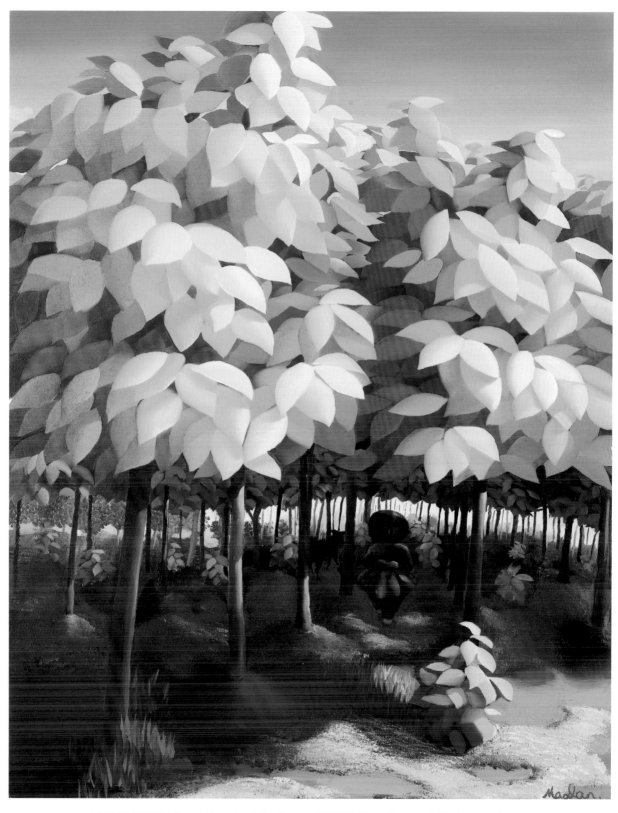

小樹林的神秘跟蹤 A Secret Flowering in the Grove　布面油畫 Oil on Canvas　100×80cm　2011

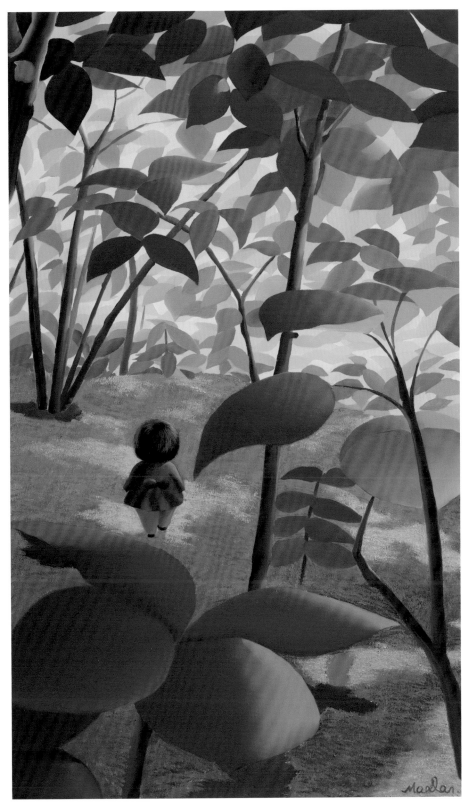

靜謐的樹蔭下 Calm under the Shade　布面油畫 Oil on Canvas　150×90cm　2011

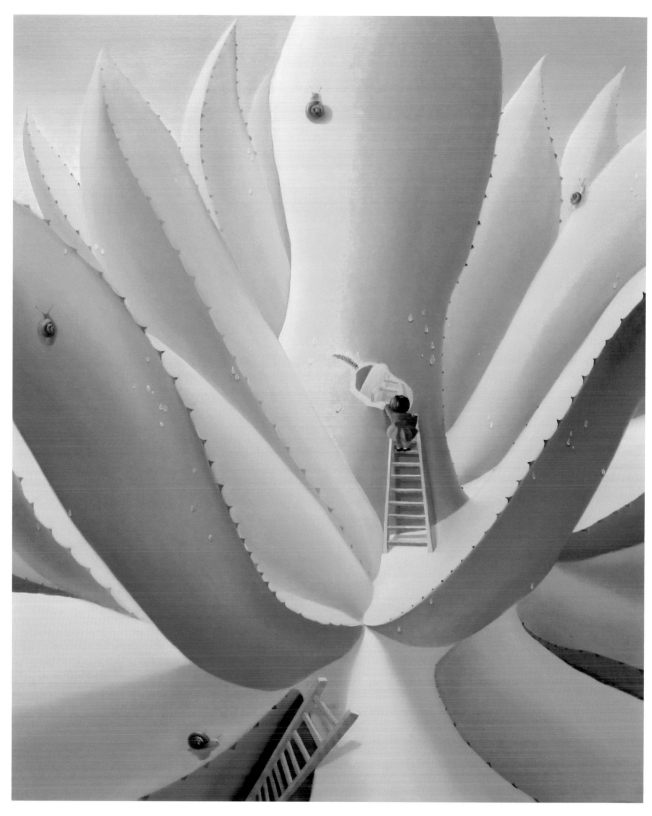

盲從之一各行其道 Blind Following - By Your Own Way 布面油畫 Oil on Canvas 160×130cm 2011

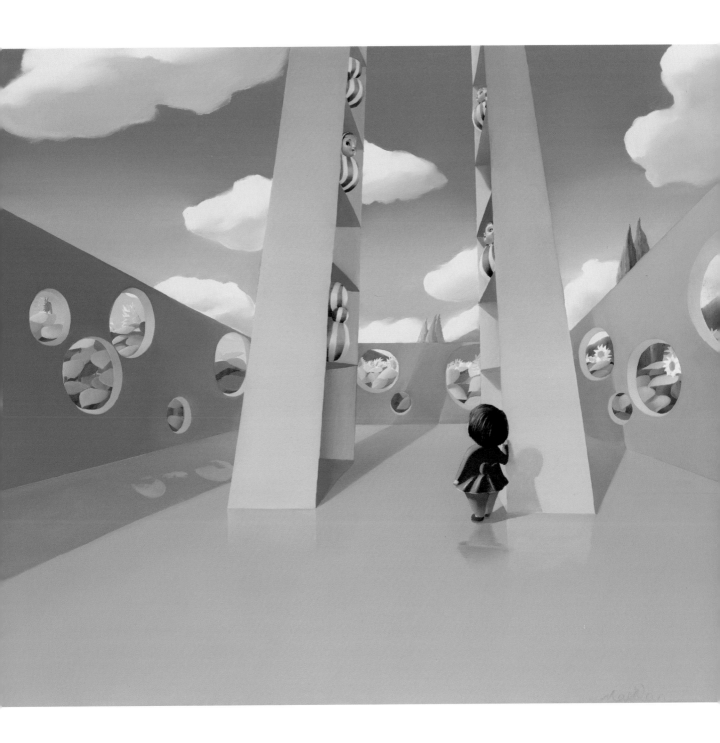

圍觀 Surrounding　布面油畫 Oil on Canvas　130×160cm　2011

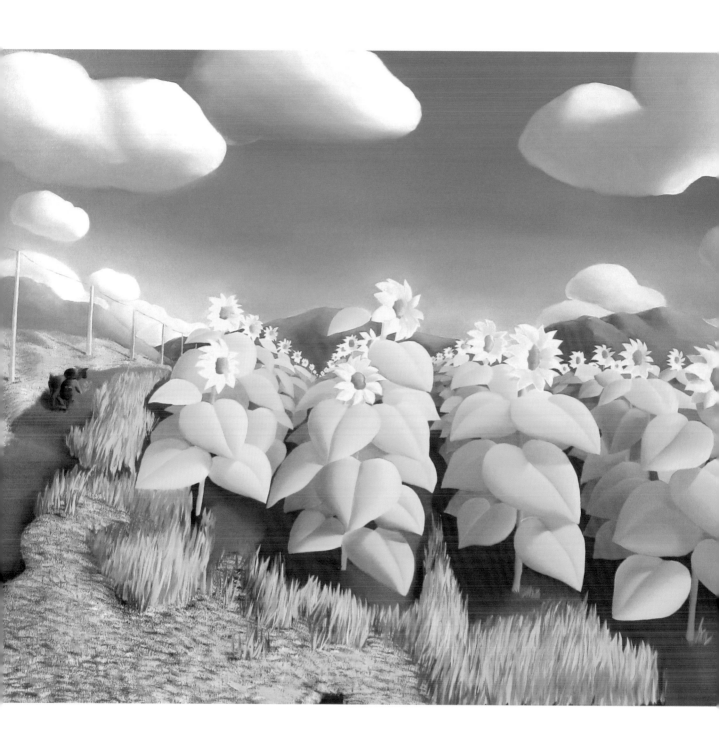

陽光下─我們 Under the Sun-Us　布面油畫 Oil on Canvas　130×160cm　2011

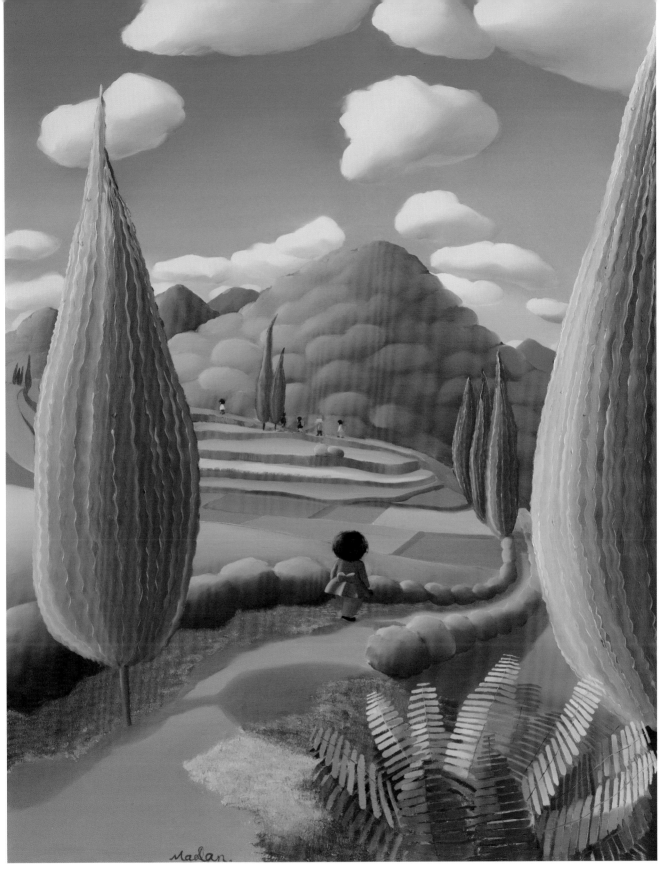

暖丘—遠遊 Warm Mound - Long Trip 布面油畫 Oil on Canvas 130×100cm 2011

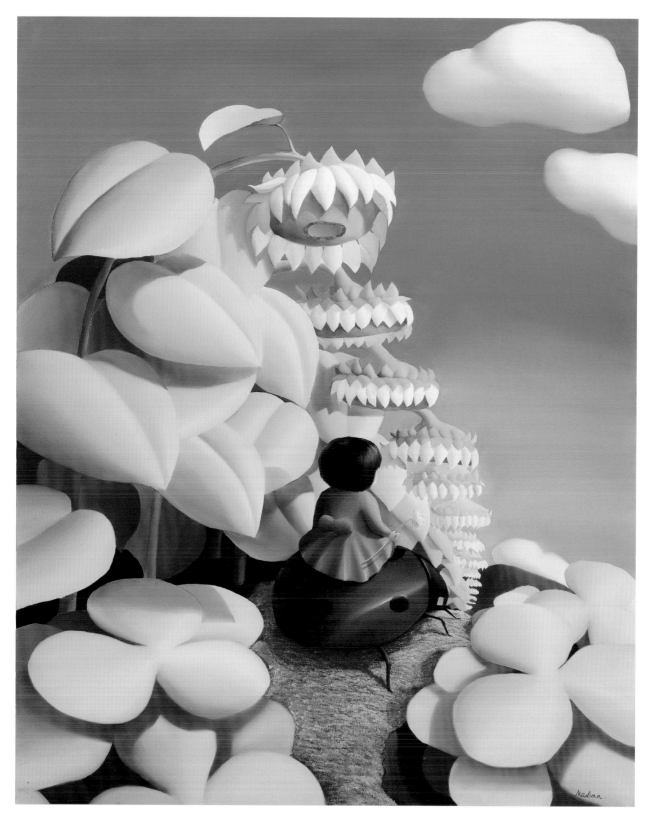

今天我做主2 Today I am the Boss No.2　布面油畫 Oil on Canvas　160×130cm　2011

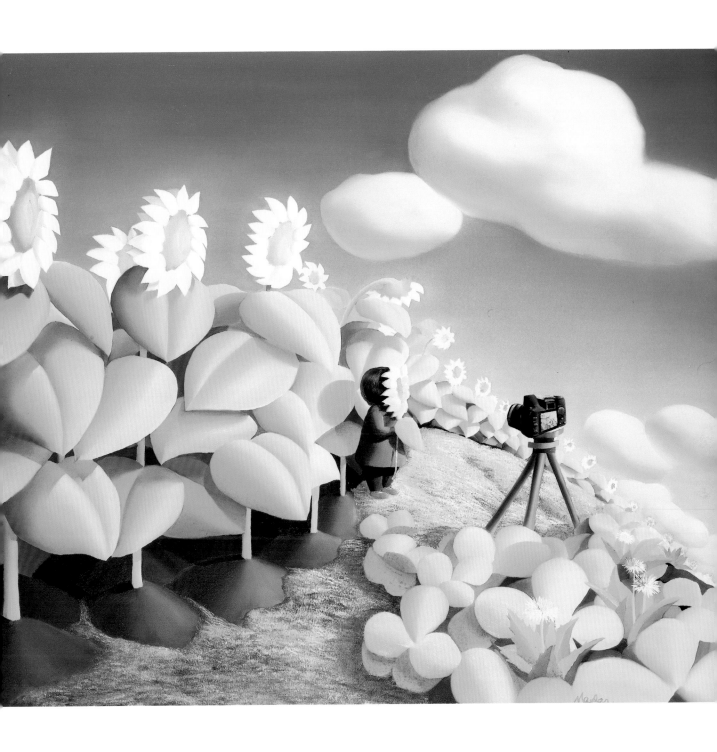

自拍—冒充 Autoportrait - Pretending　布面油畫 Oil on Canvas　130×160cm　2011

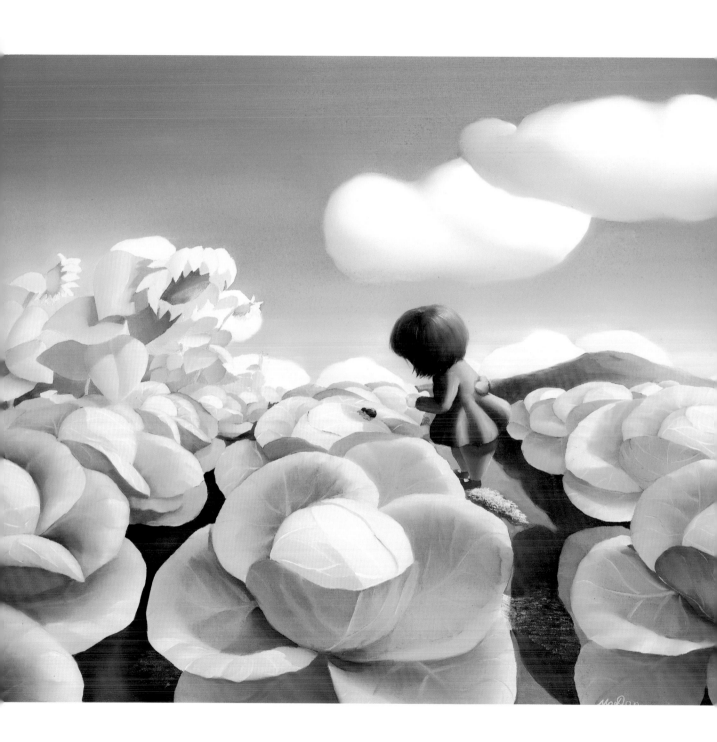

和他們一起快樂呼吸的日子 Those Happy Days When We Were Breathing Together　布面油畫 Oil on Canvas　80×100cm　2011

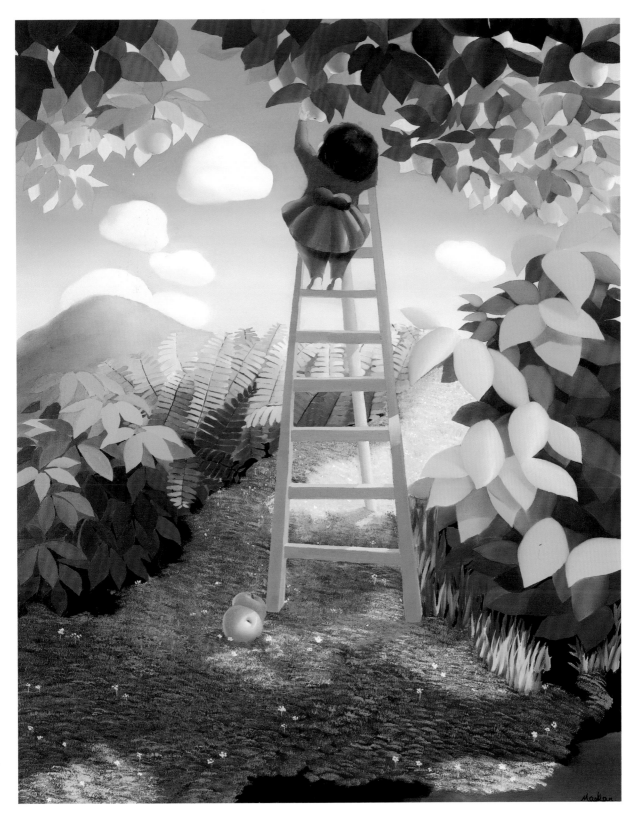

果園 Orchard　布面油畫 Oil on Canvas　150×120cm　2011

對於自然的迷戀，有時候來自於一些摸不著的崇高感，
或對所失去的東西的一種渴望和找尋。

The obsession with nature sometimes comes from an
indescribable sense of the sublime, or it is the yearning
and searching for things lost.

晨 Morning　布面油畫 Oil on Canvas　80×100cm　2011

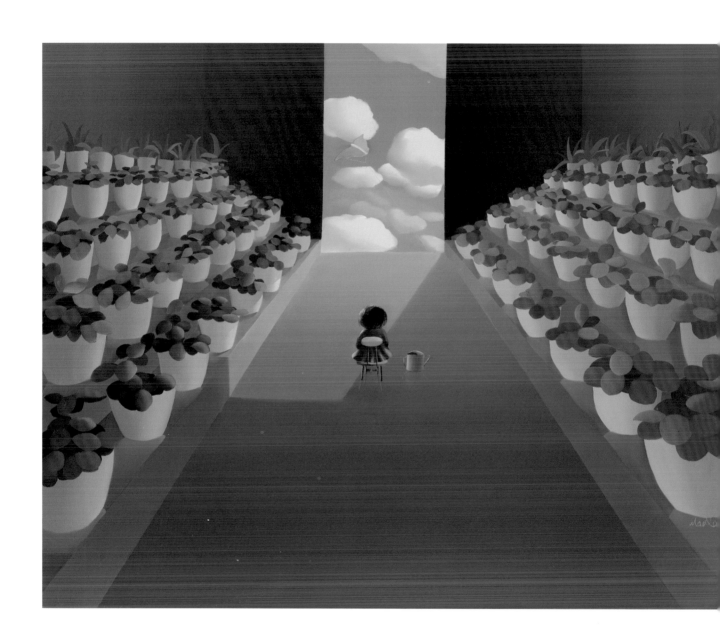

守護 Guard　布面油畫 Oil on Canvas　120×150cm　2011

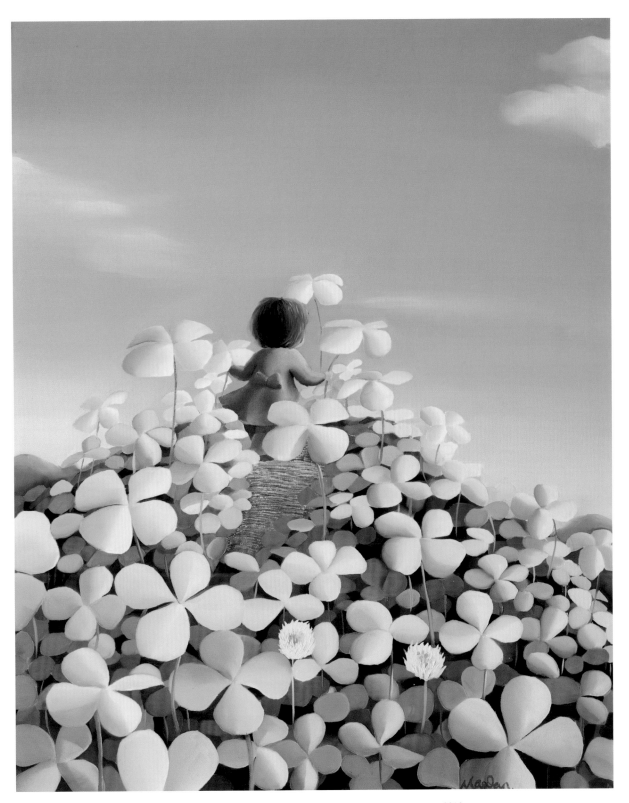

幸運滿地 Lucky Field　布面油畫 Oil on Canvas　100×80cm　2010

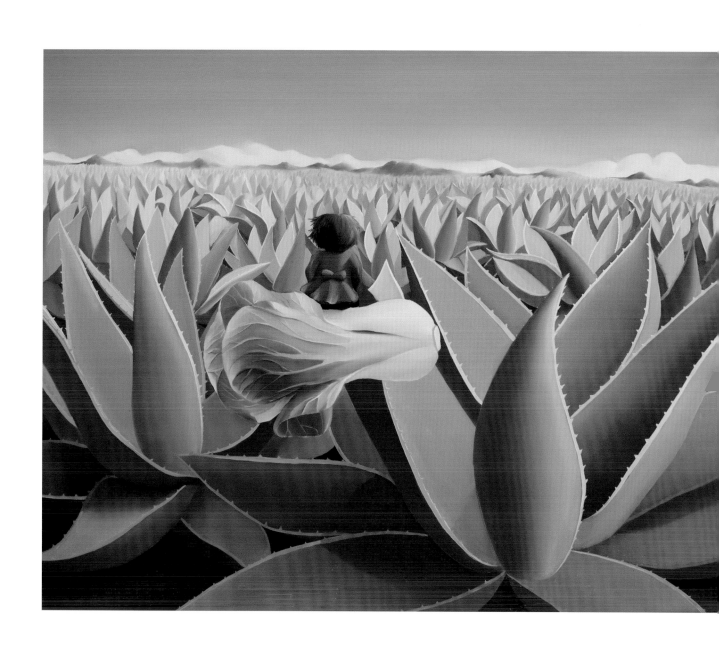

白菜給的浪漫 Cabbage to the Romantic　布面油畫 Oil on Canvas　115×145cm　2010

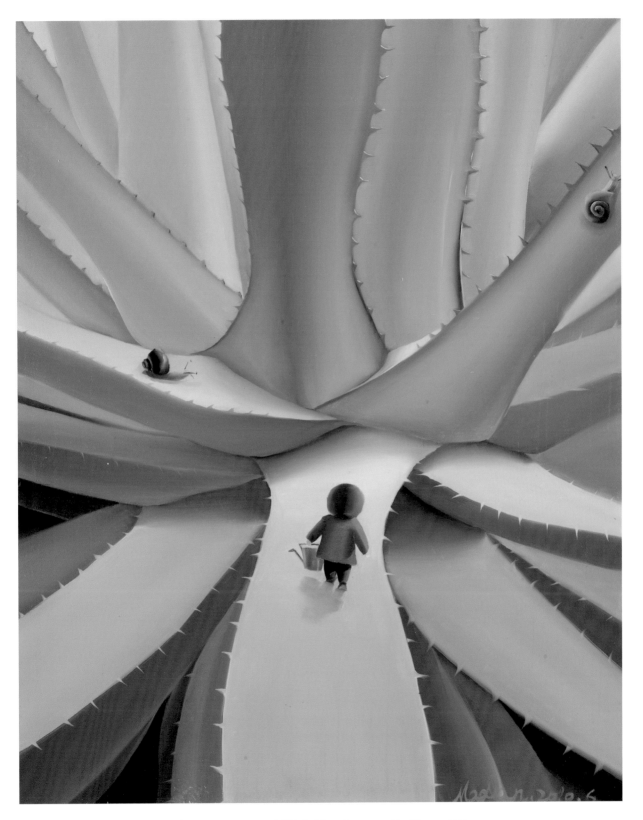

盲忙 Blind Activities　布面油畫 Oil on Canvas　100×80 cm　2010

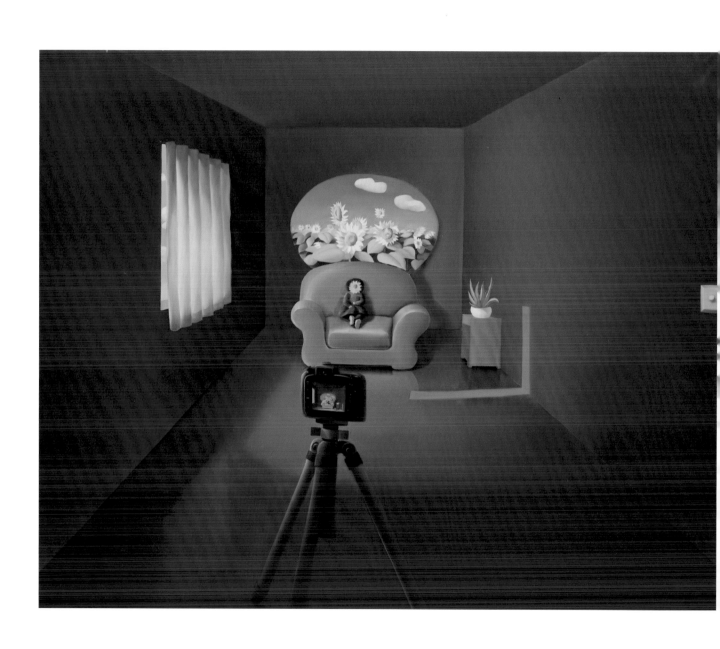

自拍2 Autoportrait No.2　布面油畫 Oil on Canvas　160×200cm　2010

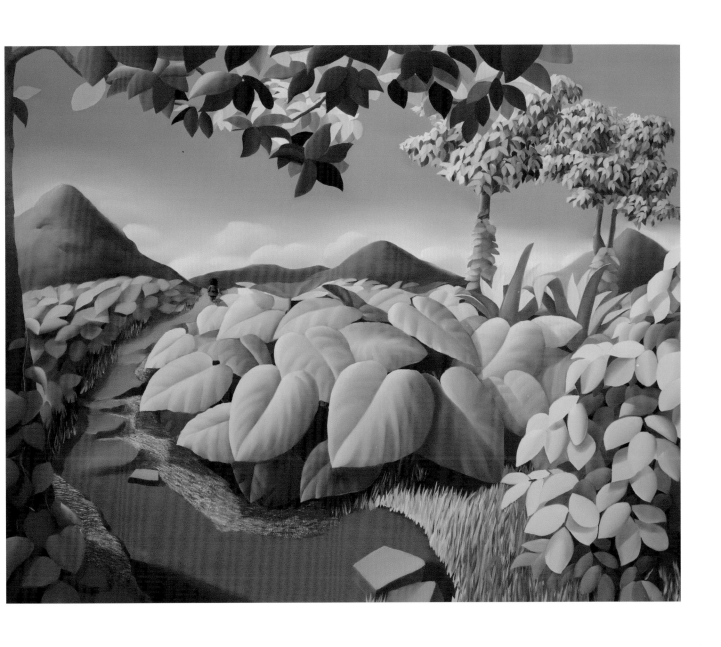

走過後山 Passing the Mountain　布面油畫 Oil on Canvas　160×200cm　2010

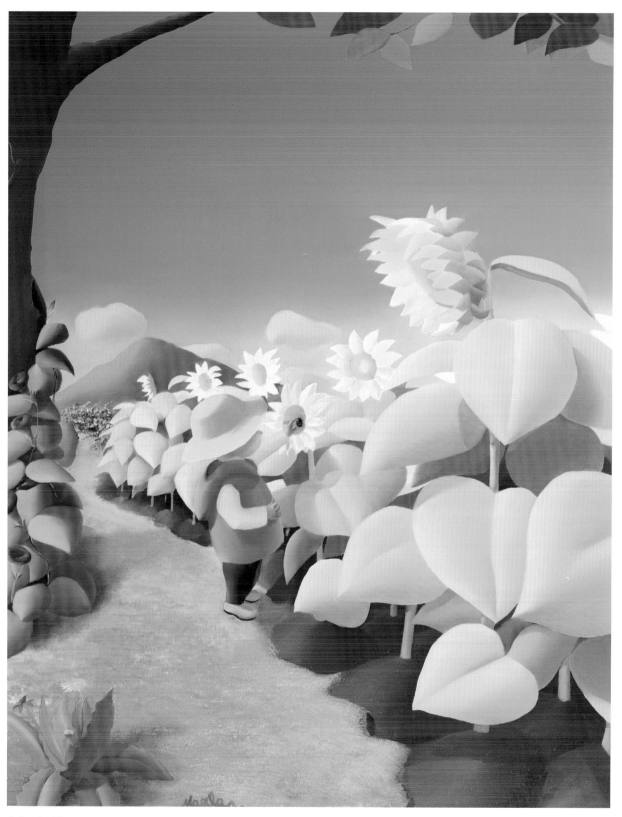

葵花地的誘惑 The Attractive Sunflower Field　布面油畫 Oil on Canvas　145×115cm　2010

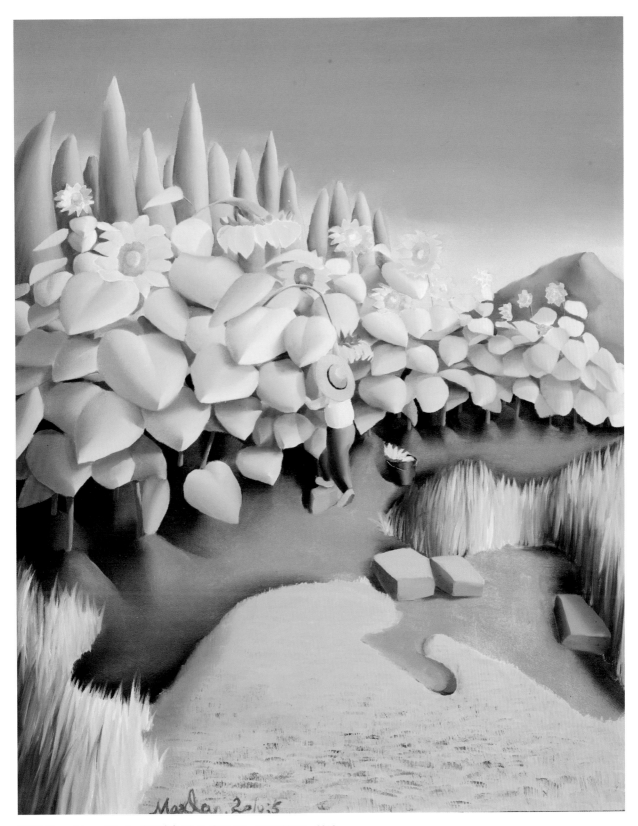

暖丘1 Warm Mound No.1　布面油畫 Oil on Canvas　100×80cm　2010

大自然是物質豐富形式的集結，這集結誘發令人高尚的接觸、成長的喜悅、繁盛的生命力的傳遞，這些都不斷地滋養著我，將我與其他事物連接起來，再次充分融入生命，幫助我通往我所認為的崇高生命。

Nature is a collection of material rich forms. This assembly induces noble contact, joy of growth, and the transmission of vitality. These forms constantly nourish me, connect me with other things, and again fully integrate into life, and help me to lead my vision of the sublime life.

暖丘2 Warm Mound No.2　布面油畫 Oil on Canvas　100×80cm　2010

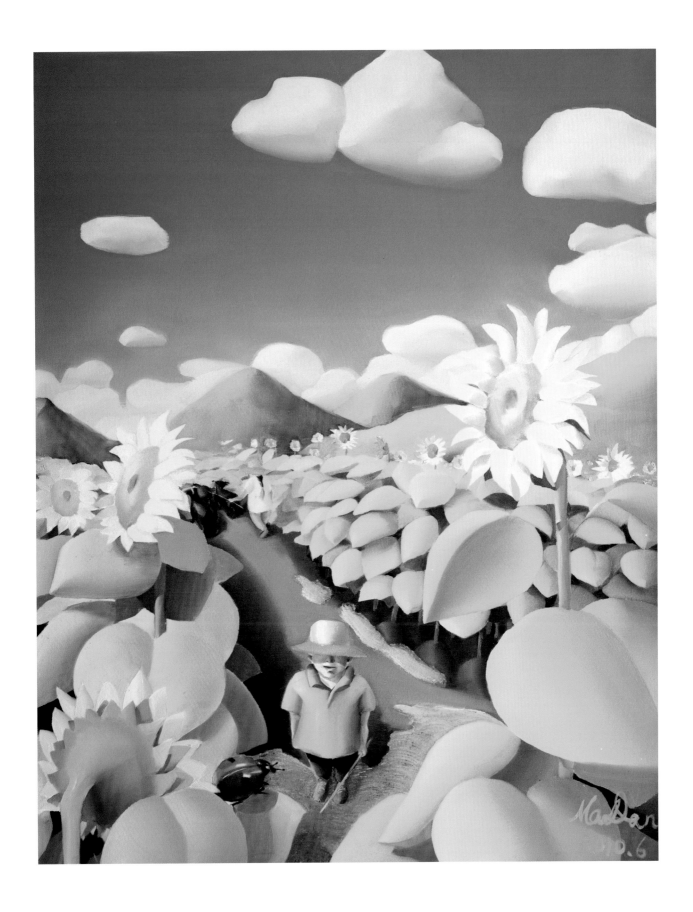

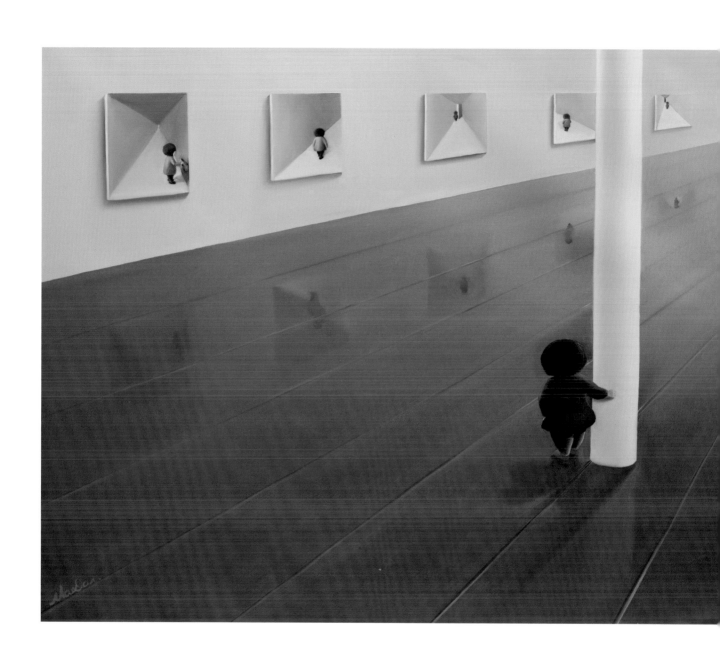

孤獨展 Lonely Show　布面油畫 Oil on Canvas　115×145cm　2010

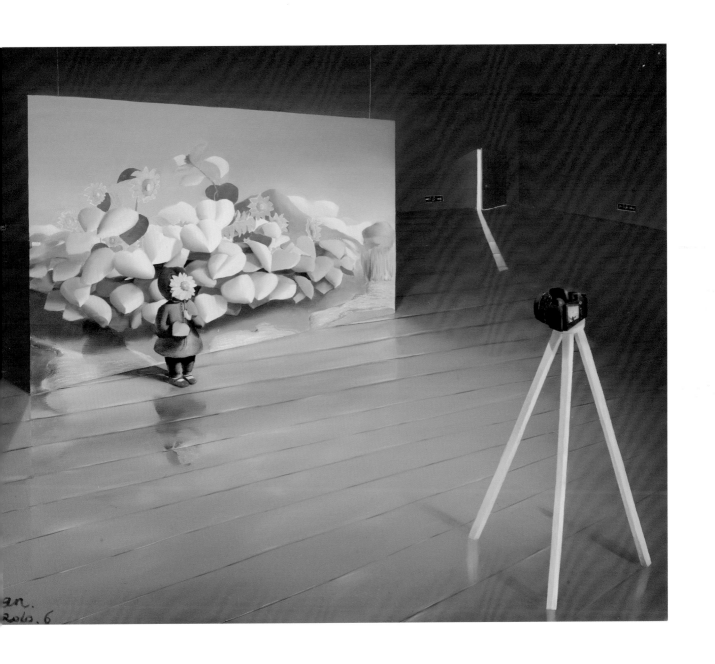

自拍 Autoportrait　布面油畫 Oil on Canvas　110×140cm　2010

後記

李穎

艾米李畫廊創始人

　　與馬丹的緣分始於2010年。那年，我到昆明找毛旭輝，晚飯後他建議去他學生們的工作室參觀，我翻看著一本由呂澎策展的《改造歷史》畫冊時，其中一頁畫面中一個穿紅裙子小女孩的背影跳進我的視線，迎面而來的是一種熟悉的愉悦的感覺，我停了下來，深呼吸；毛旭輝在一旁説，這也是我的學生……

　　對很多人來説，雲南是一個有著綺麗多姿的自然風光和奇特多樣的民族風情的烏托邦，沒有哪個地方能帶給人如此層次豐富的文化氛圍。生長於雲南的馬丹是一個愛做夢的女孩，她常常夢到童年記憶中故鄉，那是一個由葉子肥碩的植物、敦實的山脈、肥沃的紅土構成的故鄉。這裏的一切都與美好有關。身穿紅裙子背對觀者的小女孩如愛麗絲夢遊仙境般成為馬丹特有的色調。在馬丹的作品中，厚實且細膩的筆觸和豐富的色彩還原了她的夢境和想像，超現實主義般的畫面來自她對這片土地的熱愛和對美好的追求，畫中彷彿吹來一陣和煦的春風，為觀者帶來一絲的暖意。

　　儘管經過了美術學院的訓練，馬丹依然固執地拋開當代藝術的種種潮流與風格，她的創作直指自己的內心世界。她營造的夢幻般的風景，使人迷失又陶醉，場景似曾相識卻又新鮮。當單純的小女孩與單純的風景相遇時，我們重新發現了自由與純真，那是生命最原始的特質，來自最純潔的心靈，是一種思想無法取代的情感。

　　馬丹作品中這些奇幻的風景始終圍繞著這個小女孩。我們在馬丹早期的系列作品中看到，小女孩是畫面的主角：參觀自己的展覽〈孤獨展〉（2010）、在一棵白菜上漫遊田野〈白菜給的浪漫〉（2010）、在小山坡上尋找四葉草〈幸運滿地〉（2010）。在後來的作品〈晨〉（2011），〈雲上一探險〉（2012），〈自拍2〉（2012）中，開始出現她充滿好奇且頑皮而不懼的孩童心態，〈今天我做主〉（2011）以及〈果園〉與〈暖丘〉系列更是將自己未來主人翁的角色牢牢佔座。近年來的〈半夢〉，〈浮生〉和〈窺見方寸〉系列明顯表現了馬丹從一個小女孩內心獨白的世界進入到將自己抽離以旁觀者身份來觀看這個多維世界的轉變，畫面中開始出現兩個或更多小女孩的背影形象。

　　從2010年到2019年，我和馬丹一起完成了她的6次個展，包括在北京畫廊，還有法國巴黎、義大利拿坡里基金會；作品參加了包括美國、法國、義大利、英國、台灣、新加坡、韓國、印尼等10個國家的42個藝博會，欣喜的是收藏她的作品的藏家和機構也遍布各地。

　　這麼多年過去了，我不知道當年看到了什麼，但我仍然記得那份愉悦，這裏借一位台灣藏家的話：馬丹作品掛在家裏就像擁有了一台氧氣機。我想這就是我們一直在尋找的那種心動有氧作品的感覺吧。

　　借此機會感謝台灣藝術家雜誌社何政廣社長給予我們這次出版的機會，感謝駐北京辦事處許玉鈴女士和藝術家雜誌社全體編輯部的鼎力支持，感謝一路支持馬丹和畫廊的機構及藏家朋友們。

2019年7月10日於北京

Postscript

Amy Li

Founder of Amy Li Gallery

My relationship with Ma Dan dates back to the year 2010. At that time I was visiting Mao Xuhui in Kunming. After dinner, he suggested that we visit his students' studios. When I was looking through the catalogue of an exhibition curated by Lv Peng, the back of a little girl in a red dress drew my attention, and a sense of familiarity and delight washed over me. I was astonished and took a deep breath. Meanwhile Mao Xuhui said that it was done by one of his students too.

For many of us, Yunnan is a utopia abounding with glorious natural landscapes and diverse ethnical cultures. There is simply no other place which has such a multi-cultural atmosphere. Having grown up in Yunnan, Ma Dan is a girl who enjoys dreaming. She often dreams of the homeland from her childhood memory; it was a place of vigorous vegetation, stocky mountains and fertile red soil. It was a place where everything was good. The girl in a red dress whose back faces the viewer is Ma Dan's unique icon, her Alice in Wonderland. In Ma Dan's works, the thick, smooth paint strokes and rich colors restore the tone of her dream and imagination. The surrealistic scenery is borne of her passion for this land and her pursuit of goodness and happiness. It is as if a gentle breeze stirs from the canvas to bring warmth to the viewer.

Even though she had gone through training at the art academy, Ma Dan resolutely drifted away from the trends and styles of contemporary art. Her creativity is truly about her inner self. The viewers are lost and intoxicated in her dream-like spaces, and the scenery is both fresh yet familiar. When the innocent little girl encounters the innocent landscape, we rediscover anew freedom and truth. That is the most elemental essence of life, which comes from the purest heart, and a feeling which cannot be replaced by the thinking process.

The little girl is the main theme in the fantasy world created by Ma Dan. In her earlier works, the girl is the main character. *Lonely Show* (2010) is about the girl viewing her own exhibition, and *Cabbage to the Romantic* (2010) depicts the girl exploring the countryside while perched on a cabbage, and *Lucky Field* (2010) depicts the girl looking for four-leaf clovers on the hills. In her later works, such as *Morning* (2011), *Upon the Clouds-Explore* (2012), and *Self Portrait 2* (2012), the little girl begins to reveal a childlike curious and mischievous, yet fearless, disposition. In *Today I am the Boss* (2011) and the *Orchard* series and the *Warm Mound* series, the little girl shows her confidence to be the hope of the future. In her more recent series *Unfinished Dream*, *Life Is Short as if a Dream* and *Glimpse of a Small World*, we witness a clear transformation from the monologue of a little girl's interior world to a spectator's multi-perspective view of the changing world. Now, two or more little girls' backs are beginning to appear in the picture.

From 2010 to 2019, Ma Dan and I collaborated on her six solo exhibitions at the gallery in Beijing, and also in France Paris, and the Napoli Foundation in Italy. Her works have also been presented in 42 art fairs around the world, including the U.S., France, Italy, the U.K., Taiwan, Singapore, South Korea, Indonesia. It is also particularly gratifying that the collectors and institutions that collect her works come from all around the world.

So many years have now passed, and I do not remember what I saw that day all those years ago, but I still remember the sense of delight when I saw her work. Here, I shall quote from one of her Taiwanese collectors: To hang a Ma Dan work at home is like owning an oxygen-generation machine. I think that this is just what we have always been searching for – works which bring us a feeling of freshness.

I would like to thank the President of the Artist magazine in Taiwan, Mr. Ho, Chengkuang, for the opportunity to publish this book. Also, I would like to thank Ms. Xu Yuling of the Beijing office, and the editors of the Artist magazine for their valuable support. And thanks too to the institutions and collectors who support Ma Dan and the gallery.

Written in Beijing on July 10, 2019

馬丹

1985　生於中國雲南
2008　畢業於雲南大學藝術與設計學院
2011　於雲南大學藝術與設計學院獲得碩士學位
　　　現工作生活於雲南昆明

個展：
2016　浮生，艾米李畫廊，北京，中國
2015　隨行，PIECE UNIQUE，巴黎，法國
　　　半夢-花開，Al Blu di Prussia，拿坡里，義大利
2014　舞臺，艾米李畫廊，北京，中國
2012　雲上探險，艾米李畫廊，北京，中國
2011　幸運滿地，艾米李畫廊，北京，中國

群展：
2019　藝術廈門，艾米李畫廊，廈門，中國
　　　藝術北京，艾米李畫廊，北京，中國
2018 　Art Miami，艾米李畫廊，邁阿密，美國
　　　臺北國際藝術博覽會，艾米李畫廊，臺北，臺灣
　　　Asia Now：Paris Asian Art Fair，艾米李畫廊，巴黎，法國
　　　藝術南京，艾米李畫廊，南京，中國
　　　藝術深圳，艾米李畫廊，深圳，中國
　　　藝術北京，艾米李畫廊，北京，中國
2017　Art Miami，艾米李畫廊，邁阿密，美國
　　　Art New York，艾米李畫廊，紐約，美國
　　　臺北國際藝術博覽會，艾米李畫廊，臺北，臺灣
　　　藝術北京，艾米李畫廊，北京，中國
2016　童年與遠方-我們的家 我們的家園，北京時代美術館，北京，中國
　　　臺北國際藝術博覽會，艾米李畫廊，臺北，臺灣
　　　藝術北京，艾米李畫廊，北京，中國
　　　雲南種子，今日美術館，北京，中國
　　　國際動漫展「非常上癮——日產生活美學的再延伸」，銀川當代美術館，
　　　寧夏，中國
2015　倫敦Art 15藝博會，艾米李畫廊，倫敦，英國
　　　臺北國際藝術博覽會，艾米李畫廊，臺北，臺灣
　　　Context - Art Miami，艾米李畫廊，邁阿密，美國
　　　藝術北京，艾米李畫廊，北京，中國

2014	偏綠與自然的態度，雲南省博物館，昆明，中國
	藝術北京，艾米李畫廊，北京，中國
	亞洲當代藝術展，艾米李畫廊，香港，中國
	臺北國際藝術博覽會，艾米李畫廊，臺北，臺灣
2013	Art Southampton，艾米李畫廊，南漢普墩，美國
	藝術北京，艾米李畫廊，北京，中國
	臺北國際藝術博覽會，艾米李畫廊，臺北，臺灣
	天工開悟，艾米李畫廊，北京，中國
2012	Context - Art Miami，艾米李畫廊，邁阿密，美國
	藝術北京，艾米李畫廊，北京，中國
	臺北國際藝術博覽會，艾米李畫廊，臺北，臺灣
	靜能--中國當代藝術展，艾米李畫廊，北京，中國
	「現代之路」雲南現當代油畫藝術展，中國美術館，北京，中國
2011	Art Asia Miami，艾米李畫廊，邁阿密，美國
	藝術北京，艾米李畫廊，北京，中國
	臺北國際藝術博覽會，艾米李畫廊，臺北，臺灣
	臺北國際當代藝術博覽會，艾米李畫廊，臺北，臺灣
	成都雙年展特別邀請展之--「圭山看臺」雲南當代藝術特別展，成都，中國
	陽光與時間：在雲的那邊--當代藝術展，成都藍頂美術館，成都，中國
	中國當代藝術展，東方博物館，里斯本，葡萄牙
2010	Art Asia Miami，艾米李畫廊，邁阿密，美國
	過橋米線--雲南年輕藝術家作品展，艾米李畫廊，北京，中國
	四季‧春--女性藝術家聯展，創庫諾地卡，昆明，中國
	改造歷史2000/2009年的中國新藝術--中國青年新藝術邀請展，中國今日美術館，北京，中國
2009	四季‧冬--女性藝術家聯展，創庫諾地卡，昆明，中國
	我們創造--女性藝術家聯展，99藝術空間，昆明，中國
	杭州藝術博覽會，杭州，中國
	第二屆「奇觀」多媒體藝術雙年展「繪聲繪色」--數字與繪畫的對話，雲南省博物館，昆明，中國
	山水營造--大理山水間藝術造境大型文化交流活動，大理，中國
	第十一屆全國美術作品展雲南美術作品展，昆明，中國
2007	萌‧紅土--雲南油畫聯展，雲南大學美術館，昆明，中國
2006	回到圭山--油畫聯展，雲南大學美術館，昆明，中國

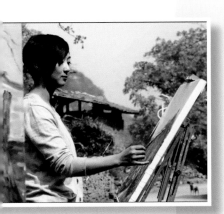

Ma Dan

1985 Born in Yunnan Province, China
2008 Bachelor of Art and Design, Art and Design Institute of Yunnan University
2011 Master of Arts, Art and Design Institute of Yunnan University
 Currently works and lives in Yunnan, China

Solo Exhibitions

2016 Life is Short as if a Dream - Ma Dan Solo Exhibition, Amy Li Gallery, Beijing,
China
2015 Companion, PIECE UNIQUE Galerie,Paris,France
 Unfinished dream - Flower Blooming,Al Blu di Prussia,Napoli Foundation,Italy
2014 Stage - Ma Dan Solo Exhibition, Amy Li Gallery, Beijing, China
2012 An Exploration from the Clouds, Amy Li Gallery, Beijing, China
2011 Lucky Field - Ma Dan Solo Exhibition, Amy Li Gallery, Beijing, China

Group Exhibitions

2019 Art Beijing, Amy Li Gallery, Beijing, China
 Art Xiamen, Amy Li Gallery, Xiamen, China
2018 Art Beijing, Amy Li Gallery, Beijing, China
 Art Taipei, Amy Li Gallery, Taipei, Taiwan
 Art Miami, Amy Li Gallery, Miami, U.S
 Art Nanjing, Amy Li Gallery, Nanjing, China
 Art Shenzhen, Amy Li Gallery, Shenzhen, China
 Asia Now: Paris Asian Art Fair, Amy Li Gallery, Paris, France
2017 Art Taipei, Amy Li Gallery, Taipei, Taiwan
 Art Miami, Amy Li Gallery, Miami, U.S
 Art New York, Amy Li Gallery, New York, U.S
 Art Beijing, Amy Li Gallery, Beijing, China
2016 Childhood and Beyond , Times Art Museum, Beijing,China
 Art Beijing, Amy Li Gallery, Beijing, China
 Seed in Yunnan, Today Art Museum,Beijing, China
 Very Addictive Re extension of Aesthetics in Daily Life,MOCA
Yinchuan,Ningxia,China
 Art Taipei, Amy Li Gallery, Taipei, Taiwan
2015 Art Taipei, Amy Li Gallery, Taipei, Taiwan
 ART15, Amy Li Gallery, London, UK
 Art Beijing, Amy Li Gallery, Beijing, China
 Context – Art Miami, Amy Li Gallery, Miami, U.S
2014 Art Taipei, Amy Li Gallery, Taipei, Taiwan
 Art Southampton, Amy Li Gallery, Southampton, U.S
 Asia Contemporary Art Show, Amy Li Gallery, Hong Kong, China
 Green and Natural Attitude, Yunnan Provincial Museum, Kunming, China

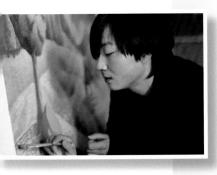

	Art Beijing, Amy Li Gallery, Beijing, China
2013	Art Southampton, Amy Li Gallery, Southampton, USA
	Art Beijing, Amy Li Gallery, Beijing, China
	Art Taipei, Amy Li Gallery, Taipei, Taiwan
	Enlightened Nature, Amy Li Gallery, Beijing, China
2012	Context - Art Miami, Amy Li Gallery, Miami, U.S
	Art Taipei, Amy Li Gallery, Taipei, Taiwan
	Quiet Energy - Chinese Contemporary Art Exhibition, Amy Li Gallery, Beijing, China
	Art Beijing, Amy Li Gallery, Beijing, China
	Modern road-Yunnan modern & contemporary Art Exhibition, Amy Li Gallery, Beijing, China
2011	Art Asia Miami, Amy Li Gallery, Miami, U.S
	Art Beijing, Amy Li Gallery, Beijing, China
	Art Taipei, Amy Li Gallery, Taipei, Taiwan
	Young Art Taipei, Amy Li Gallery, Taipei, Taiwan
	Chengdu Biennale 2011 - To Be Audience in Guishan - Yunnan Contemporary Art Special Exhibition, Chengdu, China
	Time and Sunlight - On the Other Side of the Clouds Contemporary Art Exhibition, Chengdu,Blueroof Art Gallery, Chengdu, China
	Chinese Contemporary Art, Museum of the Orient, Lisbon, Portugal
2010	Art Asia Miami, Amy Li Gallery, Miami, USA
	Go! Yunnan Rice Noodles - Yunnan Young Artists' Group Exhibition, Amy Li Gallery, Beijing, China
	Four Seasons Spring, Yunnan Female Artists' Exhibition, Nordica Gallery, Kunming, China
	Reshaping History 2000-2009, New Art of China Youth Invitational Exhibition, Today Art Museum, Beijing , China
2009	Four Seasons Winter Yunnan Female Artists' Exhibition, Nordica Gallery, Kunming, China
	We Create - Yunnan Female Artists' Exhibition, 99 Art Gallery, Kunming, China
	Hangzhou Art Fair, Hangzhou, China
	The 2nd "Spectacle" Multimedia Art Exhibition - Dialogue between Digital and Painting, Yunnan Museum, Kunming, China
	Build Landscape - Dali Shanshuijian Artificial Scenery Large-scale Cultural Communication Event, Dali, China
	The 11th Yunnan Art Exhibition of the National Art Exhibition, Kunming, China
2007	Sprout Red Soil - Oil Painting Group Exhibition, Art Museum of Yunnan University, Kunming, China
2006	Back to Guishan - Oil Painting Group Exhibition, Art Museum of Yunnan University, Kunming, China

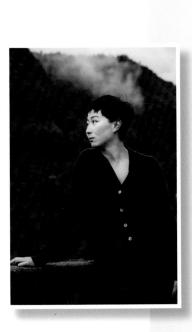

圖版索引 | Index

國家圖書館出版品預行編目資料

馬丹 / 李穎主編. -- 初版. -- 臺北市：藝術家,
2019.07. 216面；18×26公分

ISBN 978-986-282-237-1 (平裝)

1.油畫 2.畫冊

948.5 108010265

馬 丹 Ma Dan

艾米李畫廊AMY LI GALLERY www.amyligallery.com
北京市朝陽區機場輔路草場地54號院100015
No.54 Caochangdi (old airport road),
Chaoyang District, Beijing, 100015 China

製　　作 Producer　　艾米李畫廊 Amy Li Gallery
主　　編 Chief Editor　李　穎 Amy Li（Ying LI）
編　　輯 Editor　　　洪婉馨 Carolyn Hung
美術編輯 Designer　　郭秀佩 Hsiupei Kuo
翻　　譯 Translation　宋友光（新加坡）、崔保仲、董強、王博威
　　　　　　　　　　Nicholas Song（Singapore）, Joseph Cui, Dong Qiang, Wang Bowei

發 行 人　何政廣
出 版 者　藝術家出版社
　　　　　台北市金山南路（藝術家路）二段165號6樓
　　　　　TEL：(02) 2388-6715～6
　　　　　FAX：(02) 2396-5707
郵政劃撥　01044798 藝術家雜誌社帳戶
總 經 銷　時報文化出版企業股份有限公司
　　　　　桃園縣龜山鄉萬壽路二段351號
　　　　　TEL：(02) 2306-6842
南區代理　台南市西門路一段223巷10弄26號
　　　　　TEL：(06) 261-7268
　　　　　FAX：(06) 263-7698

初　　版　2019年7月
定　　價　新臺幣800元
I S B N　978-986-282-237-1（平裝）